National Gallery Technical Bulletin

Volume 21, 2000

National Gallery Company
London

Distributed by
Yale University Press

Series editor **Ashok Roy**
Associate editor **Jo Kirby**

First published in Great Britain in 2000 by National Gallery
Company Limited, St Vincent House, 30 Orange Street,
London WC2H 7HH

British Library Cataloguing in Publication Data
A catalogue record for this journal is available from
the British Library

ISBN 1 85709 251 1
ISSN 0140 7430
525457

Edited by **Diana Davies**
Project manager **Jan Green**
Typeset by **opta**
Printed in Italy by EBS

FRONT COVER
Lorenzo Monaco, *The Coronation of the Virgin*
(NG 215, 1897, 216) (detail of Plate 1, p. 44)

TITLE PAGE
Carlo Crivelli, *The Dead Christ supported by Two Angels*
(NG 602; detail), after cleaning and restoration

Contents

The Virgin and Child Enthroned with Angels and Saints attributed to Michael Pacher

JILL DUNKERTON, SUSAN FOISTER AND MARIKA SPRING

THE SMALL PAINTING showing *The Virgin and Child Enthroned with Angels and Saints* (Plates 1 and 3) was bequeathed to the National Gallery in 1947 by Miss Anna Simonson.[1] It had already been exhibited in 1932 as the work of Michael Pacher,[2] but the attribution to Pacher himself has been the subject of considerable debate ever since. The painting has been accepted by some art historians as a rare surviving example of a small devotional picture by the great Tyrolean painter and sculptor, while for others its authorship must lie among the somewhat mysterious and ill-defined members of the Pacher family and workshop.[3] In 1997–8, prior to the painting's loan to the 1998 exhibition at Klosterneustift, *Michael Pacher und sein Kreis*,[4] it was cleaned and a number of samples were taken for analysis. The cleaning provided the opportunity for a detailed examination of the painting with the aim of assessing its technique – exceptional among works in the National Gallery Collection – in the context of workshop practice in the South Tyrol in the second half of the fifteenth century.

The subject of the enthroned Virgin and Child with saints is common in both Northern Europe and Italy, but the architectural presentation of this composition, with its elaborate stone canopies set against a gilded background carved into the chalk ground, is particularly distinctive and unusual, as is the degree of animation of the small figures who appear to play out a small-scale drama before our gaze. Not only are the figures varied by being deliberately set at differing angles to each other and to the spaces they inhabit, but they also respond to one another in various ways, resulting in an interplay of relationships and actions within the picture which holds our attention. Saint Michael raises his sword and seems to concentrate not on the vanquished devil at his feet but on the two little devils – one trying to tilt the balance by carrying a miniature millstone – who have struggled onto the scales in order to outweigh the pious soul in the right-hand weighing pan. On the right of the picture, in contrast, is the still figure of an unidentified bishop saint, standing with a

book in his right hand and a crozier in his left hand.[5] The angel on the right below the Virgin offers the Child a rose but the Child seems, disconcertingly, to ignore him and instead, smiling, tries to grasp the pear offered by the left-hand angel, who stretches up as the Child reaches down. The action is observed by both angels on the pedestals above: the one on the left looks directly down, while the one on the right, whose view of the action is slightly obscured, has to lean forward. Their gazes are joined by that of the Virgin who sadly observes the Child's action. Finally there is an additional drama played out against the arches above, where the small figure of the Annunciate Virgin bows her head in response to the greeting of the Angel Gabriel.

The larger-scale figures are placed in elaborate niches and the small ones are perched on ledges and pedestals in the same way as in sculpted wooden altarpieces (Plate 2), but here the colours indicate that this fantastic architecture is to be imagined as carved from stone. The triangular projecting canopies are echoed by the curves and angles of the marbled step and flooring in the foreground. The sense of space created by the slender columns placed directly behind and to the side of the main figures is both mitigated and enhanced by the gilding of the carved floriate forms behind, which echo and contrast with the pierced trefoil decoration of the canopy above. The effect of the whole is dense and complex, though on a small scale. It is clear that the painting is the work of a sophisticated artist. The small size and high degree of finish of the painting, as well as its decoratively marbled reverse, suggest that it was intended as a private devotional picture, possibly with shutters.[6]

Michael Pacher is best known for his large altarpiece ensembles consisting of both sculpted wood and painted panels, of which the only complete surviving example is the Saint Wolfgang Altarpiece of 1471–81, still *in situ* in the pilgrimage church of that name on the Wolfgangsee. That at Gries from 1471 remains in the parish church but is incomplete, while those made for the parish churches in St Lorenz (now San Lorenzo di Sebato in the Val Pusteria),

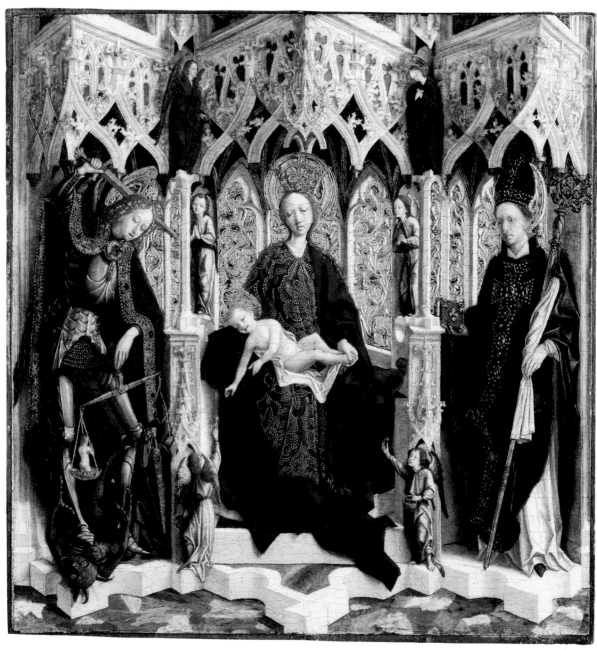

Plate 1 Michael Pacher, *The Virgin and Child Enthroned with Angels and Saints* (NG 5789), *c.* 1475. Oil on stone pine, 41.8 × 40.6 cm. After cleaning and restoration.

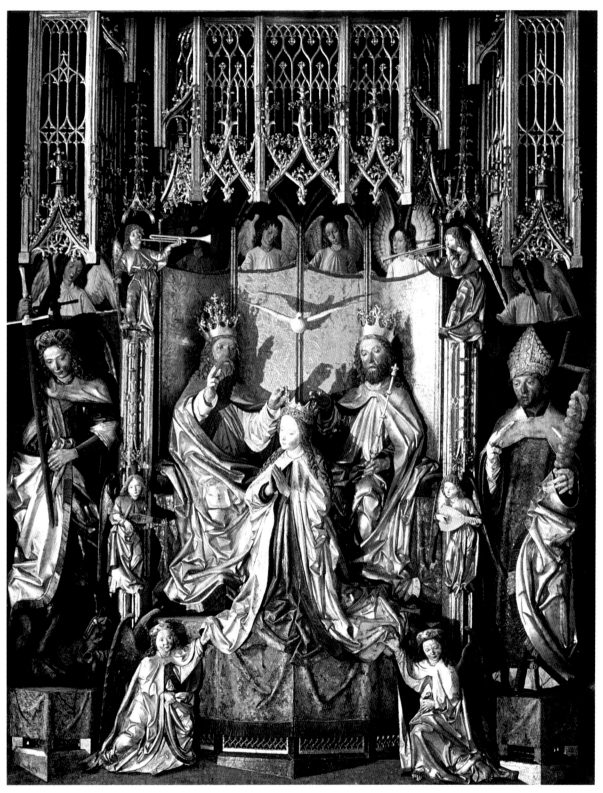

Plate 2 Michael Pacher and workshop, *The Coronation of the Virgin with Saint Michael and Saint Erasmus*, 1471. Gold and silver leaf, applied relief brocade and oil paint on carved stone pine, 360 × 300 cm (central shrine). Gries (Bolzano), old parish church.

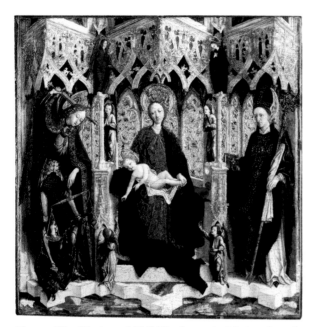

Plate 3 *The Virgin and Child Enthroned with Angels and Saints*. Before cleaning.

after 1462, and Salzburg, in 1484–98, survive only as dispersed fragments (Plates 5 and 6). No remains have been identified from the documented Bolzano altarpiece of 1481–4. The large painted altarpiece representing the Four Fathers of the Church (Plate 4), now in the Alte Pinakothek, Munich, was made, probably in the mid or late 1470s, for the choir of the abbey church of the Augustinian monastery at Klosterneustift. This is the work that can most closely be related to the National Gallery panel, both in the richly decorative architectural settings with similar canopies projecting over the almost life-size figures, and in certain details, such as the grisaille figure of Saint Catherine in the Saint Ambrose panel, whose slender neck and inclined head resemble those of the Virgin in the smaller panel. The whole altarpiece, above all the scene of *Saint Augustine disputing with Heretics* on the outer left shutter, shows the the same interest in gesture and interaction between figures, especially through eye contact, that has been observed in the National Gallery picture. Nevertheless, the huge difference in scale (even the Virgin embroidered on Saint Augustine's cope is considerably larger than her counterpart in the small panel) and the greater breadth of handling involved in the large work make for difficult comparison. The only smaller works that can be compared directly with the National Gallery picture, the two panels showing the *Assassination* and *Funeral of Saint Thomas a Becket*, cut from the shutters of a small altarpiece

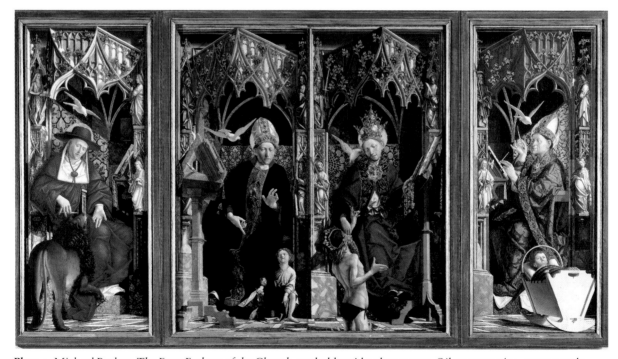

Plate 4 Michael Pacher, *The Four Fathers of the Church*, probably mid or late 1470s. Oil on stone pine, outer panels 216 × 91 cm, inner panels 212 × 100 cm. Munich, Alte Pinakothek.

Plate 5 Michael Pacher, *The Annunciation*, from the inner shutter of the Saint Lawrence Altarpiece, *c.*1470. Oil on stone pine, 100 × 97 cm. Munich, Alte Pinakothek.

Plate 6 Michael Pacher, *The Arrest of Pope Sixtus*, from the outer shutter of the Saint Lawrence Altarpiece, *c.*1470. Oil on stone pine, 104 × 100 cm. Vienna, Österreichische Galerie.

from Klosterneustift and now in Graz (Plate 7), are similarly undocumented and have been variously seen as early works by Pacher himself or as the product of the workshop without the intervention of his hand.[7] Moreover, even in the case of Pacher's well-documented commissions, as an artist who ran a large workshop encompassing both painting and sculpture, it is inevitably difficult to define exactly where his personal contributions lay.[8]

The Virgin and Child Enthroned with Angels and Saints had been cleaned in 1948–9, soon after it came into the Collection.[9] It was noted then that no resinous varnish layer appeared to be present, although, judging by the photographs, the coating on the painted area was extremely discoloured.[10] Most of this layer had been removed, but the painting had not been cleaned evenly, with disfiguring residues left in the depressions in the paint surface (Plate 8). This gave the impression that it was not as well preserved as is actually the case. In fact, it has suffered no more than a few small flake losses, most of them from areas of dark red paint on Saint Michael's cloak and wing and in the inlaid decoration of the tracery of the central canopy, and some abrasion, affecting mainly the thinly glazed cast shadows and the marbled floor tiles in the foreground (Fig.1). By the time the painting came to be considered for further treatment the retouchings applied in the last restoration had discoloured, even though the varnish remained in good condition and was only slightly yellow. The treatment undertaken in

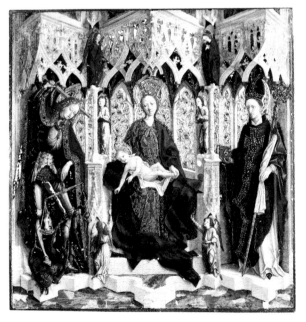

Fig. 1 *The Virgin and Child Enthroned with Angels and Saints.* After cleaning before restoration.

1997–8 involved the removal and replacement of the varnish and retouchings and, more importantly a reduction of the uneven residues of the old coatings.[11] The improvement was considerable, above all in the complex mouldings of the canopy. Previously it had not been apparent that the facets of the pillars that support the arches and tracery are lit from two sources: the main light source, from the right and in

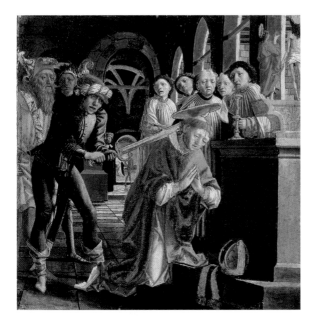
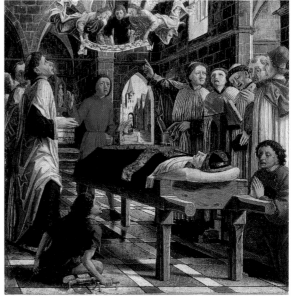

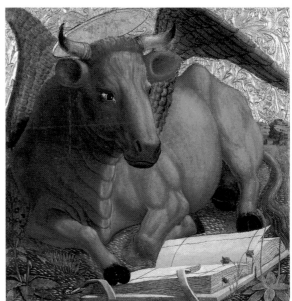

Plate 7 Michael Pacher, *The Assassination* and *The Funeral of Saint Thomas a Becket* (inner shutter) and *Symbols of Saint Mark and Saint Luke* (outer shutter), *c*.1470. Oil on panel, each 44 × 43.5 cm. Graz, Landesmuseum Joanneum.

front of the picture plane, and a second internal source, the radiance of the decorative gilded background (Plate 8).

The wood of the panel has been identified as stone pine (*Pinus cembra*),[12] the wood commonly used by Pacher for the carved elements of his altarpieces as well as for their complex structures. Although fir was chosen for the painted shutters of the Saint Wolfgang Altarpiece,[13] stone pine has been reported as the wood of many of Pacher's panels including those from the dispersed Saint Lawrence and Salzburg altars.[14] Some softwood panels have a very pronounced grain, which may become more evident with time,[15] but the stone

pine used for the National Gallery panel must have grown very slowly high on the slopes of the Alps and consequently the planks show exceptionally close and tight growth rings.

Nothing of the panel registers in the X-radiograph (Fig. 2) and the wood is now visible only where exposed by flaking of the painted decoration on the reverse (Fig. 3). The panel has been carefully constructed from two vertical planks, 1.2 cm thick, with the join 12.1 cm from the right edge and running through the architectural division between the niches for the bishop saint and the central Virgin. The join has remained tight, but can be located by the opacity

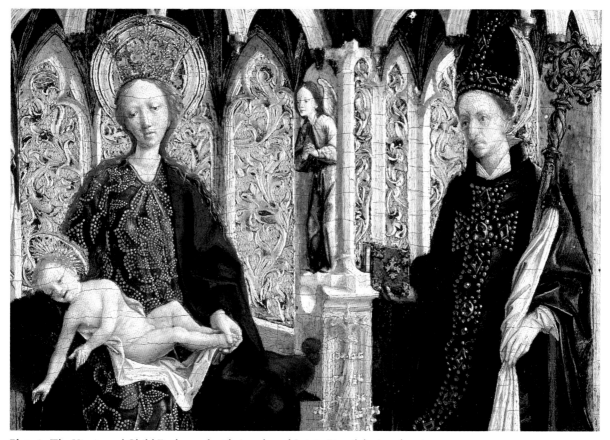

Plate 8 *The Virgin and Child Enthroned with Angels and Saints.* Detail during cleaning.

to X-rays of the adhesive, and, more evidently, on the damaged reverse. An indication of the care with which the panel was made is the setting of a small square of wood into the centre of the larger plank. It is apparent only on the reverse and does not seem to extend through the full thickness of the panel. It would seem that a fault had to be cut out and replaced with an inlay, even though this was to be the less important reverse. Many similarly neat rectangular inlays can be detected on the painted surfaces of the shutters from the Saint Lawrence and Salzburg altars and on the Four Fathers of the Church panels.

Before the application of the ground on the front face of the panel, a piece of fabric with a fine but very open weave (with a maximum of 10 warp, 10 weft threads per cm^2) was glued to the wood. In the X-radiograph it can be seen that, although the right edge is cut (Fig. 2), the frayed and ragged edges stop just short of the left and upper edges of the painted area and between six and eight centimetres short of the lower edge. Since it would have been easy to tear off another strip to add to the uncovered lower part, it seems that the fabric was considered important mainly for the area to be gilded. X-radiographs of the Saint Thomas a Becket panels in Graz also show scraps of fabric underlying the gilded backgrounds to the symbols of the Evangelists on their reverses.[16]

The ground of the National Gallery panel, built up to a considerable thickness to allow for the carving of the relief pattern in the gilded background, is composed of chalk in a glue medium.[17] On the reverse, however, the ground is less thickly applied and contains mainly dolomite (calcium magnesium carbonate), a mineral that was readily available locally, and so far found only on paintings of the fifteenth and sixteenth centuries from Southern Germany and the Tyrol. The same combination of a chalk ground on the front faces of the panels and dolomite on less important reverses has been discovered on the Saint Wolfgang Altarpiece, and also over fine canvas applied to all the wooden surfaces, both flat and sculpted.[18]

Although there is a narrow unpainted border around all the edges, both the panel and the painted area have in fact been trimmed by varying amounts. At the lower edge fragments of gold leaf can be seen under the paint layers, indicating that the frame

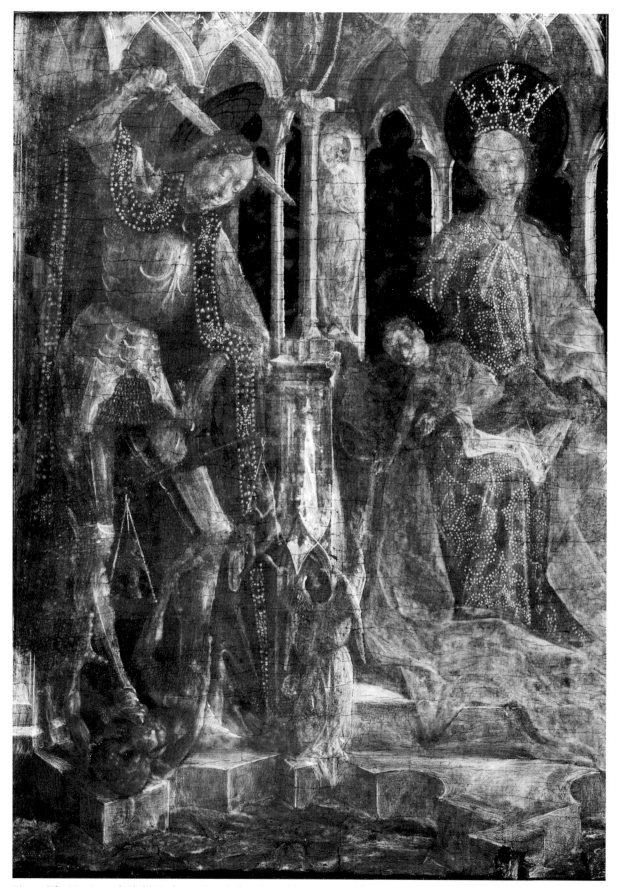

Fig. 2 *The Virgin and Child Enthroned with Angels and Saints*. Detail from X-radiograph.

Fig. 3 *The Virgin and Child Enthroned with Angels and Saints*. Reverse.

Plate 9 *The Virgin and Child Enthroned with Angels and Saints*. Detail of marbling on reverse.

mouldings were attached to the panel and grounded and gilded before painting began. Towards the corners the chalk ground has seeped, while still liquid, under the frame moulding and onto the now exposed wooden border. When the frame mouldings were removed (at an unknown date), not only was the panel trimmed, but also the edges of the painted area were neatened by trimming the presumably chipped and ragged raised barbe formed at the junction between flat surface and frame. However, along all but the right edge, occasional traces of the barbe can be found on both the front and reverse, and so no part of the image has been lost along these edges. The right edge, on the other hand, is definitely cut. As well as the evidence of the fabric glued to the wood, it can be seen that the ground and painted decoration

on the reverse extend to the very edge of the panel. The unpainted border at the front was evidently made by chipping away some of the ground and paint, but probably by no more than the 0.5 cm that makes the architecture symmetrical with that on the left.

The way in which the projecting canopies and central step are intersected by the picture edge might be thought surprising, and is certainly daring, but it has the effect of pushing the architectural setting back into the picture space so that it is truly framed as if seen through a window opening. It also avoids the admittedly fascinating spatial ambiguity of the Four Fathers of the Church panels (Plate 4). In these the canopies project to meet the fictive frame mouldings at the top and therefore the picture plane itself, while, in the lower parts, the cutting by the real frame of the receding floor tiles and figures and elements in the foreground implies a greater distance between picture plane and the enthroned saints. Furthermore, *The Virgin and Child Enthroned with Angels and Saints* – as a small devotional panel – would never have had the fixed viewing point indicated by the perspective constructions of the Four Fathers panels.

The frame mouldings must have been assembled around the panel in much the same way as those on the Saint Wolfgang shutters.[19] With their removal and the trimming of the panel any evidence has been lost as to whether there were ever any hinges. The rich and generally well-preserved colours of the National Gallery panel might suggest that it has been protected by shutters, but some other form of protective cover could also have been fitted. The decoration of the back of the panel to imitate porphyry or a coloured marble by spattering a black base colour with red earth and lead-white paints, and then painting veins with red earth (Plate 9), does not necessarily indicate that it was a folding altarpiece. There are many single devotional panels with similarly decorated reverses, especially from Italy.[20]

The single-point perspective constructions of Pacher's large altarpiece shutters were established by incising the orthogonals into the ground, as well as the principal straight lines of the settings.[21] The only incisions in *The Virgin and Child Enthroned with Angels and Saints* were made to demarcate the areas to be carved and gilded – scored lines can be seen at the tops of the pillars to the left of the bishop saint (Plate 8) – but the design of the setting is such that the only true orthogonals are those of the inlaid marble of the second of the three steps up to the Virgin's throne, and these were evidently painted freehand. Indeed, the whole design, with the extraordinary multi-faceted steps and canopy, and the random

'crazy paving' design of the marbled foreground, seems calculated to avoid the insistent recession of single-point perspective, imitating instead the shallow space of a carved altarpiece.

Such a complex design could not have been executed without a detailed underdrawing, and hints of such a drawing can in places be detected by surface examination of the picture. Unfortunately, it has been executed using a material, perhaps an iron-gall ink, which is completely transparent at all wave lengths used in infra-red examination.[22] An indication of the likely complexity of the drawing is suggested by the detail of the naked human soul in the scale pan of Saint Michael: under magnification it can be seen that even the modelling of his buttocks (no more than 5 mm across) has been precisely indicated (Plate 10). Elsewhere some of the drawing of the tiny Angel Gabriel from the Annunciation on the canopy was exposed by old damage, but the largest area of visible underdrawing is that beneath the transparent red lake of Saint Michael's mantle (Plate 11). Allowing for the great differences in scale, the short closely spaced strokes of nervous, slightly scratchy hatching, which seek to model the volumes of the drapery folds more than to establish areas of shadow, are comparable with published examples of underdrawings on the Saint Wolfgang panels assigned to Michael Pacher himself rather than to his collaborators.[23] That it was his practice to make highly elaborate underdrawings is confirmed by the exposed drawing in the very damaged fragment showing an episode in the Story of Joseph from the Salzburg Altar (Vienna, Österreichische Galerie).

The relief pattern of the gilded background beyond the arches and also the concentric circles of the haloes were carved into the thickly applied ground, a common technique on South German and Austrian panels of the fifteenth century, but the absolute reverse of the different types of applied relief decorations or the built-up *pastiglia* to be seen in Italian works. The carving of the ground on the little National Gallery panel is notable for its high quality, for the rhythm and flow of the foliate pattern, and for the subtle variation in the different levels of relief (Plate 8). It shares this distinction with similarly ornamented areas on the inner faces of the Saint Wolfgang shutters and the reverses of the Graz panels (Plate 7); indeed, in the great majority of German and Austrian panels decorated in this way, the carving is not truly in relief, for the patterns are made by simply scoring and indenting the designs into the ground.

In the areas of relief decoration, and also the haloes of the Annunciation figures, the gold leaf is laid over a very dark brown, almost black, gilding preparation, now visible in areas of damage to the gilding. The Saint Wolfgang Altarpiece everywhere has the more usual red-brown or orange bole as a base for gold leaf on both paintings and sculptures,[24] as do the Graz panels, but black bole appears to underlie the gilded background of *The Death of the Virgin* (Munich, Alte Pinakothek) from the inner face of the Saint Lawrence shutters.[25] It also features on certain works by the Master of Uttenheim with whom Pacher seems to have had a close, if not precisely defined, connection in the earlier part of his career.[26]

On the National Gallery panel black particles, together with some small opaque red ones, can be seen under magnification. They appear in a matrix which looks brown and translucent but which, on closer examination, seems to contain relatively finely ground colourless material. EDX analysis of a sample identified the major component as calcium carbonate (the colourless particles in the matrix), together with some iron oxide (presumably the red particles) and other silicaceous minerals. Since the black particles contain no elements detectable by

Plate 10 *The Virgin and Child Enthroned with Angels and Saints*. Photomicrograph of the saved soul in the scale pan.

Plate 11 *The Virgin and Child Enthroned with Angels and Saints*. Photomicrograph of Saint Michael's cloak showing the underdrawing.

Plate 12 *The Virgin and Child Enthroned with Angels and Saints*. Photomicrograph of the eye of the devil at Saint Michael's feet.

Plate 13 *The Virgin and Child Enthroned with Angels and Saints*. Photomicrograph of the angel offering the rose to the Christ Child.

EDX they would appear to be carbon black.[27] Some modern examples of black and brown bole were examined for comparison; they are quite similar in appearance to the bole on the painting, also containing black particles and a few red and yellow iron oxide particles as well as some colourless material. They are not true boles in the sense that they do not contain the clay-like minerals found in Armenian bole, but neither are the red, orange and yellow layers applied as preparations for water-gilding on other Austrian and German paintings.

A black bole may have been chosen to give added depth to the dark gleam of the newly burnished gold, an effect now largely lost with time. As well as deciding between black and red bole, burnished water-gilding and matt oil mordant gilding, Pacher could select several different metal leafs. For the Saint Wolfgang altar gold, silver and the cheaper *Zwischgold* (gold and silver leaf beaten together), were all employed, with the latter used for less important or less visible areas.[28] He also exploited the convenient and decorative technique of applied relief brocade for textiles in certain other works, notably the Four Fathers of the Church and Saint Thomas a Becket panels and the sculpted surfaces of the Saint Wolfgang and Gries altars (Plates 2, 4 and 7).[29] EDX analysis shows that the only metal leaf on *The Virgin and Child Enthroned with Angels and Saints* is a gold leaf of high purity.[3] This was used for the water-gilding of the carved relief decoration and also in combination with an oil mordant for small gilded details such as the ribs of the vaulting, the crozier carried by the bishop saint, the binding of his book, the edge of Saint Michael's cloak, the metal parts of his balance (Plate 10), and, most effectively, for the claws and red-rimmed eyes of the devil (Plate

12). The mordant is unpigmented but appears as a translucent light brown colour where it is visible on the picture surface. The colour appears to be largely the result of darkening of the medium.

The paint film is bound with linseed oil, also reported as the medium of the Saint Wolfgang panels.[31] Although there is much meticulously executed detail, the paint is thicker and more bodied, especially in the lighter colours, than that to be seen in many Northern European paintings of the fifteenth century. This results in a strong and clear X-ray image. The opacity of the flesh painting, in particular (Plate 13), is reminiscent of the techniques for polychroming faces on sculpted figures. The highlights of the architectural mouldings and tracery form thick, raised ridges, and areas containing a high proportion of lead white sometimes have a slightly wrinkled texture, the result of drying defects in the medium rich paint.[32] The lead white paint used to highlight the countless tiny pearls was evidently also thick and viscous; occasionally a trailing thread of paint was formed as the brush was lifted from a pearl (Plate 14).

The opacity of the lighter colours contrasts with the rich intensity of the deeper toned draperies. The azurite used for the Virgin's mantle, and the vaulting of the canopy, is of the high quality often seen on German works, with the pigment coarsely ground to retain the depth of colour of the mineral.[33] Equally sumptuous are the vermilions and red lakes of the Virgin's dress and the cloak of Saint Michael, built up in the shadows with translucent layers of lake through which the drawing can now be seen. However, the most opulent textile is the blue-purple velvet of the bishop saint's cope. Its excellent condition meant that no sample could be taken, but it appears to have been painted with a mixture of azurite, red lake and lead

Plate 14 *The Virgin and Child Enthroned with Angels and Saints*. Photomicrograph of the pearls on the cope of the bishop saint.

white, the light on the pile depicted with thin scumbles of the same pigments but with a higher proportion of white.[34] The play between red, blue and purple is continued with the Annunciation figures and with the angels; two, diagonally opposite one another, are dressed in a pale greenish blue consisting of azurite and white, and the other two in a softer greyer blue, containing the same pigments but with the addition of red lake. Even the architectural setting belongs in this colour range, its unusual greyish-mauve hue the result of the use of a purple variety of the mineral fluorite (calcium fluoride) mixed with lead white. Some of the more shadowed areas, for example to the right of the bishop saint, have a patchy, slightly blanched appearance. This may be the consequence of increased transparency with time of the paint medium, or perhaps some alteration to the pigment has occurred. The colour and also, in places, the patchiness of certain architectural elements and draperies in the Four Fathers of the Church altarpiece and the dispersed shutters of the Saint Lawrence altar (Plates 4, 5 and 6) indicate the likely presence of fluorite, although it has not yet been identified by analysis of samples.[35] Identifications of fluorite made in other laboratories have been mainly on paintings and sculptures from southern Germany and the Alps; for a fuller discussion of this pigment and other occurrences on paintings in the National Gallery, see pp. 20–7 of this *Bulletin*.

Set against these colours are smaller areas of brilliant green: the lining of the bishop saint's cope built up with three layers of verdigris, lead-tin yellow and lead white, and the lighter green of the vanquished devil with a first layer of malachite, probably of natural origin,[36] followed by a layer of verdigris with lead-tin yellow and lead white, and finally a thin

and rather unevenly discoloured glaze of verdigris in oil, possibly with a small amount of added resin.[37] Patches of this glaze also survive on the rather abraded green marble tiles in the foreground. The other tiles are desaturated variations of the colours of the rest of the picture, with the golden yellow ones (a mixture of lead-tin yellow and yellow ochre)[38] perhaps intended to echo the colour of the gold. The only other 1glazes that are likely to have altered to some extent are those used for the shadows cast by the figures against their niches. A paint sample contained only black, a little azurite and perhaps some fluorite, a combination that would have made a deep purple-black colour. The greenish-brown tinge that the shadows now exhibit is almost certainly the result of discoloration of the large amount of oil added to give them an appropriate translucency. To soften their edges the painter blotted the paint with his thumb or fingertips. Other final touches include the fine black lines that emphasise the sharp junctions between steps and tiled floor and the back of the bishop saint's niche. This black outlining is a distinctive feature of Michael Pacher's larger-scale works, and especially the Four Fathers of the Church altarpiece.

Technical examination can provide no more than confirmation that the techniques and materials used for *The Virgin and Child Enthroned with Angels and Saints* are consistent with the work having been produced in the workshop of Michael Pacher. Its disparity of scale with the great altarpieces means that there will always remain a difficulty in attempting to link them. The practical necessity for workshop assistance in painting the larger works, as well as the requirement for effectiveness over the distance of a church interior, have inevitably affected their style, calling for a homogeneity and also a simplification in painting, which the painter of the small panel had no need to adopt.

However, a more direct comparison can be made with the Saint Thomas a Becket panels in Graz. Although they too have often been considered products of the workshop, they are of an outstanding quality, as a recent cleaning has revealed. As narrative scenes on altarpiece shutters they are more easily related to larger examples of Pacher's painting, and especially the Saint Lawrence panels and the outer sides of the Four Fathers of the Church altar. They share with those works the same spatial organisation, dramatically and ingeniously lit, in particular the scene of the funeral of the saint where two different light sources are implied. The interplay of a relatively limited palette of colours, mainly different shades of red, pink and purple set against a brilliant green, is also typical. The figure types, their animation and

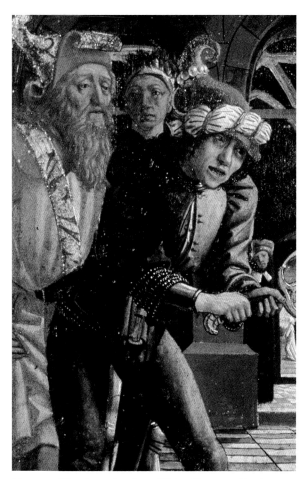

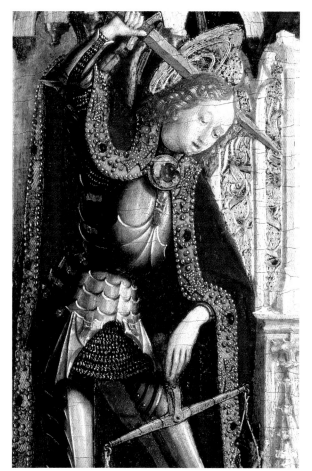

Plate 15 *The Assassination of Saint Thomas a Becket.* Detail.

Plate 16 *The Virgin and Child Enthroned with Angels and Saints.* Detail.

the way that they engage with one another, also have their equivalents in the larger works. The quality of the carving of the gilded backgrounds of the symbols of the Evangelists on the reverses has already been commented upon, and the painting of the lion's mane, with its sculpturally structured curls, can be compared with the hair and beards of the panels of Saint Peter and Saint Paul, originally shutters to the *Sarg* of the Saint Lawrence altar (now Vienna, Österreichische Galerie), or with the hair of the king who kneels before Saint Gregory in the Four Fathers of the Church altarpiece.

The Saint Thomas a Becket panels are also exquisitely refined in their detail and in the handling of the paint. The individualised heads are shown with tiny eyelashes and facial warts, also to be seen on some of the more grotesque heads in the Saint Lawrence shutters; and the artist has even observed how the stitching of the surplice has been pulled by the raised arm of the cleric at the centre of the funeral scene. Other details confirm that the painter of the Graz panels must also have painted *The Virgin and Child*

Enthroned with Angels and Saints: for example, the tiny hands and feet of the flying angels are depicted in exactly the same way as those of the angels and the Annunciation group in the London picture. There are no borders studded with tiny pearls – small pieces of applied relief brocade have been fixed to the surface instead – but the chainmail of the knight who murders the saint is highlighted with white flicks and dots in an identical manner to that employed on the figure of Saint Michael (Plates 15 and 16).

If the Graz panels represent Pacher working on a small scale at about the time he painted the Saint Lawrence shutters, then it is probably correct to consider the London picture in a similar relation to the Four Fathers of the Church altarpiece, and therefore probably dating from later in the 1470s.[39] In any case, it is clear that this is the work of a mature artist: there is nothing tentative or unresolved in the design or execution of this highly accomplished and sophisticated painting. It is a superbly crafted object, full of delicate and sometimes humorous detail, such as the devils in the scale pan and the disappointed angel whose

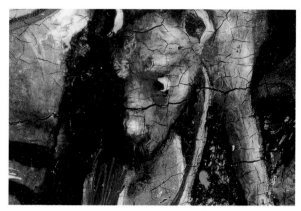 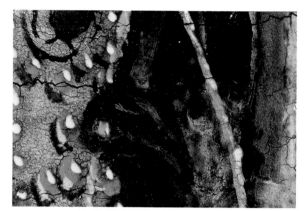

Plates 17 and 18 *The Virgin and Child Enthroned with Angels and Saints*. Photomicrographs of the devils in the scale pan.

offering appears to have been rejected by the Christ Child (Plates 13, 17 and 18). It is clearly not a routine workshop product. Both the quality of execution and the intelligence behind its conception argue for it being the work of Michael Pacher himself.

Acknowledgements

Given the rarity of works from the Tyrol in this country, we have depended greatly on the expertise of those with more experience of works of this type. No study of Pacher's technique would be complete without reference to the contribution of Dr Manfred Koller and we are grateful to him for helpful discussion of our painting. At the Bundesdenkmalamt, Vienna, we would also like to thank Dr Hubert Paschinger and Dr Helmut Richard; and at the Akademie für Bildenkunst, Professor Franz Mairinger. In Munich, Dr Andreas Burmester of the Doerner Institute was very generous with his time. At the Joanneum, Graz, we would particularly like to thank the Director, Dr Gottfried Biedermann, and his staff for making their panels available to us for detailed inspection.

Notes and References

1 According to information in the Gallery Dossier, the painting was said to have been acquired by the donor's father, George Simonson, from a family collection in Rovereto (south of Trento) in about 1913–14.
2 Exhibited Burlington Fine Arts Club 1932–3, No. 29, as by Pacher.
3 C. Gould ('A note on a Pacher-esque addition to the National Gallery', *Burlington Magazine*, 93, 1951, pp. 389–90) set out the relationship with the documented carved works and with the paintings of the Four Fathers of the Church in Munich, describing the National Gallery painting as 'a microcosm of Michael Pacher's works both in painting, and sculpture'. N. Rasmo (*Michael Pacher*, Munich 1969) and E. Egg

(*Gotik in Tirol, die Flügelaltare*, Innsbruck 1985, pp. 189 and 193) attributed the National Gallery painting to Hans Pacher, Michael Pacher's son, but there are no documented works by Hans. V. Oberhammer ('Zu Pachers St. Michael Altar für die Pfarrkirche in Bozen', *Wiener Jahrbuch für Kunstgeschichte*, XXV, 1972, pp. 54–176) attributed the painting to Michael Pacher, an opinion shared by G. Bonsanti ('Michael Pacher in Lombardia' in M.T. Balboni Brizza, ed., *Quaderno di Studi sull'Arte Lombarda dai Visconti agli Sforza*, Museo Poldi Pezzoli, Milan 1990, pp. 20–2).
4 *Michael Pacher und sein Kreis/Michael Pacher e la sua cerchia*, exh. cat., Abbey of Neustift/Novacella, July–October 1998, Bolzano 1998, no. 29, pp. 200–2.
5 His lack of attributes other than his book and crozier makes him difficult to identify. Oberhammer (cited in note 3) suggests that he might be Saint Martin, who is sometimes depicted as a bishop with book and crozier alone. It is also conceivable that he might be one of the two bishop saints of Brixen, Albuin and Ingenuin, though they are usually paired.
6 Rasmo (cited in note 3, pp. 181, 235) drew attention to a seventeenth-century document concerning an altarpiece with wooden sculpture and shutters in the parish church at Bolzano, which stood on the altar dedicated to Saint Michael. The altarpiece showed the Virgin with Saints Michael and Martin. Since payments from 1481–4 exist to Pacher for a Saint Michael altarpiece, Oberhammer (cited in note 3, p. 160) suggests that the National Gallery picture was made as a 'Modell' for this altarpiece, and Egg (cited in note 3) that it was a reflection of the finished altarpiece by Pacher's son, Hans.
7 For differing opinions about the panels in Graz see Rasmo, cited in note 3, pp. 16–24, and *Michael Pacher und sein Kreis*, cited in note 4, p.178. Few smaller scale works are associated with the Pacher workshop: among those in the 1998 exhibition were an *Annunciate Angel* (cat. 32) and a *Saint Barbara* (cat. 34), and there is also a *Saint Sebastian* in Innsbruck (Ferdinandeum), but none of these is comparable with the National Gallery panel. In 1860 a *Man of Sorrows*, presumably not large and apparently signed and dated 1465, was to be seen in the chapel of a castle near Bolzano (see Rasmo, p.57).

8 M. Baxandall (*The Limewood Sculptors of Ren-aissance Germany*, New Haven and London 1980, p. 253) has an incisive passage on the type of workshop Pacher ran and his role as painter and designer of sculpture. The followers and associates of Pacher, to whom the National Gallery picture has sometimes been assigned, are an ill-documented group. There are no documented works by Hans Pacher, Pacher's son, and there is little agreement that the works attributed to him are by a single artist. Friedrich Pacher is a shadowy figure whose family and working relationship with Michael is unclear, but who seems to have worked at Neustift; a group of paintings has been associated with his name, but without a documented basis. The group of works attributed to the Master of Uttenheim, who appears also to have worked at Neustift, is based on the painting of the Virgin and Child with saints in Vienna, formerly in Uttenheim; although it is sometimes argued that the Master is a painter of an earlier generation than Pacher who influenced him, the impact of specific works by Pacher on those by the Master of Uttenheim seems clear (see J. Shoaf Turner, ed., *The Dictionary of Art*, London 1996, Vol. 20, p. 779).

9 The painting was cleaned and restored by Sebastian Isepp. Photographs and a report are in the National Gallery Conservation Record.

10 This observation was confirmed by recent analysis by FTIR of a sample of the old coating that had accumulated in a flake loss. The analysis (by Jennifer Pilc) found mainly animal glue and polysaccharides (perhaps from gums), but none of the usual varnish materials.

11 For the cleaning in 1949 ammonia in turpentine was used to remove the discoloured coating and dirt layers. In the recent cleaning propan-2-ol was used to dissolve the soft resin varnish applied after that restoration. The uneven residues left by the previous cleaning could be broken up and partly removed with dilute ammonia applied on very small cotton wool swabs; the rest was removed mechanically. No cleaning was attempted on areas of green where the discoloured copper green glazes were already rather broken up. The painting was then given a preliminary varnish of 'Regalrez 1094' in Fluka solvent, which provided good saturation with a very thin application. The losses were retouched with pigments in 'Paraloid B-72' and the final sprayed varnish was of dammar in Fluka solvent.

12 The identification of the wood was made by Dr Peter Klein. The support was incorrectly reported as silver fir (*Abies alba*) in M. Levey, *The German School*, National Gallery Catalogues, London 1959, p. 99.

13 M. Koller and R. Prandtstetten, 'Hölzer, Holzbearbeitung und Holzkonstruktion' in M. Koller and N. Wibiral, *Der Pacher-Altar in St. Wolfgang, Untersuchung, Konservierung und Restaurierung 1969–1976*, Vienna, Cologne and Graz 1981, p. 116.

14 *Michael Pacher und sein Kreis*, cited in note 4, pp. 182–93 and 206. Associates of Pacher such as the Master of Uttenheim, Friedrich Pacher and Marx Reichlich also painted on panels of stone pine.

15 For example the fir panel of the fragment by Wolf Huber (NG 6550) illustrated in L. Campbell, S. Foister and A. Roy, eds., 'Wolf Huber's "Christ taking Leave of his Mother"', *National Gallery Technical Bulletin*, 18, 1997, p. 100.

16 We are grateful to Professor Franz Mairinger for showing us the X-radiographs of the panels made at the Akademie der bildenden Künste, Vienna. The panel of the very damaged fragment of *Joseph thrown in the Fountain* from the Salzburg Altar, now in the Österreichische Galerie, Vienna, seems to have been scored all over with a tool, perhaps a claw chisel, to roughen the surface and to improve the adhesion of the ground.

17 This was incorrectly reported as gesso in Campbell, Foister and Roy, cited in note 15, p. 22. The sample (taken from the edge) must have comprised later filling material.

18 F. Mairinger, G. Kerber and W. Hübner, 'Analytische Untersuchungen der Gemälde' in Koller and Wibiral, cited in note 13, pp. 146–9.

19 For diagrams of the frame mouldings and construction see Koller and Wibiral, cited in note 13, p. 121.

20 Examples in the National Gallery of fifteenth-century small devotional panels from Italy with decorated backs that seem never to have been part of an ensemble include *Saint Dorothy and the Infant Christ* (NG 1682), attributed to an associate of Francesco di Giorgio (the reverse is reproduced in L. Bellosi, ed., *Francesco di Giorgio e il Rinascimento a Siena 1450–1500*, exh. cat., Sant' Agostino and Pinacoteca Nazionale, Siena 1993, p. 120) and *The Dead Christ supported by Saints* (NG 590) by Marco Zoppo (illustrated in J. Dunkerton, S. Foister, D. Gordon and N. Penny, *Giotto to Dürer. Early Renaissance Painting in the National Gallery*, New Haven and London 1991, p. 85). They seem to have been less common among South German and Austrian works, although the reverse of Dürer's small panel of *Saint Jerome* (NG 6563) in the National Gallery, with its decorative starburst of a heavenly body, complete with spattering, might almost qualify.

21 See M. Koller, *Der Flügelaltar von Michael Pacher in St. Wolfgang*, Vienna, Cologne and Weimar 1998, pp. 71–5, and also M. Koller, 'Über die Entstehung der Flügelaltäre in der Pacher-Werkstätte' in *Michael Pacher und sein Kreis*, cited in note 4, p. 78.

22 No drawing could be detected by infra-red photography or by infra-red reflectography. It has sometimes been possible to show that underdrawings that are visible with the naked eye but are transparent to infra-red have been executed with an iron-gall ink but the good condition of the painting meant that no sample of the drawing material could be taken. On the little panels in Graz underdrawing can be seen in infra-red photographs and with the naked eye in areas painted with red lake, but none can be detected under the other colours. The character of this underdrawing, with more widely spaced hatched strokes than in the National Gallery picture, is a small-scale version of that to be seen on some of the Saint Lawrence panels.

23 See Koller in *Michael Pacher und sein Kreis*, cited in note 4, p. 79, fig. 10, and Koller, cited in note 22, pp. 89–96, including infra-red images of *The Martyrdom of Saint Cosmas* by Friedrich Pacher and a *Saint Sebastian*, sometimes given to the putative Hans Pacher (both in Innsbruck, Ferdinandeum). These reveal less carefully shaded and, in the case of the *Saint Sebastian*, almost scribbled, hatching. An underdrawing by Marx Reichlich, on the other hand, is precisely modelled but in a rather rigid and mechanical way.

24 Mairinger, Kerber and Hübner in Koller and Wibiral, cited in note 13, p. 149.

25 The gilding has not been sampled but the colour of the bole can be observed in areas of damage.

26 So-called black boles seem first to occur on paintings and sculpture of the late fourteenth and early fifteenth century that appear to originate from Bohemia. They then sometimes, but by no means often, feature on works of the first half of the fifteenth century from Austria and South Germany (including a sculpted *Virgin and Child* now in the Bayerisches National-museum, Munich, by Hans Multscher who was later to make an altarpiece for Sterzing/Vipiteno, near Pacher's hometown of Brauneck/Brunico). Manfred Koller has indicated (in discussion with the authors) that black boles seem to have gone out of use in the second half of the century. The black bole on the panels associated with Pacher would therefore appear to be relatively late occurrences.

27 The major peak in an EDX spectrum of this layer was Ca, with smaller amounts of Fe, Si, Al and trace amounts of S and Ti. The very small amount of Ti seen in the EDX spectrum was located in a few small yellow particles, commonly found in natural earth pigments. FTIR suggests that the 'bole' layer has a proteinaceous medium, probably animal-skin glue.

28 K. Groen and J.A. Mosk, 'Farbenanalytische Unter-suchungen der Polychromie' in Koller and Wibiral, cited in note 13, p. 138.

29 For the applied relief brocades on the Gries altar see Koller in *Michael Pacher und sein Kreis*, cited in note 4, p. 76–7.

30 It contains a barely perceptible amount of silver, found in varying quantities in all natural deposits of gold.

31 Mairinger, Kerber and Hübner in Koller and Wibiral, cited in note 13, pp. 150–3. GC–MS analysis was car-ried out by Raymond White on two samples from the National Gallery panel. A white highlight from the mouldings of the canopy was found to contain part-ially heat-bodied linseed oil, and a sample of green paint from one of the floor tiles contained linseed oil (not heat-bodied) with a small amount of pine resin.

32 Relatively thick paints, rich in medium but retaining the mark of the brush, can be observed on many of the works assigned to Pacher. Highlights on areas of flesh painting, in particular, have a distinctive almost stringy texture.

33 The Virgin's mantle was not sampled, but the use of azurite could be deduced by its appearance under high magnification and by its characteristic darkness in infra-red photographs.

34 Again this area was too well preserved for the taking of a sample, but the pigment mixture could be distin-guished by examination of the paint surface with a stereomicroscope.

35 A few samples have been taken by the Doerner Institute from the Saint Lawrence panels but not from areas of purple.

36 The relatively finely ground malachite appears as round-ed agglomerates, but around the green pigment are some colourless minerals (quartz and other silicates). These indicate that the malachite is most likely to be of natural origin despite the rounded shape of some of the particles.

37 A scraping taken for FTIR analysis seemed to contain mainly oil and verdigris, even in more browned areas. A trace of resin was also detected, and there was some evidence for copper-resin interaction.

38 XRD analysis showed it to be lead-tin yellow 'type I'. Lead-tin yellow 'type II' has been found on the Saint Wolfgang altar (see Mairinger, Kerber and Hübner in Koller and Wibiral, cited in note 13, p. 151.

39 As well as the diversity of opinion in the attribution of the National Gallery painting, there has been a range of speculative suggestions for its dating, from the earlier years of Pacher's career, to the last decade of his activity, the 1490s: see, for example, G. Bonsanti, cited in note 3, pp. 20–2. He argues that the pose of the Child in the National Gallery panel, and also that in an altarpiece by Friedrich Herlin of 1488, both derive from Foppa's *Pala Bottigella* (Pavia, Museo Malaspina), usually dated to the early 1480s. However, the resemblances are no more than general and it seem just as likely that the pose of the Pacher Child has its origins in sculpted figures.

Occurrences of the Purple Pigment Fluorite on Paintings in the National Gallery

MARIKA SPRING

THE MINERAL FLUORITE (calcium fluoride) occurs in nature in a variety of colours, including purple, pink, blue, green and yellow. Its use as a flux for smelting metals, and in the glass-making industry, was described already in the sixteenth century by the German metallurgist Georgius Agricola. He goes on to say 'moreover, from Fluores they can make colours which artists use'.[1] Purple fluorite has been found used as a pigment but, so far, relatively rarely and on works from a limited geographical area and period of time. Virtually all the occurrences that have been published are on panel paintings, polychrome sculpture and wall paintings from the Tyrol and Southern Germany, where there are particularly good deposits of purple fluorite. They date from the period 1470–1520, coinciding with the golden age of silver and copper mining in these areas – fluorite is found as a gangue mineral with the ores of these metals.[2] Several of the paintings in the National Gallery on which fluorite has been found fit in with this pattern of occurrences but, significantly, a number are on paintings which are not from Alpine areas of Europe (see Table 1).

Michael Pacher, who worked mainly in Bolzano in the Tyrol, used fluorite on his small painting of *The Virgin and Child Enthroned* (NG 5786) for the greyish-purple colour of the architecture.[3] In a cross-section of paint from the architecture (Plate 1) both colourless and purple particles of fluorite are visible, many with a characteristic rectangular shape due to the cubic crystal structure of the mineral. The sample also contains other colourless material such as calcite, quartz, and various silicaceous minerals which occur in deposits with fluorite.[4] Calcium fluoride is inherently colourless; the colour in mineral deposits is believed to result from defects in the crystal lattice generated by impurities such as rare earth elements or radioactive minerals close to the deposit.[5] Bulk samples of the mineral often have a veined appearance, with colourless and coloured fluorite interspersed. The deep purple variety, with a colour strong enough to produce a pigment of acceptable tinting strength when ground to a powder, is generally found in conjunction with radioactive minerals such as uranium ores.[6]

The painting by Pacher is rather unusual in that fluorite was mixed only with lead white, and used in the uppermost paint layer, apparently specifically for its distinctive cold greyish-purple colour. More

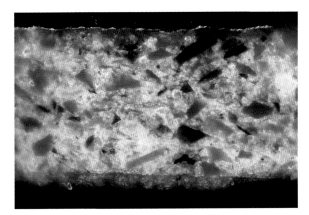

Plate 1 Michael Pacher, *The Virgin and Child Enthroned with Angels and Saints* (NG 5786). Cross-section of a sample from the mordant-gilded crozier of the bishop saint, showing the fluorite-containing greyish-purple paint of the architecture below the gilding. Original magnification 600×; actual magnification 525×.

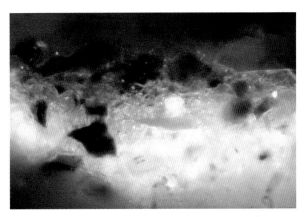

Plate 2 Albrecht Altdorfer, *Christ taking Leave of his Mother* (NG 6463). Cross-section of a sample from Christ's purple-red drapery. Veined purple particles of fluorite are visible, mixed with red lake and lead white. Original magnification 940×; actual magnification 825×.

Table 1 Occurrences of fluorite on paintings in the National Gallery

Artist	Title	Place of origin	Date	Location of fluorite on the painting
Michael Pacher	*The Virgin and Child Enthroned with Angels and Saints* (NG 5786)	Tyrol	Probably 1475?	Architecture and canopies; purple fluorite mixed with lead white.[1]
Wolf Huber	*Christ taking Leave of his Mother* (NG 6550)	Feldkirch?	c.1519	Purple-grey drapery of the Holy Woman second from the left figure group; purple fluorite mixed with lead white, azurite and red lake.[2]
Albrecht Altdorfer	*Christ taking Leave of his Mother* (NG 6463)	Regensburg?	c.1520	Christ's purple-red drapery; purple fluorite mixed with red lake and lead white in underpaint, glazed with red lake prepared with dyestuff from the kermes insect.[3]
Master of Cappenberg (Jan Bagaert)	*Christ before Pilate* (NG 2154)	Wesel	c.1520	Christ's purple-grey drapery; purple fluorite mixed with lead white.[1]
Jan Gossaert	*A Man holding a Glove* (NG 946)	Breda or Veere?	1530–2	Pink area of sleeve; purple fluorite,[4] lead white and a little red lake.
Netherlandish School	*A Man with a Pansy and a Skull* (NG 1036)	?	c.1535	Man's purple-grey sleeve; purple fluorite mixed with lead white, smalt and azurite.[4]
'Ysenbrandt'	*The Magdalen in a Landscape* (NG 2585)	Bruges	1520s[5]	Pink robe of the angel holding a crucifix; purple fluorite[4] mixed with red lake and lead white.
Style of 'Ysenbrandt'	*The Entombment* (NG 1151)	Bruges?	c.1550	Sky paint; small amount of purple fluorite[4] mixed with lead white, smalt and azurite.
After Quinten Massys	*The Virgin* (NG 295.2)	Antwerp	After 1503[6]	Virgin's blue drapery; fluorite[4] and lead white underpaint beneath ultramarine.

1 Fluorite identified by X-ray diffraction, in agreement with JCPDS file 4-864.

2 I am grateful to Mark Richter for identification of fluorite in this sample by EDX analysis in the scanning electron microscope. The sample is illustrated in 'Wolf Huber's *Christ taking leave of his Mother*', *National Gallery Technical Bulletin, Early Northern European Painting*, 18, 1997, ed. L. Campbell, S. Foister and A. Roy, p. 105, Plate 83.

3 Kermes identified by TLC, published in A. Smith and M. Wyld, 'Altdorfer's "Christ taking leave of his Mother"', *National Gallery Technical Bulletin*, 7, 1983, p. 62. The result was confirmed recently by HPLC, carried out by Jo Kirby.

4 Identified by EDX analysis in the scanning electron microscope. I am grateful to Aviva Burnstock for the use of the EDX equipment at Kings College, University of London, and for her assistance.

5 Dendrochronology was carried out by Peter Klein on the panel of NG 2585. The last ring present was from 1491, giving a plausible creation date of after 1508.

6 Dendrochronology was carried out by Peter Klein on NG 295.2. The last ring present was from 1478, giving a plausible creation date of after 1503.

often, it has been found mixed with red lake and used in underpaint, as it is on Albrecht Altdorfer's *Christ taking Leave of his Mother* (NG 6463; Plate 2) and on Wolf Huber's version of the same subject (NG 6550).[7] It was perhaps used as an extender for the relatively expensive red lake, or to give a purple-red colour without using blue pigments, which were also expensive.

Plate 3 Jan Gossaert, *A Man holding a Glove* (NG 946). Cross-section of a sample from the pink sleeve; purple fluorite mixed with lead white over a lead white priming layer. Original magnification 800×; actual magnification 700×.

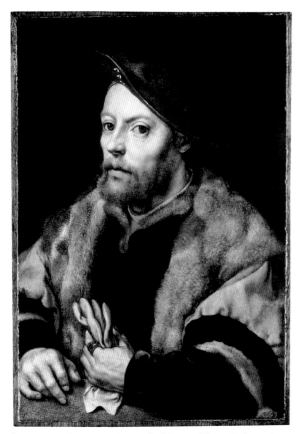

Plate 4 Jan Gossaert, *A Man holding a Glove* (NG 946), *c.*1530–2. Panel, 24.4 × 16.8 cm.

These three works were all painted in Alpine regions, close to well-known European sources of purple fluorite. The other six paintings in the National Gallery on which it has been found, however, are not by painters from the Tyrol or Southern Germany (Plates 3–8). Five of the paintings are from the Netherlands. Jan Gossaert's *Portrait of a Man holding a Glove* (NG 946) was painted around 1530 when Gossaert was working mainly in the northern part of the Netherlands, perhaps in Breda.[8] The *Magdalen in a Landscape* (NG 2585) attributed to 'Ysenbrandt' was almost certainly painted in Bruges,[9] as was *The Entombment* (NG 1151), which has been classified as style of 'Ysenbrandt'.[10] *The Virgin* (NG 295), probably after Quinten Massys, is likely to have been painted in Antwerp. The *Portrait of a Man with a Pansy and a Skull* (NG 1036) has been dated around 1535 on the basis of the costume, but it is not known where it was painted.[11] It is close in style to portraits by Jan van Scorel, who was based in Utrecht.[12] It is worth noting, also, that the purple fluorite on these paintings is weaker in colour and of smaller particle size than on the paintings from Alpine regions.

There is no obvious link between these paintings, making it difficult to draw any conclusions about the pattern of use of fluorite in the Netherlands. In the occurrences on paintings from Alpine areas it appears to have been used because it was a local material. It is, in fact, a common mineral – the most abundant fluorine mineral in the earth's crust – and although the deep purple variety is less common, good deposits are also found elsewhere in Europe, notably in the Massif Central in France (Puy-de-Dôme), Asturias in Spain (La Collada) and the Pyrenees.[13] A detailed search of the mineralogy literature shows that there are deposits in several places in the Ardennes in the southern part of the Low Countries.[14] The same region was the source of a zinc ore which was being mined in this period for the brass industry, so it is feasible that the veins of fluorite were also being exploited.[15] These paintings all date from the first part of the sixteenth century, a time when many artists – including, it is thought, Jan Gossaert – made the journey across the Alps on their way to Italy.[16] They may have come across the use of fluorite as a pigment during their travels. Jan van Scorel was in Austria long enough to paint an altarpiece for the parish church of Obervellach, and while he was there he is known to have used local painting materials.[17] It is also possible that fluorite was traded across Europe – there were well-established trading links with the copper and silver mines in Alpine areas, the same mines which are thought

Plate 5 'Ysenbrandt', *Magdalen in a Landscape* (NG 2585). Cross-section of a sample from the pink drapery of the angel holding a crucifix. Small purple particles of fluorite are visible, with red lake and lead white, in the uppermost layer. The paint of the angel lies over the green foliage, which contains some green copper sulphate pigment. Original magnification 750×; actual magnification 660×.

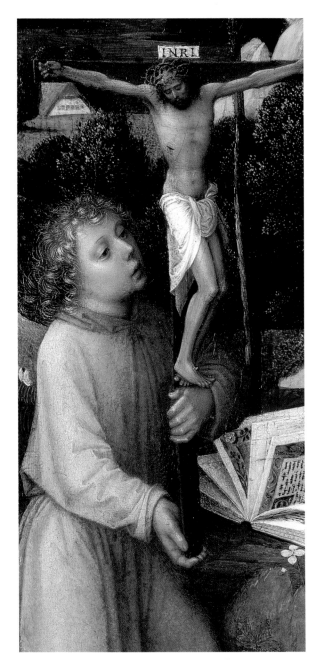

Plate 6 'Ysenbrandt', *Magdalen in a Landscape* (NG 2585). Detail of the angel holding a crucifix.

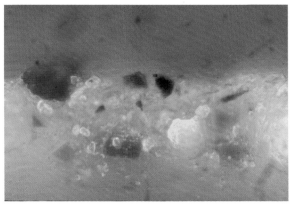

Plate 7 Style of 'Ysenbrandt', *The Entombment* (NG 1151). Cross-section of a sample from the greyish-blue sky, containing fluorite, azurite, smalt and lead white. Original magnification 940×; actual magnification 660×.

Plate 8 After Quinten Massys, *The Virgin* (NG 295.2). Cross-section of a sample from the Virgin's blue robe; a layer containing lead white and a small amount of purple fluorite lies beneath ultramarine. Original magnification 750×; actual magnification 660×.

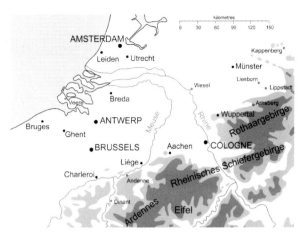

Fig. 1 Map of the Netherlands and Westphalia (modern coastline).

Plate 9 Master of Cappenberg, *Christ before Pilate* (NG 2154). Cross-section of a sample from Christ's brownish-purple drapery. The uppermost layer contains lead white and a small amount of purple fluorite. Original magnification 600×; actual magnification 525×.

to be the source of the fluorite used by artists working in the Tyrol.[18]

The other painting on which fluorite was found is attributed to the Master of Cappenberg, now generally identified as Jan Bagaert. *Christ before Pilate* (NG 2154) was almost certainly originally part of one of the wings of the high altar at the abbey church in Liesborn, Westphalia, in which case it would have been painted in Wesel in the western part of Westphalia, where Jan Bagaert's studio was located, as documents exist concerning the transport of the panels.[19] Again, it is rather surprising to find fluorite on a Westphalian panel – here in Christ's brownish-purple drapery (Plates 9 and 10) – as it is far from the Alpine areas of Germany. Wesel is close to the modern Dutch border, as near to the deposits of fluorite in the Ardennes as Antwerp or Bruges. There are also small deposits of deep violet fluorite in

Westphalia, for example in the Casparizeche mine near Arnsberg and in the Schiefergebirge mountains, east of Wesel but close to the towns of Cappenberg and Liesborn (Fig. 1).[20]

Fluorite was not the only local material to have been used on the painting by Pacher. Dolomite (calcium magnesium carbonate) was used for the ground layer on the back of the panel, and has also been found in the ground layers of many of the other works from Alpine areas on which fluorite has been found.[21] The use of fluorite was reported on a sculpture by the Augsburg master Sebastian Loscher (1513), polychromed by Hans Burgkmair, together with natural mineral posnjakite (green copper sulphate) in areas of green paint, yet another natural material which has been found relatively rarely as a pigment.[22] Interestingly, green copper sulphate was used for the background of the *Portrait of a Man with a Pansy and a Skull*, for the foliage on Ysenbrandt's *Magdalen in a Landscape*, and for the background of Gossaert's *Portrait of a Man holding a Glove*.[23] It has also been reported on other Netherlandish paintings of the early sixteenth century, including works by Jan Massys, Lucas van Leyden and Jan van Scorel, with much discussion about whether it is natural or artificial in origin.[24] In Ysenbrandt's *Magdalen in a Landscape* the green copper sulphate is almost certainly a natural mineral, as the paint also contains colourless material such as quartz and other silicates which occur with the natural mineral. As with fluorite, the pigment could have been imported to the Netherlands from elsewhere, or could have come from a more local source such as the small deposit of posnjakite that exists in the Ardennes, in the north of the Meuse valley.[25] Another material which is not usually used on paintings was found on the Master of Cappenberg's *Christ before Pilate* (Plate 10). The red-brown layer on which the gold leaf of Christ's halo is laid contains a black pigment that proved to be a bismuth compound, probably bismuth sulphide, mixed with red earth.[26] The use of bismuth sulphide, or bismuthinite as the mineral is called, as a pigment is extremely rare – it has been found only on a few sixteenth-century paintings from Italy.[27]

The use of fluorite as a pigment was clearly more widespread than has so far been thought. The group of paintings examined here are not particularly well documented, making it difficult to draw definite conclusions about when, where and why fluorite was used. There are, however, some intriguing connections between them, such as the use of other rarely encountered pigments which are found as natural minerals, particularly green copper sulphate, in other

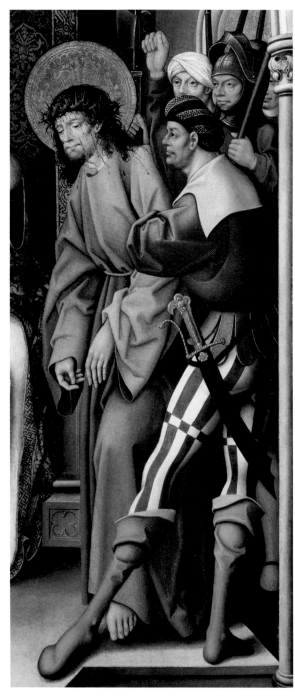

Plate 10 Master of Cappenberg, *Christ before Pilate* (NG 2154). Detail showing the figure of Christ.

areas of the paintings. All the Netherlandish paintings on which fluorite has been found date from the first part of the sixteenth century, a period at which there does seem to have been a change in the taste of colour on paintings, evolving towards less saturated, more subtle hues. The journey to Italy via Alpine regions that many artists made at this time may also have had an important effect on their choice of materials: some aspects of Jan van Scorel's technique, for example, are thought to have been influenced by his travels.[28] Fluorite may also have been used on paintings from some of the other localities where there were notable deposits of the purple variety and it seems certain that further examples will come to light.

Acknowledgements

Lorne Campbell and Susan Foister provided much help with the art-historical aspects of this paper, particularly the references. I would also like to thank Michele Marincola, Andreas Burmester, Hubert Paschinger and Helmut Richard for useful discussion on the subject of fluorite on Tyrolean and South German works. I am also grateful to Mark Richter for analysis of the sample from the painting by Huber, and to Aviva Burnstock for assistance with the analysis of the National Gallery samples.

Notes and References

1 G. Agricola, *De Re Metallica*, trans. by H.C. Hoover and L.H. Hoover, New York 1950. Agricola's discussion of 'stones which melt easily in the fire' in *Bermannus* and *De Natura Fossilium* is reproduced in note 15, p. 380. The properties described point to some of these stones being fluorite.

2 M. Richter and R. Fuchs, 'Violetter Flußspat', *Restauro*, 5, 1997, pp. 316–23. Richter and Fuchs gathered together all the published occurrences and reported some more examples of the use of fluorite. Richter has also, more recently, identified fluorite on a painting by Cranach, see G. Heydenreich, 'Artistic Exchange and Experimental Variation: Studies in the Workshop Practice of Lucas Cranach the Elder', *Painting Techniques: History, Materials and Studio Practice*, Preprints of the IIC Dublin Congress, 7–11 September 1998, ed. A. Roy and P. Smith, London 1998, pp. 112–14. It seems to have been used by Cranach only when he was working in Vienna. It has also been reported on a gothic sculpture from Hungary, see Aktuell, *Restauro*, 5, 1998, p. 297. A few more examples on paintings from the Tyrol were published in M. Koller and M. Vigl, 'Großgmainer Altar', *500 Jahre Meister von Großgmain*, exh. cat., Großgmain bei Salzburg, 1–22 August 1999, pp. 93–4.

3 See also the article on Pacher in this issue of the *Technical Bulletin*.

4 C.S. Hurlbut, *Dana's Manual of Mineralogy*, 18th edn.,

reprinted 1971, New York and London, p. 312. Fluorite is usually found in hydrothermal veins, where it can be the chief mineral or a gangue mineral with metal ores, especially lead, silver and zinc. Other minerals that have been found associated with it include calcite, dolomite, gypsum, celestite, barite, quartz, galena, sphalerite, cassiterite, topaz, tourmaline and apatite. EDX analysis on the sample from the painting by Pacher revealed that many of the colourless impurities were quartz and calcite. Some silicaceous material was also present (Si, Al, K detected, together with a small amount of Ti, Fe and Ca).

5 The cause of the colour is discussed in Richter and Fuchs, cited in note 2.

6 A. Chermette, *La Fluorite*, Paris 1986, p. 24.

7 Fuchs and Richter, cited in note 2.

8 H. Pauwels, H.R. Hoetink and S. Herzog, *Jean Gossaert dit Mabuse*, exh. cat. Museum Boymans van Beuningen, Rotterdam, and Groeningemuseum, Bruges 1965, p. 379. Quittances were signed by Gossaert in Breda, 27 March 1532, and Turnhout, 19 May 1532. His wife and family probably resided at Veere, however.

9 T.-H. Borchert, 'Adrian Isenbrandt', *Bruges et la Renaissance, De Memling à Pourbus, Notices*, exh. cat., Memling-museum, Bruges 1998, pp. 65–7, No. 39.

10 R. Billinge, 'Links with Schongauer in Three Early Netherlandish Paintings in the National Gallery', *Looking Through Paintings, Leids Kunsthistorisch Jaarboek XI*, ed. E. Hermens, 1998, pp. 88–9.

11 M. Davies, *National Gallery Catalogues, The Early Netherlandish School*, 3rd edn., London 1968. For Gossaert see p. 61, for Massys p. 92, for Netherlandish School (NG 1036) p. 137 and for Ysenbrandt pp. 177–9.

12 Personal communication with Lorne Campbell.

13 Chermette, cited in note 6, pp. 42, 92, 96.

14 J. Mélon, P. Bourguignon and A.-M. Fransolet, *Les Minéraux de Belgique*, Belgium 1976, pp. 102–4. There are many deposits of fluorite in the Ardennes massif, between Liège and Charleroi. A detailed list of the locations, and the colours of the fluorite found there, are given in this publication. See also R.F. Vochten, M.K. Van Doorselaer and H. Dillen, 'Fluorite from Seilles, Andenne, Belgium: Colouration, fluorescence and a remarkable crystal geometric discolouration phenomenon', *Zeitschrift-Deutsche Gemmologische Gesellschaft*, 43, June 1994, pp. 73–84. The Seilles deposit is in the north of the Meuse Valley, where it occurs with limestone and dolomite.

15 J. Day, 'Brass and Zinc in Europe from the middle ages until the mid-nineteenth century', *2000 Years of Zinc and Brass*, British Museum Occasional Paper no. 50, ed. P.T. Craddock, London 1990, rev. edn. 1998, pp. 133–56. The production of brass goods in the fifteenth and sixteenth centuries was concentrated in Dinant, Bouvignes and other smaller communities along the Meuse because deposits of calamine (zinc carbonate), a necessary raw material, were found there. Zinc ore of particularly high quality was found in the Eifel near Aachen. The importance of Aachen as a centre for

brass production increased after the sack of Dinant by the Duke of Burgundy in 1466.

16 Pauwels, Hoetink and Herzog, cited in note 8, p. 374. Embassy of Philip of Burgundy to Rome via Trent and Verona, over the Brenner pass, recorded in December 1508, when Jan Gossaert was in his service.

17 M. Faries and M. Wolff, 'Landscape in the early paintings of Jan van Scorel', *Burlington Magazine*, November 1996, pp. 724–33. Dolomite (calcium magnesium carbonate) was found as a ground layer on Jan van Scorel's *Adoration of the Magi*, Art Institute of Chicago. It is painted on a fir panel, which was used as a support mainly in Alpine regions.

18 E. Westermann, 'Copper production, trade and use in Europe from the end of the fifteenth century to the end of the eighteenth century', *Copper as Canvas, two centuries of masterpiece paintings on copper 1575–1775*, exh. cat. published by Phoenix Art Museum and Oxford University Press, New York and Oxford 1999, pp. 117–23.

19 M. Levey, *National Gallery Catalogues. The German School*, London 1959, pp. 65–70. R. Brandl, 'The Liesborn altar-piece, a new reconstruction', *Burlington Magazine*, cxxxv, 1993, pp. 180–90. Brandl proposes that NG 2154 and NG 263 were part of the wings of the Liesborn Altarpiece, and are therefore the panels documented as having been sent to Jan Bagaert in Wesel for painting. The forthcoming National Gallery Catalogue of German paintings before 1800 will provide more concrete technical evidence in support of this proposal.

20 H. Hatton, 'Flußspatvorkommen auf der Casparizeche bei Arnsberg/Westfalen', *Der Aufschluss*, Vol. 30, 6, June 1979, p. 210. Violet as well as light yellow fluorite is found near Valentinite (Sb_2O_3) and Berthierite ($FeSb_2S_4$) in the antimony deposits of Arnsberg, Westphalia.

21 Richter and Fuchs, cited in note 2, mention several paintings on which fluorite has been found which have a ground layer containing dolomite.

22 A. Burmester and J. Koller, 'Der heilige Alexius: naturwissenschaftliche Untersuchung der Farbfassung Hans Burgkmairs' *Der heilige Alexius im Augsburger Maximilianmuseum'*, *Arbeitsheft 67, Bayerisches Landesamt Für Denkmalpflege*, Munich 1994, pp. 38–47. The sculpture by Sebastian Loscher of 1513 was polychromed at a later date by Hans Burgkmair. Fluorite was used in purple areas and a mixture of green copper salts in green areas of paint, including copper sulphate of the posnjakite and langite form, which can occur together in natural deposits. The presence of quartz led to the conclusion that a natural mineral had been used.

23 Identified by EDX analysis on a cross-section. The foliage paint on *The Magdalen in a Landscape* attributed to 'Ysenbrandt' (NG 2585) contains some quartz (only Si detected in some particles by EDX) and other silicaceous minerals in addition to copper sulphate, therefore the pigment is almost certainly natural in origin.

24 P.F.J.M. Hermesdorf et al., 'The Examination and restoration of the Last Judgement by Lucas van Leyden',

Lucas van Leyden – studies, Nederlands Kunsthistorisch Jaarboek, 29, 1978, Haarlem 1979, p. 407, note 144. Posnjakite was identified on a sample from the *Last Judgement* by X-ray diffraction. Posnjakite was also reported on a painting by Jan van Scorel (identified by X-ray diffraction), see J.R.J. van Asperen de Boer, 'Examen scientifique des peintures du groupe Jan van Scorel', *Jan van Scorel d'Utrecht*, exh. cat. Musée Central Utrecht and Musée de la Chartreuse, Douai 1977, pp. 54–5. Long blue-green crystals of posnjakite, $Cu_4(SO_4)(OH)_6.H_2O$, were also identified by X-ray diffraction on two paintings by Jan Massys (*Saint Jerome*, Rouen, Musée des Beaux-Arts, *David and Bathsheba*, Paris, Louvre) and a copper sulphate pigment was found on *Judith and the Head of Holofernes* (Paris, Louvre), although the particular form of copper sulphate could not be confirmed, see E. Martin and M. Eveno, 'Contribution to the study of old green copper pigments in easel paintings', *3rd International Conference on non-destructive testing, microanalytical methods and environment evaluation for study and conservation of works of Art*, October 1992, Viterbo, pp. 781–91. At the end of this paper the possibility that it may be artificial is suggested. This is discussed in more detail in E. Martin, A. Duval and M. Eveno, 'Une famille de pigments verts mal connue', *Techne*, 2, 1995, pp. 76–9.

25 R. Van Tassel, 'Occurrence de Posnjakite en Belgique', *Annales de la Société Géologique de Belgique*, 100, 1977, pp. 203–4.

26 Bismuth was detected in the black pigment by EDX analysis. One of the major Bi peaks overlaps with the S peak in the EDX spectrum therefore it was not possible to confirm that it was bismuth sulphide, which occurs naturally as the mineral bismuthinite.

27 C. Seccaroni, 'Some Rarely Documented Pigments. Hypothesis and Working Observations on Analyses Made on Three Temperas by Correggio', *Kermes*, Year XII, No. 34, January–April 1999, pp. 41–4. Bismuth metal was used for bismuth painting, a technique used mostly for decorating caskets and boxes which developed in Switzerland and Southern Germany in the sixteenth century. See R. Gold, 'Reconstruction and Analysis of Bismuth Painting', *Painted Wood: History and Conservation*, Proceedings of a Symposium at Williamsburg, Virginia, 11–14 November 1994, ed. V. Dorge and F. Carey Howlett, 1998, pp. 166–78.

28 M. Faries, 'Some results of the recent Scorel research: Jan van Scorel's definition of landscape in design and color', in *Color and Technique in Renaissance Painting, Italy and the North*, ed. M.B. Hall, New York 1987, p. 92.

A Virgin and Child from the Workshop of Albrecht Dürer?

PAUL ACKROYD, SUSAN FOISTER, MARIKA SPRING
RAYMOND WHITE AND RACHEL BILLINGE

THE PAINTING OF the Virgin and Child currently catalogued as 'Style of Dürer' poses one of the most intriguing art-historical puzzles in the National Gallery Collection (Plate 1). Long regarded by many scholars as the work of Dürer himself, it was purchased as such by the Gallery in 1945.[1] Yet its attribution was the subject of debate even at the time of its acquisition, and only three years later the Gallery changed the painting's label to 'attributed to Dürer'.[2] Barely more than a decade later, in a long and carefully argued entry in his German School catalogue of 1959, Michael Levey relegated the painting further, to the status of the work of an imitator of uncertain date, 'arguably near to Dürer's lifetime or a little later', and hence to the 'Style of Dürer'.[3] His reasons for doing so are outlined below. More recently, the painting has come under renewed scrutiny, and its critical fortunes have revived: it has again been suggested that it might be the product of Dürer's workshop, perhaps even a work begun by Dürer and completed by his workshop while he was in Venice in 1505–7.[4]

The National Gallery painting depicts the Virgin seated on a grassy bench, holding the infant Christ. She is placed within a vine-hung bower and surrounded by flowers and plants of various kinds, including a peony and a prominent iris, hence the title *Madonna with the Iris* by which the painting is often known. In the background to the left is a ruined arch with the sea beyond, and above in the sky is a very small representation of God the Father, his hand raised in blessing. On the wall to the left of the Virgin is a monogram AD and the date 1508, giving rise to the view that the painting was a signed and dated work by Albrecht Dürer.

The National Gallery painting is one of three known versions of the same composition (see Plates 6 and 7), and the only one to bear a date and monogram.[5] Nothing is known of its history before the early nineteenth century.[6] According to the catalogue of Dürer's paintings published by Heller in 1827 it was in the Felsenberg collection in Vienna by 1821; its date of 1508 is mentioned but the monogram is not.[7] It was brought to England and offered to the National Gallery as early as 1872 but evidently refused.[8] It was acquired in 1892 by Sir Francis Cook and was regarded as one of the prime pictures in his notable collection.[9] In 1945 it was offered to the Gallery by his trustees and this time it was purchased.

One of the most intriguing features of the National Gallery painting lies in its numerous points of reference to paintings, drawings and prints by Dürer, including famous studies such as the 'Great Piece of Turf' in Vienna and the 'Irises' in Bremen. For many of the scholars who studied the picture these connections suggested an overwhelming case for Dürer's authorship. However, Levey in his 1959 catalogue entry found deeply unconvincing the combining of the various elements in the composition that have a close relation to actual works by Dürer of different dates, such as the stone architecture and the plants, including the iris: 'the picture is almost suspiciously full of Dürer motifs and these do not seem to have been very intelligently treated.' For instance, God the Father appears from on high in an engraving by Dürer of the Virgin and Child,[10] but as Levey points out in this and other works 'he is never shown there on such a minute scale'.[11] He argued that the combining of such motifs suggested that the painting was carried out by a follower of Dürer, and not by Dürer himself. Levey regarded the painting as a sixteenth-century work, and rejected the view of some scholars that the painting was produced as a forgery at a slightly later period,[12] citing the discovery of a pentimento to the right of the Virgin's head where a reserve had been left for a rose which was never painted.[13] However, much remained to be clarified concerning the condition of the painting. Levey quoted the view of the Dürer scholar Winkler that parts of the picture appeared to be of differing styles and periods: in particular the vine and the peony were 'unlike Dürer and seemingly of later date'.[14]

The 1959 National Gallery catalogue described the painting, which had been cleaned and restored shortly before its acquisition, as 'in general in fair but uneven condition, being rather worn and in

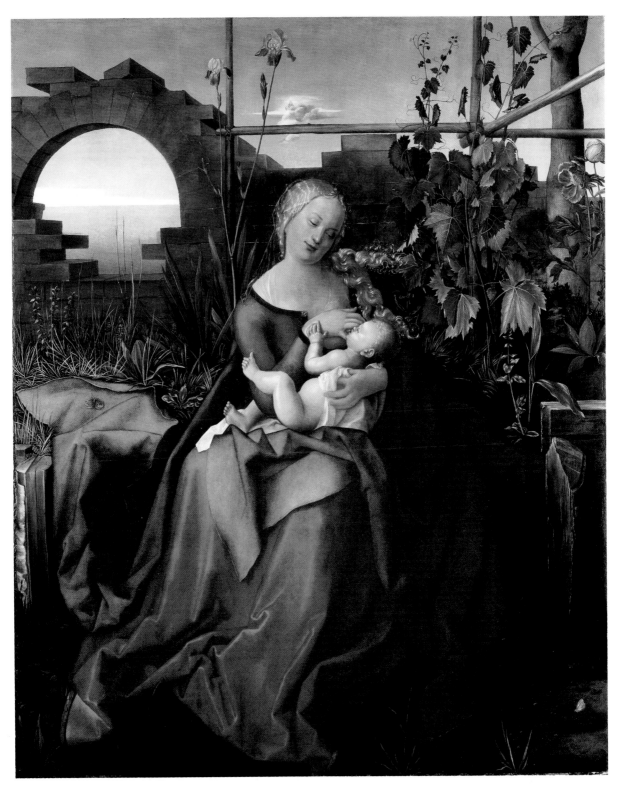

Plate 1 Workshop of Dürer?, *Virgin and Child* (NG 5592), early 16th century. Panel, 149.2 × 117.2 cm.

Fig. 1 Detail of the foliage showing a rectangle of old varnish during the 1945 cleaning.

Fig. 2 X-radiograph detail showing wood inserts in the panel covered with hairs or fibres.

parts repainted'. It went on to raise many questions concerning the originality or otherwise of parts of the picture. The monogram AD it declared to be false, the date 1508 dubious, the Virgin's veil 'likely to be a later addition'.[15] However, these problems, as well as views such as those of Winkler concerning disparities in other areas of the picture, were difficult to resolve conclusively at a period when technical examination was still in its infancy. In 1996 the Gallery's Trustees agreed that the painting should be cleaned, as the varnish had noticeably discoloured and many of the retouchings made in 1945 had blanched.[16] The 1945 cleaning of the picture had removed an unusually thick and heavily discoloured varnish layer that must have hampered a proper assessment of the painting's status prior to this date (Fig. 1). It also became evident during this last restoration that the painting had been severely abraded in parts by a much earlier restoration. The present cleaning has provided the opportunity for a detailed examination of the picture using modern techniques of analysis, as well as an examination using infra-red reflectography, which allowed underdrawing beneath areas

of green and blue paint, not made visible by infra-red photography, to be revealed.[17] Also, a new X-ray photograph was made after the cradle, which obscured the image in the previous X-ray photograph, was removed during the recent panel treatment.[18] The results reported here should help to clarify the problematic status of this picture, and will enable new arguments to be put forward with more confidence than was possible before.[19]

Materials and Technique
Support and preparation

The painting is on a limewood panel composed of eight vertical planks, and would have been assembled and prepared by independent craftsmen separate from the artist's workshop.[20] Limewood is a material commonly associated with South German panel painting construction until the seventeenth century,[21] when canvas became more widely adopted as a painting support. The wood planks were simply butt joined and reinforced by two inset battens, positioned horizontally at the reverse across

Table 1 **Summary of Analysis of Pigments**

Green foliage		Underpaint: verdigris, lead-tin yellow 'type I', lead white, dark brown.[1] Light and dark green paint of leaves: verdigris, lead-tin yellow 'type I', lead white and brown pigment in varying proportions.
Red drapery	**Scarlet dress**	Underpaint: vermilion, red lead, lead white, in varying proportions according to the modelling. First layer of red lake: large red lake particles in a matrix of finely ground colourless material consisting of calcium salts and some silaceous material.[2] Second red lake glaze; red lake on an Al-containing substrate.[3]
	Crimson cloak	Underpaint: red lake and lead white. Red lake glazes in shadows only.
Brown paint of wall		First layer: vermilion, black, a little lead white. Second layer; lead white, black, vermilion, azurite, red iron oxide, brown earth, Si-containing particles (probably quartz).[3]
Sky paint		Azurite and lead white.
Flesh paint		Lead white, charcoal black, vermilion.

1 EDX analysis indicates that, in addition to Cu from the verdigris, the layer contains some Ca and some Cl. The Cl content is likely to be a result of the method of manufacture of the verdigris. The Ca seems to be located in some of the brown particles; it is possible these are yellow lake. In some areas of foliage the green paint has discoloured to brown.

2 EDX analysis detected Al in the red lake particles. The matrix around the red particles contains areas where Ca is combined with S (calcium sulphate, confirmed by FTIR, concentrated around the red particles), areas where only Ca was detected (probably calcium carbonate) and some silaceous material (Si, K, Ca and traces of Mn, Mg, Na detected by EDX). There are a few particles which contain only Si.

3 Identified by EDX analysis.

the top and bottom. Only traces of these battens remain and they were probably planed down when the support was thinned and cradled in 1945. In the original wood preparation, knots in the timber were replaced with wooden inserts set into the front face. These are clearly visible in the X-radiograph (Fig. 2), which reveals that they were covered with coarse hairs or fibres to prevent cracking in the subsequent paint and ground layers. Similarly, hairs or fibres have been employed as a means of joint reinforcement on the backs of panel paintings by Dürer and Cranach,[22] and have also been found in the ground layer covering a panel join in Cranach's *Charity* (NG 2925). Although not exclusive to German panel production (similar reinforcements have been discovered on Early Netherlandish and Spanish panels as well as frames), the practice seems to be less common after the sixteenth century.[23] The ground layer is composed of chalk, over which a thin off-white priming layer has been applied (lead white tinted with a little black and red). It can be said, therefore, that the physical evidence from the painting's support is in keeping with other sixteenth-century German paintings.

Traces of original incised lines around all four edges of the panel, used to delineate the image area, indicate that the dimensions are intact.[24] Additionally, an unpainted border and raised edges of paint and ground at the edges not only confirm the unaltered size of the picture, but also show that the panel was probably constructed with an integral frame.

Paint layers

The painting was sampled in the 1950s, when it was established that no anachronistic pigments were present which might exclude the painting from being a sixteenth-century work.[25] However, little comparative information on other paintings from the period was available at that time. Many more technical studies of early sixteenth-century German paintings have now been published, including a detailed study of a number of paintings by Dürer in the Alte Pinakothek.[26] Also, more detailed analysis of the composition of the paint layers has been made possible by the more sophisticated methods now available.

The palette is straightforward: azurite for the sky,

Plate 2 Cross-section of the Virgin's red drapery showing several layers of red lake over an opaque red layer containing vermilion, lead white and red lead. Original magnification 400×; actual magnification 350×.

Plate 3 Detail of the Virgin's dress showing the red lake glaze that has been protected from light by the veil paint, which has subsequently been lost.

verdigris and lead-tin yellow for foliage, vermilion, red lake and red lead for the Virgin's red drapery (see Table 1). The Virgin's scarlet dress has a base colour consisting of vermilion and a small amount of red lead, with lead white added in highlights, a mixture which has also been found on the left panel of Dürer's *Four Apostles* in Munich, although it is not particularly unusual.[27] The shadows are modelled with transparent red lake glazes over the opaque scarlet paint. The cross-section illustrated in Plate 2 is from the deepest shadow below the Virgin's arm, where there are several layers of red lake which differ in appearance. The uppermost layer contains relatively large, closely packed, particles of red lake pigment which has a conventional alumina-containing substrate. In the lower layer, the transparent red particles are dispersed in a matrix of colourless material which appears yellow as a result of discoloration of the oil medium. The colourless material consists predominantly of calcium salts, together with a few silicaceous particles (see Table 1). The composition of this layer is most likely the result of the method of manufacture of the red lake rather than a mixture made when the paint was prepared; several of the recipes for red lake pigments which survive from this period list ingredients that could produce a pigment containing a mixture of calcium salts together with alumina.[28] Red lakes with a calcium-containing substrate are known to fade more quickly than those struck on to alumina; the red lake glazes on this painting are certainly much stronger in colour where they have been protected from light by the paint of the Virgin's veil and the blades of grass which overlap the red drapery (Plate 3).[29] Although the composition of the substrate differs, the dyestuff

in both layers originates from the kermes insect.[30]

Red lake glazes are rarely analysed in this much detail, making it difficult to assess whether the use of a calcium-containing red lake is unusual. Interestingly, some other early sixteenth-century German paintings in the National Gallery have red lake glazes of similar composition, including silicaceous particles with the same combination of minor components.[31] The choice of this type of relatively unstable red lake has probably caused the characteristic pale pink faded colour of some of the draperies on paintings in the National Gallery attributed to the Master of the Saint Bartholomew Altarpiece. Painters would not have made their own red lake pigments but would have bought them, probably from a pharmacy. The names of lake pigments which are specified in documents – such as *sinoppre de Coullongne* and *Paris rot* – suggest that there may have been centres that were known for the manufacture of lake pigments and that they were not necessarily made locally.[32]

The depiction of the foliage behind and around the Virgin and Child follows a straightforward but well-conceived formula. A bright green base colour was first applied which provided a mid-tone, and the leaves and plants were created by overlaying dark green lines in the shadows and an opaque pale green for the highlights. Finally, the outlines of the leaves were carefully picked out in a transparent dark brown. Although a greater degree of realism was attained in the specific plant specimens, such as the irises, peonies, bugle and vine, the basic technique is the same. The different shades of green paint consist of verdigris, lead-tin yellow and lead white in varying proportions, an absolutely standard mixture for green paint in

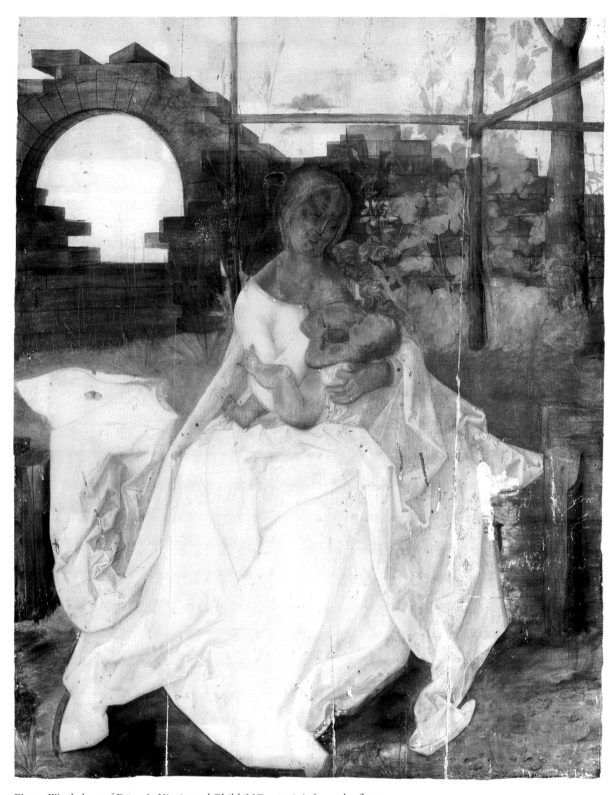

Fig. 3 Workshop of Dürer?, *Virgin and Child* (NG 5592), infra-red reflectogram.

Northern European painting throughout the sixteenth century. Paintings by Dürer are no exception – this type of mixture was found on the majority of the paintings studied in Munich.[33] The verdigris is of a type that contains a small amount of copper chloride. Again, this is not exceptional, and was also found in samples from Dürer's *Madonna with a Pink* in Munich.[34]

The modelling of the flesh consists of cool pinkish-grey paint scumbled over the pink-beige priming. In the final stages the highlights were emphasised in a cool white, and the main outlines picked out in a black-brown colour giving a hard, porcelain-like appearance to the flesh.

Evolution of the Composition
Underdrawing and changes during painting

Infra-red reflectography revealed a careful and detailed drawing for a Virgin and Child, seated on a turf bench, with a ruined wall behind them, surrounded by plants (Fig. 3). In the course of painting, however, some major changes took place in the arrangement of the wall and the plants (see below). The drawing was done free-hand, using a black pigment in a liquid medium, applied with a brush.

The drawing for the Virgin's draperies is particularly detailed. Each fold is drawn, and extensive hatch-

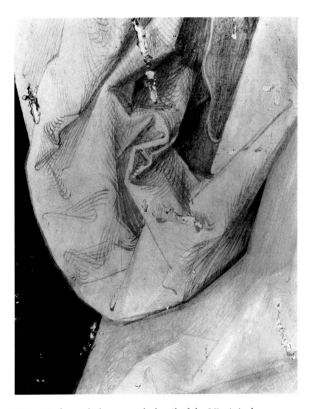

Fig. 4 Infra-red photograph detail of the Virgin's drapery.

ing and cross-hatching used to indicate varying degrees of shadow. In the darkest areas of shadow this hatching becomes so dense that the lines begin to merge together to form a solid area. In lighter areas they are more widely spaced. The hatching tends to follow the direction of the fold and is often curved. In the lighter areas, such as the part of the cloak which curves up onto the bench at the left of the picture, the small folds are drawn with distinctive swirls of curved hatching, some of which look like fishbones (Fig. 4). Unfortunately the presence of an unusually large amount of carbon black in the flesh paint makes it much more difficult to see the underdrawing in the Virgin's face and in the Child. Drawing is present in these areas, but appears to be confined to outlines.

This underdrawing establishes the position of the Virgin, and the basic shape that she and her flowing draperies make against the background. There is a certain degree of confidence in the overall placement of the figures which suggests that they were drawn with reference to existing drawings. Numerous small changes, however, were made to the drawing: folds were repositioned, and, most significantly, alterations were made to the arrangement of Christ within the Virgin's lap. Lines relating to the Virgin's drapery are evident beneath the baby's head, and more of the Virgin's dress is drawn below Christ's arm. Moreover, slight adjustments have been made to the child's bottom, left foot and hand, and to the Virgin's left hand supporting the child. These changes are all redrawn, suggesting that it was important to the artist to establish the precise arrangement of the figures before starting to paint.

In the background, drawing is limited to the main features: the wooden fence supporting the turf bench, the tree, the poles supporting the vine, a ruined wall and some of the more significant plants. At this early stage the arch was not drawn; the wall ended just to the left of the Virgin's right shoulder. An iris, with two open flowers and several buds, was drawn slightly to the right of the painted iris. It is shorter, the top flower appearing at the corner made by the vine poles, the lower flower just above the Virgin's head (Fig. 5). The vine was drawn, but the actual positions and shapes of the drawn leaves and tendrils were not followed in the painted version. Visible in the underdrawing, but not part of the painted composition, are a rose, with unopened buds, just to the right of the Virgin's head, and a tall spiky plant, possibly a dead-nettle, extending from beside the rose towards the vine.

The infra-red reflectogram mosaic and the X-radiograph both show that some painting had begun

before these changes in the background were made. The rose can be seen as a well-defined lighter area in the reflectogram, and as a matching darker area in the X-radiograph because paint for the wall has been applied, carefully leaving in reserve an unpainted area where the rose was to go (Fig. 6).[35] A second paint layer for the wall removed this plant from the composition. Similarly, reserves were left during the initial application of colour for the wall where the iris, the tall spiky plant and the vine were drawn, but the reserves were not followed in the final painting. The later version of the iris was painted after the sky without any further drawing.

After the first layer of wall colour had been applied, but before the sky was begun, the wall was extended to the left to create the arch. There are several under-drawn and incised lines made for the curves of the arch. The first incision outlined the front edge of a slightly wider arch which springs from the first painted wall but extends beyond the image at the left. This was revised with further incisions so that the entire arch was incorporated within the design. Having established this new position for the arch the brickwork was underdrawn. The sky was then painted leaving a reserve for the arch. At a later stage during the painting of the architecture the perspective was altered to show more of the underside of the arch. Additionally, other late changes were made to the wall; the bricks to the upper left and right of the Virgin's head and those over the top of the arch were not drawn but were added after the sky had been completed.

The X-radiograph shows that two shapes were left in reserve during the first application of sky colour in the area where God the Father is painted, in the clouds above the Virgin. Drawing exists, but is difficult to interpret; it may relate to more plants, an extra iris bud and more of the tall spiky plant, but it is possible that two birds were planned in this position perched on the vine pole.

Several significant features do not appear in the underdrawing at all, but were added during the painting process. These include the piece of turf on the left, the bugle and peony plants on the right, and the Almighty in the sky. None has a reserve left for it; the peony, for example, was added on top of the painted tree trunk and sky. In the area of the bugle, the infra-red reflectogram shows a confused arrangement of overlapping, curved brushstrokes, which may have represented grass. To the right of the bugle, there is drawing for leaves similar to, but smaller than, the plantain painted in the final composition. The rather wispy foreground plants overlapping the Virgin's drapery were not underdrawn,

Fig. 5 Infra-red reflectogram detail of the irises.

but a grass-like plant had been planned in the under-drawing just above the butterfly in the bottom right corner.

The figure of the Virgin was taken to a relatively high degree of completion before the foliage was painted, and few changes were made at the painting stage; there are only a few points at which the green background paint overlaps the red paint of the drapery. Only the final touches, such as the fine strands of curled hair, overlap the foliage paint. The early reserves left for the plants overlapping the first painted wall were also meticulously established. By contrast, the second application of wall paint, which obliterated reserves for the plants which were never painted, casually overlaps the drawing for the tree trunk at the far right and the reserve for the iris in its initial position. Similarly, the broad application of paint in the sky shows little regard for the drawn outlines of the wall and vine poles, as can be seen in the X-ray photograph.

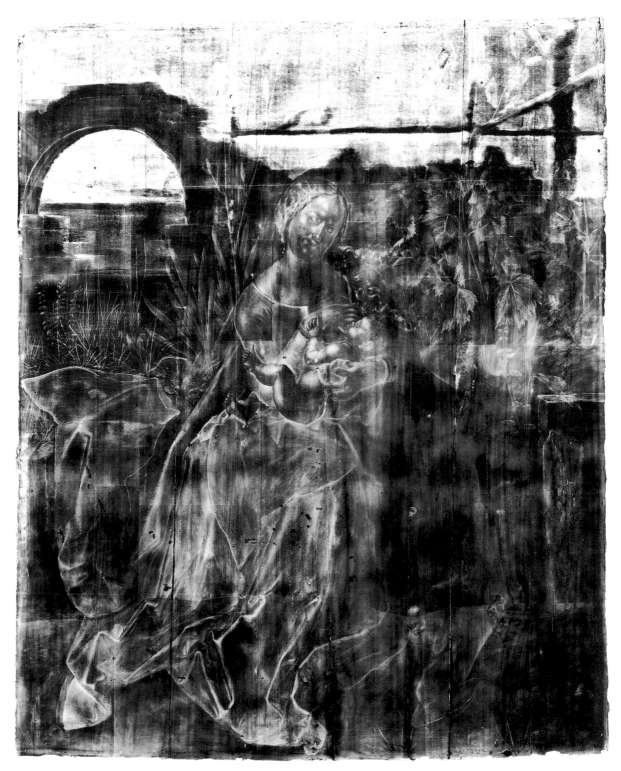

Fig. 6 Workshop of Dürer?, *Virgin and Child* (NG 5592), X-radiograph.

The Monogram and Date

A crucial question is whether the monogram and date need to be included in further discussions of the status of the painting. The monogram is certainly false. When brown overpaint, probably applied during the documented restoration in 1945, was removed during the recent cleaning, a scrubbed patch of paint in the shape of a square became visible on the brown wall in the area of the monogram (Plate 4). The monogram lies on top of remains of older brown overpaint covering the old cleaning damage, and so is not contemporary with the rest of the painting. Some idea of how much later the monogram was applied is given by the presence of Manila copal resin, in addition to drying oil, in the old brown overpaint beneath the monogram.[36] All the available evidence to date suggests that Manila copal was not used in European painting before the middle of the eighteenth century, meaning that the monogram is applied over eighteenth- or nineteenth-century repaint.[37]

The paint of the date, however, is clearly earlier than that of the monogram. The pigments in the paint are lead white, vermilion and lead-tin yellow, the last of which fell out of use during the first half of the eighteenth century.[38] The paint of the figure '8' of the date lies over a layer of varnish, which also survives in patches elsewhere on the wall (Plate 5). In paintings of this period this would usually be taken to mean that the paint above the layer of varnish is significantly later than the painting itself. However, varnish has occasionally been found between original paint layers on sixteenth-century paintings,[39] so it is conceivable that the painting was varnished before the date was applied and that both the date and the varnish layer beneath it are original. The fact that the date of 1516 on Dürer's *Portrait of Michael Wolgemut* (Nuremberg, Germanisches Nationalmuseum) is painted over an earlier date is further reason to consider this hypothesis.[40]

The early varnish layer

The varnish layer beneath the date was analysed to investigate whether any of the components indicated how early the varnish might be, and therefore whether it could be an original varnish. It was found to consist of a Cupressaceae resin such as sandarac or juniper: the absence of drying oil indicates that it is a spirit varnish – a resin dissolved in a volatile solvent – rather than an oil varnish where the resin is dissolved in a drying oil. The analysis also revealed traces of polyterpene, most likely remains of an essential oil such as oil of spike lavender used as a

Plate 4 Detail of the monogram after cleaning.

Plate 5 Cross-section of a sample from the figure '8' of the date. The layers are, from bottom upwards: brown paint of the wall, the early varnish layer, the paint of the figure '8' containing lead white and lead-tin yellow, further varnish and overpaint layers. The chalk ground and priming layers are missing from the sample. Original magnification 940×; actual magnification 825×.

solvent for the resin. Usually the solvent leaves no trace – the polyterpene here is probably an indication that the varnish was not entirely fresh when it was used.[41]

Our knowledge of the history of varnishes comes from recipes in treatises on painting materials and from the very small number of analyses of fragments of varnish which are believed to be original which have survived on paintings – usually under a frame or beneath early alterations and overpaint.[42] Very early recipes for oil varnishes exist, but the earliest known recipe for a spirit varnish, consisting of a mixture of spirit of wine (i.e. alcohol) and benzoin (a balsamic resin), is in the Marciana manuscript, which dates from the first half of the sixteenth century.[43] Raffaello Borghini, in his *Il Riposo* of 1584, describes a varnish very similar to that found on this painting, containing oil of spike lavender and sandarac, under the heading 'Varnish that dries

in the shade', and although this dates from the last part of the sixteenth century, it probably describes earlier practice.[44] These recipes are both Italian, but this probably reflects the fact that more Italian writings on painting technique have survived, rather than regional varnishing practice.

The surviving recipes suggest that the varnish beneath the date on this painting could have been applied at the beginning of the sixteenth century, although it would be a very early example of a spirit varnish. In a letter of 1509 to Jakob Heller, Dürer mentions a 'special varnish' which should be applied one, two or three years after painting, when the paint has hardened.[45] It is intriguing that he shows a particular interest in varnish and, although he does not give a precise recipe for his 'special varnish', it might suggest that he could have used something as innovative as a spirit varnish.[46] Leaving the painting to dry for a few years before varnishing was almost certainly standard practice. It seems likely that this procedure was followed for the *Virgin and Child*, and therefore unlikely that the date was applied immediately after the painting was finished.

Michael Levey also questions the status of the veil, which he describes as 'clumsy'. Cross-sections show that the paint of the veil lies over the same varnish as the date, at least in the areas sampled, and it seems very likely that they were added to the painting at the

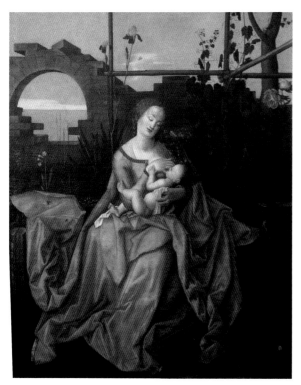

Plate 6 After Dürer, *Virgin and Child.* Panel, 194.7 × 155.7 cm. Prague, Národní Galerie.

same time.[47] The butterfly sitting on the Virgin's cloak, with a cast shadow carefully painted with red lake, has never been questioned, but it also lies over the early (possibly original) varnish, as do some of the red lake glazes on the Virgin's drapery.[48] Close copies of the painting, in Prague and Austria, which are thought to date from the end of the sixteenth century (Plates 6 and 7), include the veil and butterfly, but not the date and monogram.[49] However, the cleaning of NG 5592 has allowed closer examination of the monogram and date. There is no doubt that the monogram is false, but it may be significant that the paint of the wall has been scrubbed in a squarish shape in preparation for it, and one might speculate that another (less desirable) monogram was removed. The date is clearly early, but as it lies over a layer of varnish it must have been added at least a short while after the painting was finished, together with the veil and butterflies which lie over the same varnish.

Conclusion

The further, more detailed, technical examination carried out since Michael Levey's 1959 catalogue has shown that not only are the materials consistent with a sixteenth-century production, but that there are some close similarities with other early sixteenth-century German paintings and with paintings by Dürer.[50] These similarities are not conclusive evidence – the materials found are relatively common and would still have been available at the end of the sixteenth century – but they are highly suggestive.

The production of the *Madonna with the Iris* was evidently not a simple process. Several types of intervention can be identified, which may be the result of the involvement of different hands, possibly at different times over a period of years. A number of carefully established reserves for plants, which were drawn, were obliterated when the second layer of paint was applied on the wall. New plants and foliage to left and right were then added, as was the figure of God in the sky. The broad application of the second layer of paint on the wall contrasts with the neatly painted reserves in the first stage of painting. Finally, the Virgin's veil, the butterflies and the date 1508 were added after varnish had been applied. The stage at which the part of the wall now showing the monogram was removed, and what was originally painted there, are impossible to establish. But the doubts expressed by earlier commentators regarding the homogeneity of the painted surface can now be clarified: elements such as the peony and vine are certainly part of the first

campaign of painting, while the date, the veil, the butterfly and some of the red lake glazes, although added later, may yet have been painted at a date relatively close to the first campaign, and certainly within the sixteenth century, as the copy in Prague and the technical evidence indicate.

There is, therefore, good reason to take seriously the recent suggestions that the painting may have been produced in Dürer's workshop. Moreover, the style of underdrawing revealed provides positive support for a dating in the very early years of the sixteenth century; the densely hatched folds and the use of conventions such as fishbone-style folds are found in the work of German painters of the late fifteenth and early sixteenth centuries such as the Master of the Saint Bartholomew Altarpiece.[51] A similar style has been detected in those works by Dürer himself which have been investigated with infra-red reflectography, especially earlier works such as the Paumgartner Altar in the Alte Pinakothek in Munich.[52] Detailed comparisons with Dürer's underdrawings and with the large number of studies on paper by Dürer, although beyond the scope of this study, may well prove illuminating. Any investigation of the similarities between the National Gallery picture and works by Dürer should also extend to works by identifiable members of his workshop, and others within the Dürer circle. Future studies of this kind may well lead to further clarification of the authorship of the *Virgin and Child*, now that the facts concerning the painting's physical structure have been clearly established.

Appendix
Details of organic analysis of paint samples

Two samples of the early varnish layer were analysed. One sample was scraped from the underside of the paint of the veil (the varnish runs beneath it), the other was from a patch of the early varnish which remains on the surface in the area close to the figure eight of the date. Initial analysis by FTIR microscopy suggested that a diterpenoid acid-rich resin was present, with no clear indication of drying oil or other glyceride-based material. GC–MS analysis, using thermolytic methylation, revealed the material to be a resin containing sandaracopimaric acid as the dominant component, but no dehydroabietic acid or its oxidation products were detected, nor were there labdane dicarboxylic acid components. Overall, the pattern of residual acids suggests the presence of a resin from the Cupressaceae such as sandarac, rather than copals from the Araucariaceae. Subsequent

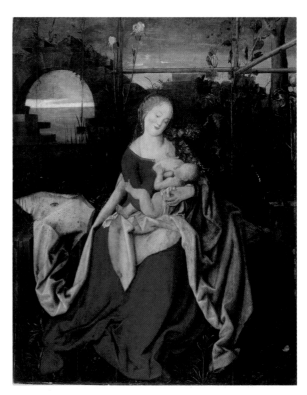

Plate 7 After Dürer, *Virgin and Child*.
Canvas, 155 × 121 cm. Austria, Wilhering Monastery.

pyrolysis gas chromatography coupled with mass spectrometry (py–GC–MS) indicated that the principal component is a resin based on polycommunic acid derived from a member of the Cupressaceae, that is, a sandarac-type resin.

An additional polyterpene component was also detected by py–GC–MS. This appears to be formed of polymerised lower terpenoids (as opposed to polymerised lower terpenes, derived from materials such as spirit of turpentine). Such materials originate from the oxygenated essential oils extracted from flowers. Camphor-derived oxidation products or their oligomers were not present in significant amounts. It is therefore unlikely that the polyterpene derives from rosemary or other camphor-rich lavender oils and is more likely to be from oil of spike lavender (*Lavendula spica* DC).

Sandarac contains a moderately polar polymer of communic acid and so is not very soluble in less polar solvents such as spirit of turpentine which is mostly a mixture of pinene hydrocarbon isomers. Oil of spike lavender would be more polar and would therefore be more effective in dissolving the resin. Normally the essential oil would evaporate from the varnish film and leave no detectable residues. Oil of spike does, however, become progressively more sticky and viscous when left exposed, in bulk, to the light and atmosphere. It may be that the sandarac

varnish was not very fresh, so that lower terpenoid oligomers and polymers of the essential oil were formed which remained in the varnish film.

The early brown repaint which runs beneath the paint of the monogram was also examined, by GC–MS. The paint contains a drying oil, although the azelaic acid content was rather lower than might be expected. This can indicate an egg tempera medium, but in this case there was no evidence for proteinaceous components, nor was there any beeswax, whose non-drying lipids can also account for a reduction in the proportion of azelate in the lipid mixture. In addition, GC–MS and py–GC–MS revealed traces of sandaracopimaric, agathic and isoagathic acids, and the corrresponding pyrolysis fragments for a polycommunic acid-containing polymer, suggesting the incorporation of some form of copal resin from the Araucariaceae. This is likely to be Manila copal, a product from *Agathis dammara* Richard, also known as *Agathis alba*. Dehydroabietic acid and its oxidation products are absent so it is unlikely that the resin is Kauri copal from New Zealand, produced by *Agathis australis*.

Notes and References

1 Board Minutes in the Gallery Archives for 3 May 1945 show that Trustees were cautious regarding the attribution to Dürer, which was not regarded as universally accepted; nevertheless the painting was registered in the Gallery inventory as a Dürer. We are grateful to Sarah Herring and to David Carter and Jacqui McComish for their assistance on this point.

2 Board Minutes 10 June 1948. In a memorandum of 1 December 1948 Cecil Gould urged the Director to change the label yet again to 'Dürer (workshop)'.

3 M. Levey, *National Gallery Catalogues. The German School*, London 1959, pp. 32–7.

4 F. Koreny, *Albrecht Dürer und die Tier- und Pflanzenstudien der Renaissance*, Munich 1985, pp. 118 and 177; see also the tentative endorsement in J. Rowlands; with the assistance of G. Bartrum, *Drawings by German Artists and Artists from German- Speaking Regions of Europe in the Department of Prints and Drawings in the British Museum. The Fifteenth Century, and the Sixteenth Century by Artists born before 1530*, London 1993, Vol. 1, p. 117, no. 262.

5 The other two are in the Národní Galerie in Prague and the monastery of Wilhering near Vienna. We are grateful to Olga Kotková and Peter Príbyl of the Národní Galerie for making it possible for us to examine the Prague painting in store.

6 E. Panofsky, *Albrecht Dürer*, London 1945, II, no. 28, argued strongly that the National Gallery picture was the Madonna painting mentioned by Dürer in documents of 1508. But Levey's 1959 National Gallery catalogue cast doubt on its documented status, arguing

that the painting mentioned in the documents was probably a small painting of a Virgin, which Dürer sold for 72 florins, rather than a large painting of a Virgin in a landscape which Dürer specifically says he had refused to paint in 1509 for as much as 400 florins.

7 J. Heller, *Das Leben und die Werke Albrecht Dürer's*, Bamberg 1827, p. 260. Heller is precise in his recording of monograms and inscriptions, therefore it is improbable that he omitted to mention a monogram present on the National Gallery painting.

8 The painting was offered to the Gallery in 1872 by P.H. Desvignes (letter in Gallery Dossier on NG 5592). It is not discussed in the Board Minutes, nor are there any letters in the Letter Book.

9 M.W. Brockwell, *A Catalogue of the Paintings at Doughty House, Richmond and Elsewhere in the Collection of Sir Frederick Cook*, Bt, III, London 1915, pp. 108–9.

10 The engraving is B. 44; see also the woodcut B. 99.

11 Several engravings again show the Virgin on a grassy bank, and with a background of vines, for instance one of 1503 (B.34). A number of drawings show similar figures of the Virgin, often on a grassy bank. Dürer's watercolour *Virgin and Child with Animals* (Vienna, Albertina), discussed by Koreny (see note 4 above), shows the Virgin again surrounded by flowers, with similar peonies on the right. The stone-built arch is paralleled in Dürer's *Nativity* in the Uffizi of 1504 as well as in other works.

12 Other scholars, including Friedländer, Glück and Winkler, all cited by Levey, have suggested that it might be a work of the Rudolphine Dürer revival at the end of the sixteenth century, although, as Levey notes, Dürer revival paintings are generally confined to close copies of Dürers rather than assemblages of motifs.

13 The pentimento was noticed in an infra-red photograph taken in 1958 when Levey was preparing the entry for the 1959 catalogue. Samples taken by Joyce Plesters from the area where the rose was visible in the infra-red photograph confirmed this observation.

14 Levey, cited in note 3, p. 35.

15 The date and monogram were not sampled, but were examined from the surface after a cleaning test was made in 1958. The monogram was dismissed on the basis that the paint was different in appearance and texture to that on the rest of the picture, but no analysis of the materials making up the paint was undertaken. The paint of the date was also thought to be inconsistent with the rest of the painting, but appeared to be old and so was considered to be dubious rather than certainly false.

16 The retouchings on the flesh were found to contain zinc white (zinc oxide, identified by EDX analysis in the scanning electron microscope), a pigment known to cause chalking. See H. Kühn, 'Zinc White', *Artists' Pigments: A Handbook of their History and Characteristics*, Vol. 1, ed. R.L. Feller, Washington/Cambridge 1986, p. 174.

17 The cleaning and restoration were carried out by Paul Ackroyd. Marika Spring analysed the pigments, while Raymond White was responsible for analysis of the

binding media and varnish. Infra-red reflectography was carried out by Rachel Billinge.

18 The cradle had created undulations in the picture surface as well as splits in the panel and was removed during the recent restoration. The painting was then placed within a supporting tray.

19 The painting will be fully discussed in the forthcoming National Gallery Catalogue of German paintings before 1800.

20 Identified as limewood by microscopic examination of a sample by Joyce Plesters, confirmed more recently by Peter Klein.

21 The types of wood used for early sixteenth-century German panel painting are discussed in P. Klein, 'Some aspects of the utilization of different wood species in certain European workshops', *Painting Techniques: History, Materials and Studio Practice, Preprints of the IIC Dublin Congress, 7–11 September 1998*, ed. A. Roy and P. Smith, London 1998, pp. 112–14.

22 See G. Goldberg, B. Heimberg and M. Schawe, *Albrecht Dürer: Die Gemälde der Alten Pinakothek*, Munich 1998, pp. 142, 171, 488, and G. Heydenreich, 'Artistic Exchange and Experimental Variation: Studies in the Workshop Practice of Lucas Cranach the Elder', *Painting Techniques: History, Materials and Studio Practice*, cited in note 21, p. 107.

23 H. Verougstraete-Marcq and R. Van Schoute, *Cadres et Supports dans la peinture flamande aux 15e et 16e siècles*, Heure-le-Romain 1989, pp. 53–4. Examples of joints reinforced with hairs on Spanish panels are discussed in Z. Véliz, 'Wooden Panels and Their Preparation for Painting from the Middle Ages to the Seventeenth Century in Spain', *The Structural Conservation of Panel Paintings, Proceedings of a symposium at the J. Paul Getty Museum, 24–28 April 1995*, ed. K. Dardes and A. Rothe, Los Angeles 1998, pp. 136–48.

24 Similar incised lines were observed on several paintings by Cranach, see Heydenreich, cited in note 22. They were interpreted as evidence that the frame and panel had been primed when joined together, but separated again at some point during painting.

25 Sampled by Joyce Plesters, unpublished report in conservation dossier, January 1959.

26 *National Gallery Technical Bulletin. Early Northern European Painting*, 18, 1997, ed. L. Campbell, S. Foister and A. Roy. Note 2, p. 44, lists numerous publications of technical studies of German paintings. Goldberg, Heimberg and Schawe, cited in note 22.

27 Goldberg, Heimberg and Schawe, cited in note 22, p. 93.

28 The exact composition of the colourless material in the lower layer is difficult to establish, as it appears to be a finely divided mixture of calcium salts. Some calcium sulphate was detected by FTIR microscopy, and EDX analysis also detected calcium in combination with sulphur, although in some areas only calcium was detected, suggesting that there is also some calcium carbonate. It seems most likely that the calcium sulphate component is the result of a reaction that has taken place during manufacture of the lake rather than a deliberate addition during grinding of the paint; it is not a material normally encountered in German painting and is very finely divided, suggesting that it has been formed by precipitation. The red particles seem to contain Al; it appears that most of the dyestuff has been co-precipitated using roch alum ($KAl_3(OH)_6(SO_4)_2$) to give a dye-alumina complex. Washing is often recommended in recipes, which removes the sulphate. Here, however, a calcium-carbonate based ingredient (chalk, white earth, egg shells, cuttlefish bone) appears to have reacted with some sulphate to form calcium sulphate, the excess remaining as calcium carbonate. It is noticeable in the back-scattered image of the cross-section in the scanning electron microscope that the calcium sulphate is concentrated around the large red lake particles. Another possible source of calcium salts in lake making might be the use of lime water to dissolve the dyestuff. See J. Kirby, 'The Preparation of Early Lake Pigments: A Survey', *Dyes on Historical and Archaeological Textile*, 6th Meeting, University of Leeds, September 1987, pp. 12-18. An example of a recipe in a sixteenth-century German treatise which might produce a red lake of this composition is in V. Boltz, *Illuminierbuch: wie man allelei Farben bereiten, mischen und auftragen soll*, Basel 1549 (annotated edn. Munich 1913; reprinted Schaan 1982), ed. C.J. Benziger, p. 65.

29 D. Saunders and J. Kirby, 'Light-induced Colour Changes in Red and Yellow Lake Pigments', *National Gallery Technical Bulletin*, 15, 1994, pp. 79–97.

30 Identified as kermes by HPLC by Jo Kirby, and confirmed by microspectrophotometry. Red lakes from other fifteenth- and sixteenth-century German paintings in the National Gallery have all been found to contain dyestuff either from the kermes insect or the madder plant. See J. Kirby and R. White, 'The Identification of Red Lake Pigment Dyestuffs and a Discussion of their Use', *National Gallery Technical Bulletin*, 17, 1996, p. 72.

31 Other early sixteenth-century German paintings with red lake glazes of similar composition, analysed for revision of the German School catalogue, include NG 707, NG 6470, NG 6497, all attributed to the Master of the Saint Bartholomew Altarpiece, and NG 1049 by the Master of the Aachen Altarpiece.

32 J. Kirby, 'The Price of Quality: Factors Influencing the Cost of Pigments during the Renaissance', *Values in Renaissance Art*, ed. G. Neher and R. Shepherd, Ashgate, in press.

33 Goldberg, Heimberg and Schawe, cited in note 22, p. 94. Nearly all the green samples from NG 5592 also contain a little brown pigment, as do several of the paintings in Munich.

34 Goldberg, Heimberg and Schawe, cited in note 22, p. 94.

35 Confirmed by cross-sections of samples from the area where the reserve was visible in the infra-red reflectogram, and from an area of the wall nearby which appeared to be away from the reserve. In the area of the reserve there was only one layer of brown wall paint (consisting of lead white, black, red, azurite), while there were two layers away from the reserve. The first layer, consisting of vermilion, black and white, was

painted leaving a reserve for the rose, which was painted out with the second brown layer of different pigment composition.

36 Analysed by Raymond White by GC–MS, see the Appendix for a detailed discussion of the results. The pigments in the monogram paint were yellow earth, chalk and carbon black.

37 Manila copal is unlikely to have arrived in Europe before the seventeenth century, and has not been identified in original paints earlier than the eighteenth century in this laboratory. Two types of 'copal' are mentioned by Pierre Pomet, *Histoire générale des drogues, traitant des plantes, des animaux and des minéraux*, Paris 1694, pp. 271–2: 'De la gomme copal', but the descriptions of their properties indicate that it is not Manila copal (*Agathis dammara* Richard, also known as *Agathis alba*) which is being discussed. Its use appears to be more common in the nineteenth century, although the East and West African copals were regarded as superior.

38 H. Kuhn, 'Lead-Tin Yellow', *Artists' Pigments: A Handbook of Their History and Characteristics*, Vol. 2, ed. A. Roy, pp. 83–112.

39 For example on *A Man and a Woman* (NG 1234), by Dosso Dossi, a varnish layer lies beneath the ultramarine sky, which is almost certainly original as documents exist for the purchase of quantities of ultramarine for this work. See R. White, J. Pilc and J. Kirby, 'Analyses of Paint Media', *National Gallery Technical Bulletin*, 19, 1998, pp. 74–95.

40 K. Löcher and C. Gries, *Die Gemälde des 16. Jahrhunderts, Germanisches Nationalmuseum Nürnberg*, Stuttgart 1997, pp. 210–12.

41 Details of the analysis are outlined in the Appendix.

42 J. Kirby, 'Italian Varnish Recipes from the Fourteenth to the Seventeenth Centuries', Unpublished lecture given at *A Look at Varnishes: Historical and Current Practices*, a symposium held in Washington DC, 20–21 April 1998.

43 Marciana Manuscript, in M.P. Merrifield, *Original Treatises, dating from the XIIth to the XVIIIth centuries, on the Arts of Painting*, Vol. 2, London 1849, pp. 628–9, no. 394.

44 Raffaello Borghini, *Il Riposo*, Florence 1584, rep. Milan 1807, Book II (Vol. 1, Book II in Milan edn.), p. 258. The ingredients for one of the recipes for varnish that dries in the shade are oil of spike lavender, 1oz, and sandarac 1oz. 'Mix and set to boil in a new glazed pipkin. If you want the varnish with more lustre have more sandarac and mix very well. When tepid spread on the work; this is a very fine and (sweet)-scented varnish.'

45 *Dürer. Schriftlicher Nachlass*, ed. H. Rupprich, Berlin 1956, p. 73.

46 Mantegna is known to have obtained a special varnish from Venice. The possibility that this was a spirit varnish is discussed in J. Dunkerton, 'Mantegna's painting techniques' in *Mantegna and 15th-Century Court Culture, lectures delivered in connection with the Andrea Mantegna exhibition at the Royal Academy of Arts, London 1992*, ed. F. Ames-Lewis and A. Bednarek, London 1993, pp. 26–38.

47 The white paint of the veil consists of lead white bound with partially heat-bodied linseed oil, identified by GC–MS by Raymond White.

48 Samples from the butterfly and from an area of the Virgin's dress glazed with red lake were analysed by GC–MS by Raymond White. An unpigmented layer visible in cross-section beneath the paint of the butterfly and beneath the uppermost red lake glaze layer in a sample from the shadows of the Virgin's dress was found to contain sandarac resin.

49 The painting is not identifiable in the Rudolphine inventory of 1621, published by H. Zimmermann, 'Das Inventar der Prager Schatz und Kunstkammer vom 6. Dezember 1621', *Jahrbuch der Königlichen Kunstsammlungen des Allerhöchsten Kaiserhauses*, XXX/2, 1905, pp. xv–lxxv. The earliest reference in the records of the Národní Galerie, Prague, is from 1800, when the painting had the number 815. We are grateful to Olga Kotková for this information.

50 Fingerprints were found in several areas on NG 5592, including the paint of the wall. They have been recorded on other paintings by Dürer, including the *Lamentation*, and his *Self Portrait*, now in the Prado, Madrid (see Goldberg, Heimberg and Schawe, cited in note 22, p. 45, ill. p. 44).

51 See K. Löcher, 'Albrecht Dürer – seine Schüler und sein Kreis', and I. Sandner, 'Unterzeichnungen auf Gemälden Nürnberger Meister, Dürer und sein Kreis', in *Unsichtbare Meisterzeichnungen auf dem Malgrund. Cranach und seine Zeitgenossen*, ed. I. Sandner, exh. cat., Wartburg-Stiftung Eisenach, Regensburg 1998, pp. 260–76 and 277–91.

52 Goldberg, Heimberg and Schawe, cited in note 22, pp. 36–42, for a discussion of style of underdrawing in paintings by Dürer.

The Restoration of Lorenzo Monaco's
Coronation of the Virgin: Retouching and Display

PAUL ACKROYD, LARRY KEITH AND DILLIAN GORDON

THE ALTARPIECE OF THE *Coronation of the Virgin* in the National Gallery was painted by Lorenzo Monaco for the Camaldolese monastery of San Benedetto fuori della Porta Pinti, Florence, probably between 1407 and 1409 (Plate 1).[1] Its original appearance has over the years been drastically altered by at least three separate physical interventions suffered before it entered the Collection. In the recent programme of cleaning and restoration described below it was decided to attempt to address some of the distortions which were severely affecting its intended composition and hence its true visual impact.

Early History

The altarpiece, which has been reconstructed on the evidence of the analogous altarpiece now in the Uffizi, painted for the high altar of Santa Maria degli Angeli, Florence, by Lorenzo Monaco in 1414, is only partly complete.[2] The centre section (NG 1897) shows the Virgin being crowned by Christ, surrounded by seven angels. Each side panel (NG 215 and 216) contains eight saints arranged symmetrically in three diagonal rows. Saint Benedict, founder of the Benedictine Order, in the left panel is balanced by Saint Romuald, founder of the Camaldolese Order, in the right; Saint John the Baptist, patron saint of Florence, is balanced by Saint Peter; Saint Matthew the Evangelist is opposite Saint John the Evangelist; Saint Miniato, a patron saint of Florence, is opposite an unidentified saint in red holding a book; Saint Stephen balances Saint Lawrence, both deacons and Early Christian martyrs; Saint Paul is opposite Saint Andrew (?); Saint Francis, founder of the Franciscan Order, balances Saint Dominic, founder of the Dominican Order; a bishop saint, probably Saint Zenobius, another patron saint of Florence, is opposite Pope Gregory the Great.

The predella showed scenes from the Life of Saint Benedict, titular of the church. Below the left section were *Saint Benedict admitting Saints Maurus and Placidus into the Benedictine Order* (NG 2862), together with a panel in Rome, Pinacoteca Vaticana (Inv. No. 193{68}), *A Young Monk tempted from Prayer* and *Saint Benedict raises a Young Monk*.[3] Below the right section were *Incidents in the Life of Saint Benedict* (NG 4062) and the *Death of Saint Benedict* (NG L2). Recently it has been confirmed that the central scene had below it the *Adoration of the Magi* in the National Museum, Poznań, as first suggested by Eisenberg.[4] The identity of the pinnacles of the altarpiece is less certain. Pudelko suggested that the *Annunciate Virgin* (formerly Vienna, Liechtenstein Collection, now Pasadena, Norton Simon Collection) had originally been the right-hand pinnacle,[5] and this has been accepted by Eisenberg who suggests that by analogy with the Uffizi altarpiece Gabriel was in the corresponding pinnacle at the left side and in the centre was the Blessing Redeemer.[6] The latter has been identified as the *Blessing Redeemer* formerly in the collection of Charles Loeser, now in a private collection.[7] Kanter suggested an intermediary tier consisting of the *Four Patriarchs: Abraham, Noah, Moses and David* in the Metropolitan Museum of Art, New York.[8] It seems to be impossible to ascertain whether the association of these panels with the altarpiece is correct or not. It has recently been suggested by Boskovits that a *Jeremiah* (New York, Richard Feigen Collection) came from one of the pilasters.[9]

The surviving constituent panels of the altarpiece in the National Gallery all have a different provenance and came into the Collection at different times (see below). The whole altarpiece was probably first dismembered in 1529, during the siege of Florence. Vasari, who saw the *Coronation of the Virgin* in Santa Maria degli Angeli in 1568, implies that the removal of the painting from San Benedetto to Santa Maria degli Angeli was occasioned by the siege, a recent event about which his information is likely to have been accurate.[10] On 23 December 1442 a Bull of Eugenio IV had united the monasteries of San Benedetto and Santa Maria degli Angeli so that the monks could move from one to the other, and in 1530 after the monastery at San Benedetto had been destroyed in order to build fortifications

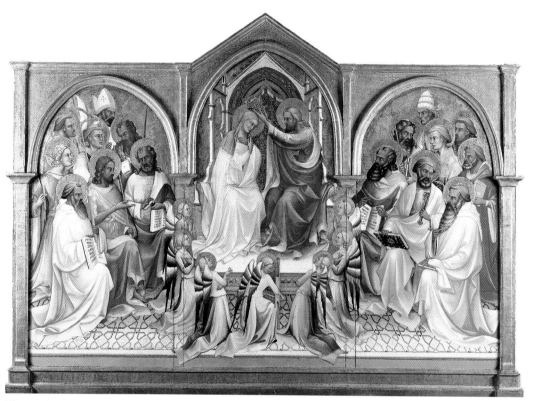

Plate 1 Lorenzo Monaco, *The Coronation of the Virgin with Adoring Saints* (NG 215, 1897 and 216), after cleaning and restoration, in modern frame. Panel, 217 × 336 cm.

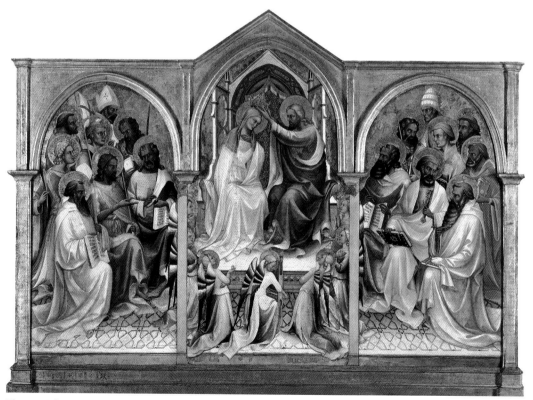

Plate 2 *The Coronation of the Virgin with Adoring Saints* before recent restoration.

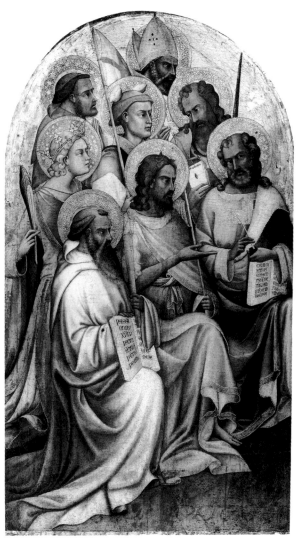

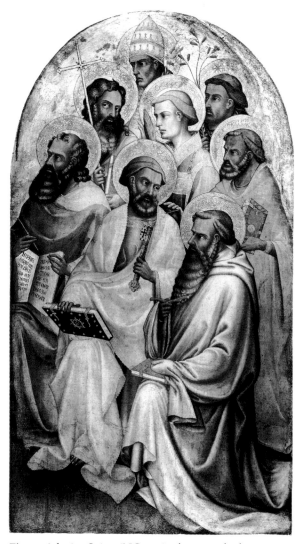

Fig. 1 *Adoring Saints* (NG 215), photographed 1932. Visual evidence of the panel's association with the other altarpiece sections, such as the truncated angel figures and the patterned floor tiles, was covered by an early restoration.

Fig. 2 *Adoring Saints* (NG 216), photographed 1932.

during the siege, the monks there moved to Santa Maria degli Angeli, together with their sacred objects and relics.[11] This is the likely time of the transferral of the altarpiece to Santa Maria degli Angeli where it was housed in the Alberti Chapel. It is not possible to estimate the extent to which the altarpiece was reconstructed in Santa Maria degli Angeli, but it seems likely that the main tier from which the three large National Gallery panels were taken remained intact, since all the main tier sections seem to have been similarly damaged along the base, probably due to the flood which Santa Maria degli Angeli suffered in 1557.[12] All three of the present sections suffered loss along the bottom and were at some stage trimmed, the outer panels (NG 215 and 216) by 15.6 cm more than the central section (NG 1897).

Such damage is not evident in the predella panels,[13] which suggests that they had by then already become separated from the main tier.

At some unknown date the main tier, an image conceived, constructed and painted as a single unified panel, was separated into the three sections now in the National Gallery, resulting in the loss of two vertical bands of the composition each about seven centimetres wide between the present divisions. The panel with *Adoring Saints* (NG 215) is first recorded in the Fesch Collection in 1839,[14] and the corresponding panel with *Adoring Saints* (NG 216) was purchased from J. Freeman in Rome at an unknown date by William Coningham,[15] and presented to the National Gallery, together with NG 215, in 1848 (Figs. 1 and 2). The *Coronation of the Virgin* is last

recorded in Santa Maria degli Angeli in 1792,[16] and came into the Gallery in 1902.[17] The connection between the *Adoring Saints* and the *Coronation of the Virgin* had first been made by Crowe and Cavalcaselle in 1864, and then by Pudelko in 1938,[18] but it was only when the side panels were cleaned in 1940 followed by the central panel that the fragments of the angels from the side panels were discovered, confirming the association;[19] after this restoration the three separate sections were displayed together in a newly constructed frame, incorporating unreconstructed vertical strips in the place of the painted areas lost between the present sections as a result of the old dismemberment.

Condition of the Painting and its Early Restoration

The decision to begin the most recent restoration of this altarpiece was largely based on the consideration of its physical condition. By 1995, the date of the beginning of the project, the 1940s dammar varnish, while not particularly thick, had noticeably discoloured, and an experimental mixed medium used in the 1940s restorations had also proved unstable (Plate 2);[20] retouchings done then had generally darkened, although in some cases they had also blanched, or whitened, and the general effect of these changes was to create a messy and fairly incoherent image, significantly obscuring the legibility of the original paint. Lorenzo's image was compromised by the changes that had occurred in the mid-century restoration, and it became apparent that it would benefit from further restoration work.

Although many parts of the work were in very good condition, most notably the upper part of the central section, there were also extensive areas of considerable damage, both total loss and wearing or abrasion of original paint layers. It seems likely that the damage along the bottom edge, resulting in the trimming of the outer sections and extensive losses along the central bottom, was caused by the damp or flooding of 1557. Other extensive losses must have been the result of the decision to separate the originally continuous image into the three sections. Some damage must have occurred from the vibration of the actual sawing through of the altarpiece, but the crude attempts in centuries past to disguise this with extensive repaint, perhaps carried out through several cycles of reworking and harsh cleaning, also contributed to the current condition of the paint along either side of these cuts (Plate 3). At some unknown date the fragments of the side angels who overlapped

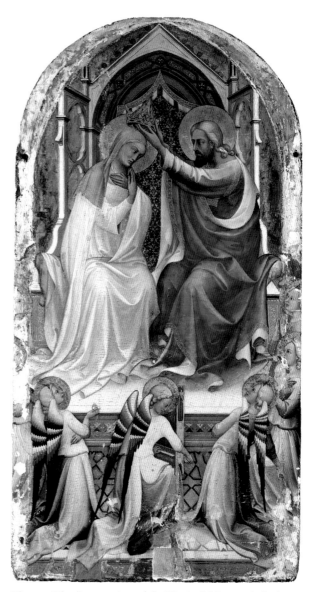

Plate 3 *The Coronation of the Virgin* (NG 1897), during recent cleaning.

both main and side panels, and therefore remained fragmentary in all three sections when the panels were separated, were painted out in an obvious attempt to make the three sections into independent and therefore more saleable paintings (Fig. 3). When Milanesi saw the *Coronation of the Virgin* in a chapel of a former Camaldolese abbey in 1830 or 1840, at Elmo or Adelmo, near Cerreto, the panels had already been separated, since he described only three angels.[21] Likewise only three angels appear in the drawing of the *Coronation of the Virgin* in Frankfurt, inscribed *Di Lorenzo Monaco alla Badia virgo* (? rubbed) *Certaldo* (Fig.4), made by Johann Anton Ramboux (1790–1866) on one of his two Italian trips undertaken between 1818 and 1822 and between 1830 and 1843.[22] In all three main tier panels the

Fig. 3 *The Coronation of the Virgin*
(NG 1897), photographed 1939.

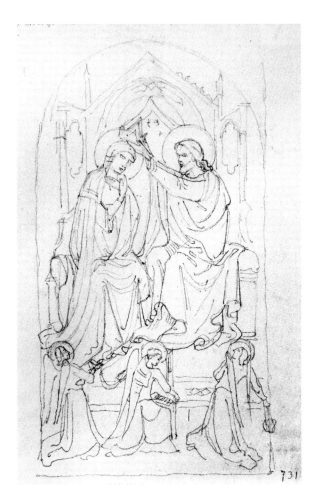

Fig. 4 *The Coronation of the Virgin*, drawing by Johann
Anton Ramboux. Frankfurt, Städelsches Kunstinstitut.

tiled floor was at some stage overpainted with red
paint (removed in a previous cleaning), possibly to
disguise the damage caused by flooding or to sup-
press the evidence of the original larger composition
provided by the receding perspectival orthogonals.
It is likely, although not certain, that this coincided
with the painting out of the cropped angels.

While it is not possible to know with precision
either the number of restoration interventions asso-
ciated with the dismemberment and dispersal of the
altarpiece, or their dates, it is clear that they resulted
in considerable damage throughout the image. Before
the nineteenth century restorers did not generally have
access to organic solvents, and were therefore obliged
to use less easily controllable acidic or alkaline re-
agents, the results of which were often decidedly

uneven and sometimes disastrous. The white robes of
the two outer kneeling saints, Benedict and Romuald,
had at some stage been repainted into dark grey
habits; possibly these panels had been moved to a
different monastic foundation.[23] This repaint was very
old, but clearly made long after the original execu-
tion of the work, as examination of samples taken
from remaining traces of the grey repaint showed
that it had been carried out in oil paint,[24] unlike the
egg tempera used by Lorenzo and his contemporaries.
This later grey paint was itself removed well before
the paintings were acquired by the Gallery, certainly
before any known photographic documentation. Its
removal was disastrous for the original painted
white habits, as it left considerable traces of the grey
overpaint and also greatly eroded and abraded the
original beneath, thus creating enormous difficulties
in retouching (Plate 4).

Plate 4 Detail of Saint Benedict's robe, from NG 215, during cleaning, showing traces of old grey repaint and abrasion of original.

Plate 5 Detail of doorway cut into central panel, showing parts of several earlier reconstructions of the missing section.

The last noteworthy damage is that caused by the cutting of a lunette-shaped door into the bottom centre of the central panel, resulting in total loss of the original surface and panel in that area. The doorway would have opened into a space such as a cupboard or tabernacle in which would have been placed either the host or a relic; the Lorenzo Monaco altarpiece now in the Uffizi had a similar but larger doorway as an original element,[25] although that doorway was changed and enlarged at a later date. There is no evidence that the doorway of the National Gallery painting was an original feature of the construction, and the lunette-topped shape of the doorway incision would be an atypical, anachronistic design for the beginning of the fifteenth century. The existence of several superimposed reconstruction attempts over the replacement wood also points to its later date (Plate 5). The blue pigments used in the reconstructions of the missing drapery of the central organ-playing angel, itself painted with lapis lazuli ultramarine, echo the history of the use of blue pigments through the subsequent centuries. There are at least three clearly discernible restorations and the oldest one appears to date from around the seventeenth century, judging from circumstantial evidence of the azurite and smalt pigment mixture used to make the drapery colour. The reconstruction over that contained the pigment Prussian blue in its drapery and thus must date from sometime after its invention in the early eighteenth century, and over that were the modifications made during the mid-twentieth-century restoration, using both Prussian blue and artificial ultramarine pigments.

Cleaning

The cleaning itself was generally straightforward, as both the varnish and the retouchings were for the most part fairly recent and not difficult to remove.[26] The general effect of removing the yellowed layers was to enhance the cooler, more blue end of the colour spectrum, giving a more correct impression of the intended interplay between the various colours, even with the loss of intensity of some of the red lakes through fading.[27] Photographic and X-ray documentation undertaken during earlier restoration work provided a clear and unambiguous record of the extent of loss and damage to the original work as cleaning progressed. After cleaning, the picture presented a variety of types of retouching problems: abrasion and small losses, larger areas of total loss, and whole missing sections both at the edges and through the centre of the image. This variety of

damage could not be readily resolved by a single consistent approach to the retouching, but demanded a more flexible application of existing methods. The need to compensate for large losses in the painting also raised a number of ethical issues that are central to the debate over modern attitudes to restoration, and it was therefore useful to evaluate past approaches to restoration in the particular context of the *Coronation of the Virgin*.

Past Approaches to Retouching

In general a policy of deceptive or invisible retouching has been adopted at the National Gallery since the nineteenth century. It was the policy adopted in the 1940s restoration of the *Coronation of the Virgin* for all the losses apart from the two vertical additions and the missing sections at the bottom of the outer panels. Henry Merritt, a nineteenth-century connoisseur and a participant in the 1853 Select Committee on restoration at the National Gallery, succinctly describes the objectives of invisible retouching: 'the artist proceeds to sketch and colour the parts to match those adjoining in form and colour, accomplishing this so accurately in tint and texture that the keenest eye may never after discover where the injuries have been.'[28] By today's standards a good deal of imitative restoration from previous centuries would be considered excessive, and there are well-documented instances, most notably during the mid-nineteenth century, where restorers indiscriminately repainted undamaged areas of paintings with little respect for the original in order to satisfy the sensibilities and tastes of their own particular age.[29] Attitudes have since changed, and there are now important differences between nineteenth- and twentieth-century practice. In general, nineteenth-century aesthetic concerns tended to concentrate almost exclusively on the painting as an image, disregarding the naturally occurring evidence of age, such as cracks, which were frequently concealed. By contrast, over the latter half of this century a more historically informed approach to restoration has evolved, giving greater consideration to paintings as aged objects as well as aesthetic images. The current aims of restoration, therefore, are to preserve many of the naturally occurring traces of time on paintings, by retaining the visible presence of craquelure and the inevitable fading and discoloration of certain colours, while at the same time re-establishing the legibility of the image. Imitative retouching attempts to satisfy both of these aims by ensuring that the viewer's attention is not distracted by damages or by the visible presence of the restoration.

In reality, however, successful deceptive retouching of large areas of loss can be difficult to accomplish. Extensively abraded passages, for example, are practically impossible to retouch in an invisible manner without the area appearing over-restored, and a compromise has to be reached between increasing definition of form and accepting some appearance of damage. The invisible reintegration of large areas of complete loss can also be problematic, not only because of the ethical issues involved, but also because it may be impossible to reproduce the spontaneity of the original paint handling. This may be due to the simple fact that the restorer cannot handle paint in the same way as the original artist, but the constraints imposed by most modern retouching media also play a part. This latter problem is more acute when dealing with later periods of oil painting where individual brushwork plays a more prominent role; the retouching of large losses in early Italian paintings such as the *Coronation of the Virgin* tends to be less difficult since the original finely hatched egg-tempera technique is more akin to modern retouching methods.

Visible restoration employing a so-called 'neutral' style of retouching has been carried out on several paintings in the National Gallery Collection where the damages were considered too extensive to attempt full reconstruction (Plate 2).[30] The uniform grey colour used in the 1940s restoration of the missing sections of the *Coronation of the Virgin* is one such example of this approach. The intention here was to apply a colour, normally over an untextured fill and similar to a dominant colour within the picture, but often paler in tone than the surrounding original so that the losses appeared to recede behind the picture plane. A variety of different types of 'neutral' restoration were first devised in Germany in the 1920s, and were in effect compromises between deceptive retouching and other proposals made at that time for leaving damages totally unrestored.[31]

Helmut Ruhemann, restorer at the National Gallery from 1934 to 1972, spent his early career working in Germany, and although an early advocate of neutral restoration his opinions on the subject changed. Writing in 1968 he commented: 'Retouching in a neutral tone is frequently recommended. This may appear to be a good idea, but in practice impossible; for, however grey a tinge may be in itself, the neighbouring or surrounding colour will give it, by contrast, a more colourful hue.'[32] Now little practised on easel paintings, this form of 'neutral' restoration is still widely employed for the reintegration of losses in wall paintings.

Retouching and Display

The question of how the missing sections should be dealt with was probably the most important and interesting aspect of the National Gallery restoration, and is certainly a fundamental issue in decisions behind the painting's current display. The Gallery had previously shown the altarpiece with fictive reconstructions for the missing sections on the edges, that is, the bottom strips of the outside sections and the central reliquary door, but the two missing vertical strips on either side of the central section were left unreconstructed and simply toned-in in what was intended to be a neutral and unobtrusive colour. This solution had the clear advantage of eliminating any doubt on the part of the viewer as to the general state of the actual work, but at a significant price – the legibility of the original image, its composition and the intended illusion of depth and recession were greatly compromised. The presentation of the vertical losses simply toned-in gave a very misleading impression of the original composition, implying the traditional tripartite organisation of many fourteenth- and fifteenth-century polyptychs, and disguising the effect of the original unified painted surface.[33] The intended sweep of the semicircle of angels around the throne was completely flattened by the unrestored vertical losses, greatly reducing the impact of the image. To suggest that original composition in the most recent restoration was therefore an important goal.

The reconstruction deemed necessary to regain the sense of the original required careful consideration. Although the ideal goal would be both to preserve paintings as historical objects and also to maintain the essence of their intended aesthetic content, finding the appropriate balance between these aims is a subtle and often contentious issue, with no single solution being correct for any one picture, much less for pictures in different sorts of physical condition. While some reconstructions are relatively straightforward, for example spanning a continuous simple form like a single drapery fold or regular tiled floor pattern across a loss, other damages require more invention on the part of the restorer. 'Invention' in a restoration context should be firmly grounded in study of the original artist's technique and style in other paintings or drawings – in other words it must start from a highly educated hypothesis. Most restorers therefore search for some sort of compromise where the compositional integrity of the original is restored, but in a way that gives the viewer information or visual clues that some of what is now visible is in fact restoration. This can be a fine balancing act,

Plate 6 Duccio, *The Transfiguration* (NG 1330), 1311. Panel, painted surface 44 × 46 cm. The missing section of the bottom central figure has been reconstructed no further than the underdrawing stage.

and different types of solutions have been used in different cases throughout the world and indeed within the Gallery. An intermediate solution between neutral toning and full reconstruction can be seen in the restoration of Duccio's *Transfiguration* (Plate 6). The damage to the central apostle was considered both too large to invent the complex missing drapery folds with enough certainty to do a full reconstruction, and also too spatially important to simply tone in a flat colour. The solution, carried out by Ruhemann in 1952, of developing a plausible reconstruction only so far as the drawing stage completes the composition, greatly reducing the visual disturbance of the loss, and still allows some understanding of the painting's condition.

The specific timing of the *Coronation* restoration project was also influenced by the fact that contemporaneously the Uffizi version of the *Coronation of the Virgin*, painted by Lorenzo Monaco in 1414, was being restored at the Opificio delle Pietre Dure e di Restauro in Florence. This provided invaluable opportunities for collaborative work between restorers and curators in London and Florence during the course of the respective campaigns.[34] Since one of the key concerns of the restoration was to rethink the way in which the altarpiece was presented as a whole, which in turn raised numerous issues concerning retouching and reconstruction relevant for both altarpieces, this kind of interaction was particularly useful.

Plate 7 Detail from *Adoring Saints* (NG 215).
An irregular line shows where the recent reconstruction of the missing bottom section joins the original.

Reintegration of the Altarpiece

Given the uniqueness of each reconstruction problem it is not surprising that ultimately an approach different from either the flat tones left in the earlier restoration of the *Coronation*, or the partially executed reconstruction of the National Gallery Duccio, was decided upon. The outside bottom strips were redone much as before, with the floor patterns and step reconstructed along the lines clearly suggested in the remaining sections, although with no attempt to simulate either the uneven surface or the crack pattern of the original. The actual horizontal dividing line between restoration and original is visible as the shadow made by the slight differences in level which has been reinforced with a faint dark painted line (Plate 7).

The vertical strips were also reconstructed to a very high degree, the decision to do so being based on several factors (Plate 8). First, the width of the losses could be precisely calculated because of the continuation of the exactly circular haloes across the missing span of the losses. Secondly, much of the required reconstruction demanded little more than linking compositional elements extant on either side of the loss across the missing section. Finally, where more invention was required, for instance in the details of physiognomy or hairstyle, it was possible to make reconstructions which were entirely plausible because of the numerous examples both within the *Coronation* panels themselves and in other paintings by Lorenzo. Another important aspect of the vertical strip reconstructions was the fact that they were not physically joined to the panel fragments themselves, but were painted directly onto the untextured dividing structural members of the modern frame.[35] This meant that the restoration could be taken to a highly finished and detailed level of reconstruction, imitating the original paint build-up and style of handling as closely as possible, but still leaving strong visual information that it was not original – such as the actual physical separation and the smooth and uncracked surface of the new restoration (Plate 9).

The reconstruction of the damage around the bottom central door required a slightly different approach. While the door incision was itself a perfectly symmetrical arch-top shape, the associated paint loss around its edges was jagged and irregular (Fig. 5), so that any attempt to provide a different surface texture or painted division line looked intrusive and distracting. The area of the damage itself, which cut irregularly into the main panel at just about eye level when the work was exhibited on its plinth and was therefore an area of great spatial and compositional significance, meant that a high level of finish was required in its restoration. Here the reconstruction was carried out on a surface which had been textured with raised cracks in imitation of the original surface (Plate 10). The figure of the angel, which is slightly different from the previous reconstruction in the disposition of its drapery and the inclusion of the foot, was more plausibly developed from a similar figure of the Annunciatory Gabriel in Lorenzo Monaco's Monte Oliveto Altarpiece (Fig. 6). Clues were still left, however, to indicate its status as restoration: the pattern of mordant gilding used to suggest embroidery on the blue fabric was not continued across the damage, although its regular symmetry meant that it would have been easy to do so. In general, however, the doorway reconstruction is less easily discernible than that of the vertical strips as a result of its imitative surface texture; this more visually integrated solution was considered appropriate given the central position of the damage and its intrusion into the main image (Plate 11). The censer held by the angel to the right of the organ-playing angel had been almost completely destroyed, with only fragments of its handle and chain remaining. The earlier reconstruction was therefore almost entirely conjectural, and there was no good existing evidence on which to base a feasible reconstruction (the base of the well-preserved censer depicted to the left of the central angel is entirely obscured by that angel's wings). Because the right censer was of no great importance in the larger aim of re-establishing the recession of the depicted compositional space, it was decided to leave it in its fragmentary state.

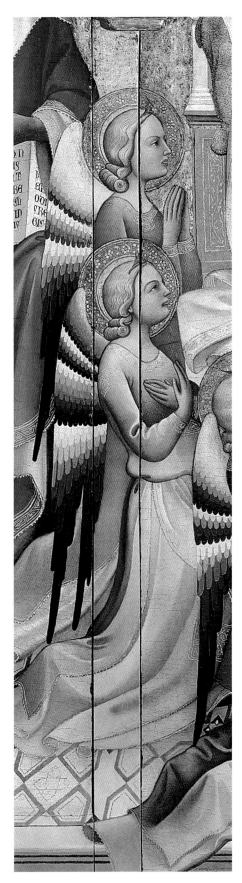
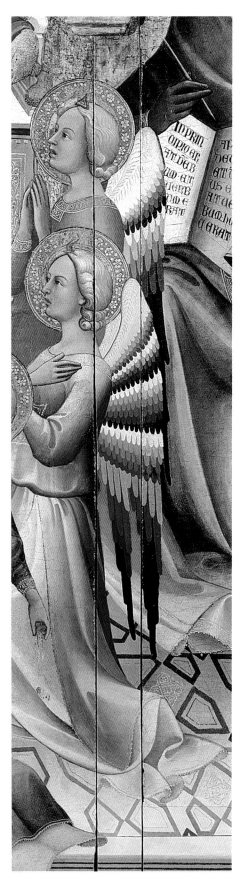

Plate 8 Details of reconstructions of the missing vertical sections between the outer and central panels, carried out on structural elements of the modern frame.

Plate 9 Raking light detail of the vertical reconstruction between NG 1897 and 216. No attempt has been made to imitate the surface texture of the original paint.

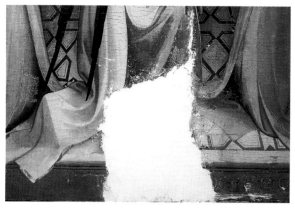

Fig. 5 Detail of the loss associated with the insertion of the central doorway. The loss has been filled and textured in imitation of the surface of the surrounding original paint.

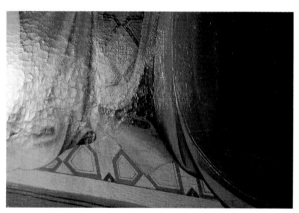

Plate 10 Raking light detail of retouching over textured fill for the central doorway loss.

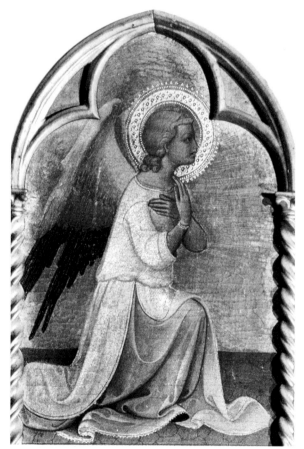

Fig. 6 Lorenzo Monaco, *Annunciatory Gabriel*, detail from the Monte Oliveto Altarpiece, 1407–10. Florence, Accademia.

Plate 11 Detail of the restored central doorway.

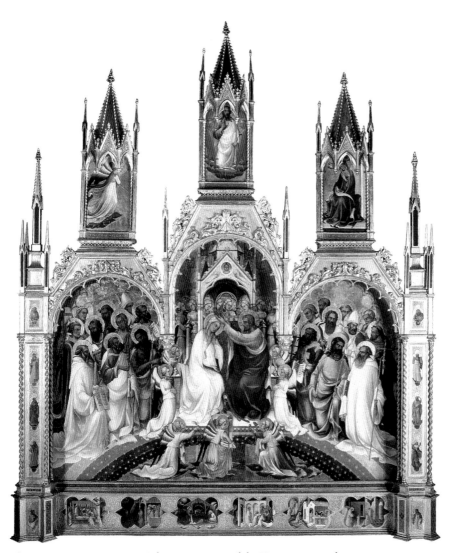

Plate 12 Lorenzo Monaco, *The Coronation of the Virgin*, 1414, after recent restoration. Panel. Florence, Galleria degli Uffizi.

In comparison with the National Gallery version the main panel of the Uffizi *Coronation of the Virgin* is in an excellent state of preservation, the only significant loss being in the area of the tabernacle door (Plate 12). The Florentine restorers were faced with a damage left by the replacement of the original door with another, somewhat larger, door which had itself been lost, leaving a large loss in the same location as that of the National Gallery panel. Notwithstanding a more conservative tradition regarding reconstruction in Florence, the restorers of the Uffizi *Coronation* opted for an approach which, although different in execution, had the same general aim: both to complete the composition and to make it identifiable as a reconstruction. They made a reconstruction of the musician angel on a separate board which was placed onto the original panel in an easily removable manner (Plate 13).[36] The reconstruction itself was painted in a very finely hatched technique best understood as a

practical evolution of a theory of visible retouching – the so-called chromatic selection and chromatic abstraction techniques – developed from the late 1960s by Umberto Baldini and Ornella Casazza.[37] In practice these retouching techniques, essentially consisting of finely hatched colours that are discernible as retouching upon close inspection but merge into a more integrated effect from normal viewing distance, are very close to the finely hatched egg-tempera technique of Lorenzo Monaco himself. It is interesting to note that the Opificio and the National Gallery reconstructions, each in some way the product of quite distinct restoration traditions, are in fact broadly similar in result; both sought to reintegrate a key missing compositional element in a restoration technique that is both highly deceptive in painting execution but at the same time readily discernible through differences in texture, structural separation, or other visual clues.

Plate 13 Detail of the reconstructed doorway of the Uffizi altarpiece.

Conclusion

The *Coronation of the Virgin* by Lorenzo Monaco in the National Gallery has, like most Renaissance altarpieces, suffered drastic changes to its appearance over the centuries. The cleaning and restoration of the altarpiece were undertaken to redress some of the damage. The solutions were arrived at after intensive discussion between curators and conservators, and consultation with colleagues, taking into account not only the evidence of the surviving parts of the altarpiece itself, but also contemporary altarpiece design, and the need to provide a coherent image without in anyway deceiving the viewer. It is important to note that the exact extent and nature of the work have been documented in detail during the course of the restoration, and the reconstructed areas have also been clearly signalled on the label in the Gallery, although it is intended that the National Gallery reconstructions are understood as such from the visual evidence of the painting itself. All materials used for the retouching have undergone rigorous scientific testing and several decades of accumulated collective empirical experience; all the evidence suggests that they will age well and remain stable.[38] That same testing and cumulative experience have also shown that the restoration can easily be removed in the future, for however strongly held the rationale behind the present work, the history of taste and aesthetics shows that it cannot be assumed that in future decades the present solution will weather aesthetically as well as it may be presumed to do physically. The resulting restoration is necessarily a compromise, since it will never be possible to recover the altarpiece as a whole. But it is a solution which it is hoped goes some way towards restoring to the viewer the glory of the original image while not compromising its integrity.

Acknowledgements

The authors would like to thank the team at the Opificio delle Pietre Dure at the Fortezza da Basso in Florence for their friendly collaboration and help, in particular Cecilia Frosinini, Patrizia Riitano, Maria Teresa Cianfanelli, and also Giorgio Bonsanti and Marco Ciatti for so enthusiastically encouraging not only this, but a number of other collaborative projects between the National Gallery and the Opificio.

Notes and References

1 D. Gordon and A. Thomas, 'A new document for the high altar-piece for S. Benedetto fuori della Porta Pinti, Florence', *Burlington Magazine*, 137, 1995, pp. 720–2, and D. Gordon, 'The altar-piece by Lorenzo Monaco in the National Gallery, London', ibid., pp.723–7. See also Martin Davies, *Catalogue of the Earlier Italian Schools*, 2nd edn. London 1961, reprinted 1986, pp. 305–2. A revision of this catalogue is currently in progress.

2 For the recent cleaning and restoration of the Uffizi altarpiece see eds. Marco Ciatti and Cecilia Frosinini, *Lorenzo Monaco. Tecnica e Restauro: L'Incoronazione della Vergine degli Uffizi. L'Annunciazione di Santa Trinita a Firenze*, Florence 1998.

3 M. Eisenberg, *Lorenzo Monaco*, Princeton University Press 1989, p. 166; W.F. Volbach, *Il Trecento. Firenze e Siena. Catalogo della Pinacoteca Vaticana*, II, Vatican City 1987, pp. 35–6, no. 40; C. Pietrangeli, A. De Strobel and F. Mancinelli, *La Pinacoteca Vaticana. Catalogo Guida*, Vatican City 1993, p. 17, no. 68.

4 Eisenberg 1989, cited in note 3, pp. 141 and 161–2; Maria Skubiszewska, *Italian Painting before 1600. Catalogue of the National Museum in Poznań Collection*, Poznań, 1995, vol. 4, pp. 128–34. Skubiszewska gives the provenance as the collection of Samuel Festetits, Vienna, before it was purchased by Atanazy Raczyński in 1863. It entered the Museum in 1903.

5 G. Pudelko, 'The stylistic development of Lorenzo Monaco', *Burlington Magazine*, 73, December 1938, p. 247. He wrongly stated that NG 215 and 216 were in the Liechtenstein Collection in Vienna; Eisenberg, cited in note 3, p. 158.

6 Eisenberg, cited in note 3, p. 141.

7 See L. Kanter in the exhibition catalogue, *Painting and Illumination in Early Renaissance Florence 1300-1450*, Metropolitan Museum of Art, New York 1994,

p. 260, and M. Boskovits, 'Su Don Lorenzo Monaco, pittore camaldolese', *Arte Cristiana*, LXXXII, 1994, p. 353 and Fig. 8. Eisenberg 1989, p. 198, does not accept the attribution of this panel to Lorenzo Monaco.

8 Kanter in his review of Eisenberg's monograph on Lorenzo Monaco cited in note 3 above, *Burlington Magazine*, 135, 1993, p. 633. For a discussion of these panels see Eisenberg pp. 151–3. In a letter dated 27 February 1995 Kanter adds to his catalogue entry the evidence of 'slivers of wood adhering to the backs of three of the panels,...vertical in grain, which would have been used to fix the patriarch panels to the subjacent panels.'

9 New York exhibition catalogue, 1994, cited in note 7, p. 261, no. 32b.

10 G. Vasari, *Le Vite* (ed. G. Milanesi), 1878, II, p.19 (not in the edition of 1550).

11 G. Farulli, *Istoria Cronologica del Nobile ed Antico Monastero degli Angioli di Firenze*, Lucca 1710, p. 286, and F. Masetti, *Teatro Storico del Sacro Eremo di Camaldoli*, Lucca 1723, p. 258 and p. 280. See also J.B. Mittarelli and A. Costadoni, *Annales Camaldulenses Ordinis Sancti Benedicti*, Venice 1762, Vol. II, p. 207; the union was confirmed in 1474 'ut congregatio nova fieret' (ibid., p. 291).

12 See *Annales Camaldulenses*, Vol. V, 1760, p. 395. According to Luca Landucci (ed. I. Del Badia), *Diario Fiorentino dal 1450 al 1516 di Luca Landucci. Continuato da un Anonimo fino al 1542*, 1883, pp. 309–10, the altarpiece of the *cappella maggiore* of San Benedetto had two holes made in it by lightning on 13 June 1511, but there is no evidence of this on the surviving parts of altarpiece, although there may have been on the lost sections.

13 Although A. Conti, 'Quadri Alluvionati 1333, 1557, 1966', *Paragone*, no. 215, 1968, p. 13, also saw evidence of flood damage in the craquelure of the predella panels.

14 Inventory of 1839, Cat. no. 15385; p. 93, no. 2283; and Sale Catalogue, *Galerie de Feu S.E. Le Cardinal Fesch*, designed for 22–25 March 1844, and taking place in Rome, March-April 1845, p. 242, lot 990–2283. It was bought together with NG 216 in 1848 (both as by Taddeo Gaddi). See D. Thiébaut, *Ajaccio, musée Fesch. Les Primitifs italiens. Inventaire des collections publiques françaises*, Paris 1987, pp. 5–43, and p. 182 for the inventories of 1839 and 1841.

15 Letter from William Coningham, 14 October 1848, in the Gallery archives.

16 Follini-Rastrelli, *Firenze Antica e Moderna*, IV, 1792, pp. 83–4. Caution is needed because of the tendency for guide books to copy each other.

17 The painting was seen in the Landi Collection by Crowe and Cavalcaselle (J.A. Crowe and G.B. Cavalcaselle, *A History of Painting in Italy*, I, 1864, p. 554) and was purchased shortly before 1900 from the Landi family by M. Galli-Dunn of Florence who sold it to the National Gallery.

18 Crowe and Cavalcaselle, ibid., p. 554. The association was denied by O. Sirén, *Don Lorenzo Monaco*, Strasbourg 1905, pp. 63–8, and by R. Van Marle, *The Development of the Italian Schools of Painting*, The Hague 1927, IX, p.164. See also Pudelko 1938, cited in note 5, pp. 247–8.

19 M. Davies, 'Lorenzo Monaco's "Coronation of the Virgin" in London', *Critica d'Arte*, XXIX, 1949, pp. 202–8.

20 According to the 1940s written record of the conservation dossier his medium was a combination of gum tempera (presumably egg tempera with gum arabic) and glazed with wax and dammar (presumably in a mixture).

21 Milanesi in Vasari, *Le Vite* (ed. Milanesi), 1878, II, pp.19–20, note 1, described it in 1830 as being 'in una cappella della già Badia Adelmi, poco distante dall'altra di Cerreto, ed una volta appartenuta anch'essa ai monaci camaldolensi di Firenze ... questa tavola è stata adatta ad un moderno ornamento ... colla Incoronazione della Vergine, accompagnata da soli tre angeli inginocchiati dinanzi a lei'; in the Le Monnier edition of Vasari, II, 1846, p. 211, note 1, in 1840, see p. 210, note 1.

22 The inscription was kindly confirmed by Mr Michael Kollod at the Graphische Sammlung who also provided the information that the volumes of drawings are inscribed by Ramboux with these dates. Ramboux also drew the Uffizi *Coronation of the Virgin* when it was in San Pietro, Cerreto (Cecchi in eds. Ciatti and Frosinini 1998, cited in note 2, p. 31 and Fig. 2).

23 Possibly a black Benedictine monastery. The links between the Camaldolese (who followed the Rule of Saint Benedict) and the black Benedictines were close, as demonstrated by the fact that the Abbey of Rosano was black Benedictine but subject to the Camaldolese San Giovanni Evangelista, Pratovecchio. See *Annales Camaldulenses*, Vol. IV, p. 196, and G. Raspini, *I Monasteri nella Diocesi di Fiesole*, Fiesole 1982, pp. 253–67.

24 As identified by Raymond White of the National Gallery Scientific Department using gas chromatography–mass spectrometry (GC–MS).

25 See eds. Ciatti and Frosinini 1998, cited in note 2, pp. 82–6.

26 The varnish was removed with mixtures of acetone and white spirit; a component of the 1940s retouching medium remained water soluble and therefore could be removed with saliva and acetone. For a study of some detailed aspects of the cleaning see R. White and A. Roy, 'GC–MS and SEM studies on the effects of solvent cleaning on Old Master paintings from the National Gallery, London', *Studies in Conservation*, 43, 3, 1998, pp.159–76, esp. pp. 167–9, 172–3.

27 For a full account of the composition and fading of Lorenzo's lakes see A. Burnstock, 'The Fading of the Virgin's Robe in Lorenzo Monaco's "Coronation of the Virgin"', *National Gallery Technical Bulletin*, 12, 1988, pp. 58–65, J. Kirby and R.White, 'The Identification of Red Lake Dyestuffs and a Discussion

of their Use', *National Gallery Technical Bulletin*, 17, 1996, pp. 56–80, esp. p. 70, and D. Saunders and J. Kirby, 'Light-induced Colour Changes in Red and Yellow Lake Pigments', *National Gallery Technical Bulletin*, 15, 1994, pp. 79–97, esp. p. 80. For an account of the technique of the construction and painting of the altarpiece see P. Ackroyd and L. Keith, 'The Restoration work on the National Gallery's *Coronation of the Virgin*', in eds. Ciatti and Frosinini 1998, cited in note 2, pp. 151–7.

28 H. Merritt, *Dirt and pictures separated, in the works of the old masters*, London 1854, p. 18.

29 For examples of the different nineteenth-century attitudes to restoration see J. Anderson, 'Layard and Morelli', *Austen Henry Layard Tra l'Oriente e Venezia* (*Atti del Simposio* a cura di F.M. Fales e B.J. Hickey), Venice 1987, pp. 109–37.

30 In 1952 Ruhemann carried out a 'neutral' restoration in a large damage through the central figure in Duccio's *Transfiguration* (NG 1311). In this restoration the missing parts of the figure were redrawn and the lost sections of the background, drapery, neck and hand were retouched in colours close to the original but lighter in tone. A number of other 'neutral' restorations have been carried out on paintings in the Gallery's Collection, for example, in 1972 the large losses in two panels by Ugolino di Nerio – *Isaiah* (NG 3376) and *Saints Simon and Thaddeus* (NG 3377) – were restored using unmodulated colours corresponding to the surrounding original (see D. Gordon and A. Reeve, 'Three newly-acquired panels from the altarpiece for Santa Croce by Ugolino di Nerio', *National Gallery Technical Bulletin*, 8, 1984, pp. 36–52). Similarly, in 1982 the damages along the bottom section of Duccio's *Annunciation* (NG 1139) were reintegrated with a uniform warm grey colour.

31 V. Bauer-Bolton, 'Sollen fehlende Stellen bei Gemälden ergänzt werden?' in *Verlag der Technische Mitteilungen für Malerei*, Munich 1914, and M. Von der Goltz, 'Is it useful to restore paintings? Aspects of a 1928 discussion on restoration in Germany and Austria', *Preprints to the ICOM Committee for Conservation, Twelfth Triennial Meeting*, Lyon 1999, pp. 200–5.

32 H. Ruhemann, *The cleaning of paintings: problems and potentialities*, London 1968, p. 257.

33 For a discussion of the unified picture surface in Florentine painting from the end of the fourteenth century see Eisenberg 1989, cited in note 3, pp. 122–3, and *idem*, *The 'Confraternity Altarpiece' by Mariotto di Nardo. The Coronation of the Virgin and the Life of Saint Stephen*, The National Museum of Western Art, Tokyo 1998, pp. 51–5.

34 See eds. Ciatti and Frosinini 1998, cited in note 2.

35 The reconstructed gilding of the missing halo and background sections was done by Isabella Kocum of the National Gallery Framing Department. The frame itself was constructed by Arthur Lucas in connection with the National Gallery 1940s restoration of the altarpiece. While the frame is misleading in many aspects of its design, most notably the curvature of the three upper sections, the difficulties associated with incorporating only some of the known predella panels and the ambiguity surrounding the design of the altarpiece's upper sections have meant that a more correct framing has not been introduced.

36 For a fuller account of the Florentine reconstruction see eds. Ciatti and Frosinini 1998, cited in note 2, pp. 68–9 and 114–15; for discussion and documentation of the original doorway see pp. 82–6.

37 At the Fortezza da Basso studio of the Opificio delle Pietre Dure e di Restauro in Florence a policy of deceptive retouching was applied prior to the 1960s. During a period of crisis caused by floods in the city in 1966 a more visible type of restoration was formulated by Umberto Baldini, Director of the Opificio delle Pietre Dure from 1970 to 1983, who provided the theoretical framework while his colleague Ornella Casazza devised the practical means of implementation. The Florentine approach owes much to the '*tratteggio*' method of visible retouching developed in Rome from the 1940s by Cesari Brandi, then Director of the Istituto Centrale, working closely with his colleagues Laura and Paolo Mora. '*Tratteggio*', now little practised outside Rome, is a rather rigid formula intended to reduce the opportunity for the conservator to make subjective decisions during the course of restoration. The method consists of vertically hatched brushstrokes of colour, applied over untextured fills that when seen at normal viewing distance blend into a coherent effect, thereby rendering the losses invisible, but on close inspection are immediately legible as additions. The visual effect is not unlike that achieved by pointillism. The Florentine methods of visible retouching for large losses, proposed by Casazza, can be seen as more flexible and often more finely worked adaptations of the '*tratteggio*' technique, employing a similar hatching method using a limited range of colours that optically mix to match the surrounding original at normal viewing distance. For further reading see U. Baldini, *Teoria del restauro e unità di metodologia*, Florence 1978; O. Casazza, *Il restauro pittorico nell'unità di metodologia*, Florence 1981; C. Brandi, *Teoria del restauro*, Rome 1963; and M. Ciatti, 'Cleaning and retouching: an analytical review,' *IIC Brussels Congress: Cleaning, Retouching and Coatings*, London 1990, p. 61. For a wider survey of historical attitudes toward the restoration of early Italian painting see C. Hoeniger, 'The Restoration of the Early Italian "Primitives" during the 20th Century: Valuing Art and Its Consequences', *Journal of the American Institute for Conservation*, 38, 2, 1999, pp. 144–61.

38 Retouching was carried out using dry powdered pigments and Paraloid B–72 resin. For a study of the resin's ageing characteristics see R.B. Feller, 'Standards in the evaluation of thermoplastic resins', *Preprints to the ICOM Committee for Conservation, Fourth Triennial Meeting*, Zagreb 1978, pp. 78/16/4/4.

The Restoration of Two Panels by Cima da Conegliano from the Wallace Collection

JILL DUNKERTON

IN AUGUST 1859, at the sale of the collection of the 2nd Baron Northwick, the National Gallery was prepared to pay up to £600 for a panel of *Saint Catherine of Alexandria* by Cima da Conegliano (Plate 1). The Gallery was, however, outbid by Samuel Mawson, acting for the 4th Marquis of Hertford, who secured the painting for 800 guineas.[1] In 1897, on the death of the widow of Sir Richard Wallace, the Wallace Collection, incorporating the Hertford pictures, was left to the Nation, the *Saint Catherine* eventually being assigned the first number in the catalogue of paintings.[2] Meanwhile the National Gallery had managed to acquire several works by Cima, among them the large altarpiece of the *Incredulity of Saint Thomas*, which underwent a long and complicated restoration in the 1970s and 1980s.[3] Although the Conservation Department of the National Gallery exists principally to care for paintings in the Collection, its facilities and accumulated experience – especially in the treatment of panel paintings – are a resource available, when necessary, to other national museums such as the Wallace Collection. Therefore in 1993 it was agreed that the *Saint Catherine*, together with its lunette, *The Virgin and Child with Saints Francis and Anthony of Padua*, also in the Wallace Collection, should be treated at the Gallery.

The *Saint Catherine* was originally at the centre of a triptych painted by Cima in about 1502 for the high altar of the Franciscan church of San Rocco at Mestre, on the Venetian mainland.[4] It was almost certainly commissioned by the Scuola di San Rocco, a devotional confraternity particularly concerned with the plague, and on either side of *Saint Catherine* were panels showing *Saint Sebastian* and *Saint Roch*, now in the Musée des Beaux-Arts, Strasbourg (Plate 9). Above was the arch-topped panel of *The Virgin and Child with Saints Francis and Anthony of Padua*. The altarpiece seems to have remained in place until at least 1726 when the Scuola di San Rocco obtained permission to build a new stone altar on condition that the old altarpiece be hung on a back wall behind the altar. By 1769 it had been moved to a side wall but plans were discussed for restoring it to its original position. Soon after, however, it was sold to John Strange, British Resident at Venice. It seems to have been replaced in the church by a copy, now in the Sacristy of the Duomo of San Lorenzo at Mestre (Fig. 1),[5] and it was probably also at about this time that an engraving of the four panels (Fig. 2) was made by Antonio Baratti (who died in 1787). They are shown in an elaborate rococo frame, surely the engraver's invention and no reflection as to how they might have been framed at the time. It can be assumed that the original frame, if it survived the various movements of the altarpiece, was left in the church. The church was suppressed in 1806 and the copy, which no longer has a frame, was probably transferred to the Duomo at this date.

In 1799 the entire altarpiece was included in the London sale of the Strange collection, and it was sold again in 1832. By 1846 it had been dismembered and the *Saint Catherine* alone was to be seen in Lord Northwick's collection at Thirlestone House, Cheltenham, where in 1854 it was admired by Gustav Waagen as 'noble and dignified in head and figure, and painted in the artist's best style of colouring and drapery'.[6] In 1857 it was included in the Manchester Art Treasures exhibition – Waagen was one of the organisers – and was among the paintings to be photographed.[7] The photographic print was evidently much retouched but it shows that already there were differences between the state of the painting by 1857 and the image that appears in Baratti's engraving. Most of the upper part of the picture had been lost, leaving only a few centimetres of the architrave of the ceiling of the loggia or canopy that covered the saint; the landscape at the lower left had been simplified, with no sign of the rocky outcrop and the buildings to be seen in the print.

By 1902, when another photograph of the *Saint Catherine* was published,[8] the upper edge had been trimmed further, leaving little more than a centimetre of paint from the architrave, the condition in which the painting survives today. It was, by then, displayed in a heavy and ornate gilt frame, typical of

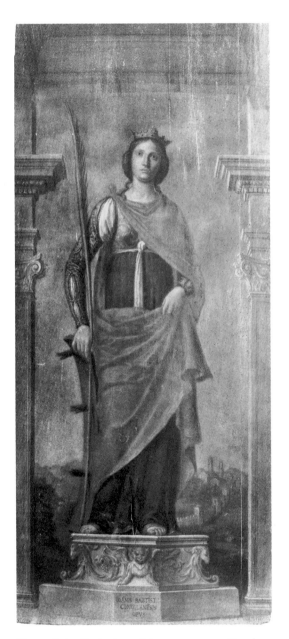

Plate 1 Giovanni Battista Cima da Conegliano, *Saint Catherine of Alexandria* and *The Virgin and Child with Saints Francis and Anthony of Padua, c.* 1502. Main panel, 153 × 77 cm; lunette, 40 cm × 81.3 cm. London, Wallace Collection. Before cleaning.

Fig. 1 *Saint Catherine,* 18th-century copy. Panel, 173 × 77 cm. Mestre, Duomo di San Lorenzo.

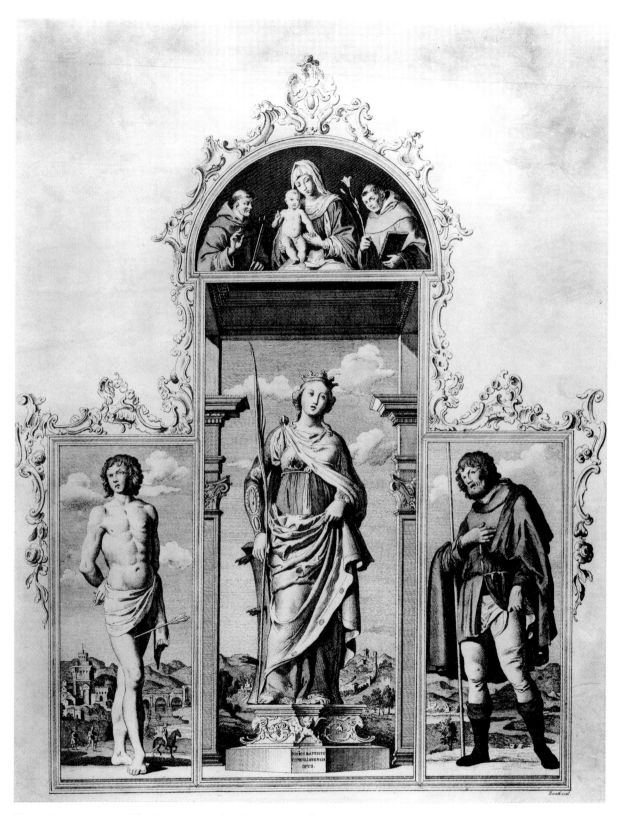

Fig. 2 Antonio Baratti, *The Mestre Altarpiece*, before 1787. Engraving.

those fitted by Sir Richard Wallace. In 1933 the lunette of *The Virgin and Child with Saints* was presented to the Wallace Collection,[9] reuniting it with the *Saint Catherine* after a century of separation. This necessitated the making of a new frame in a fifteenth-century Venetian style (Fig. 4).[10]

Much of the nineteenth-century restoration history of the *Saint Catherine*, including the cutting of the top and the repainting of the landscape on the left, can be reconstructed, and, after the establishment of the Wallace Collection, a record of its deteriorating condition was kept.[11] Probably in about 1896 the panel was planed down and cradled by William Morrill, whose stamp is on the cradle and who also frequently fitted cradles to paintings in the National Gallery. In 1924 the condition of the painting was causing concern. Vertical cracks in the panel, blisters, large areas of repaint and a 'heavy oil varnish ... degenerated into a dirty yellow tone' were all noted by the curator. In 1933, when it was about to be reframed, blisters were secured by Morrill, and some cleaning was carried out by William Holder, another restorer who worked regularly for the National Gallery. He seems to have removed some of the varnish and repaired any new losses, but he simply 'blended in' many of the old damages and repainting, including the landscape on the left. In 1946 blisters and discoloured restoration were observed. In 1962 an estimate was supplied by D.R. Vallance on behalf of W. Holder and Sons, 'to secure extensive blistering pigment, secure cracks in panel, slight clean, repair and varnish'. It is unclear whether this treatment was carried out, but, in any case, the same problems were again reported in 1976, when the general condition was described as 'poor' and the observation made that treatment to the paint and ground layers was of little value without treatment of the panel and, in particular, the removal of the cradle.

The panel, constructed from three vertical planks of poplar, had been planed to a thickness of no more than about 3 mm and a heavy mahogany cradle fitted. Many of the splits and cracks in the wood are likely to be old but others were clearly caused by the constriction of the cradle. Woodworm damage was considerable, especially in the left-hand plank. Restored and overpainted losses of paint and ground from this plank were extensive, the shape and distribution of the losses – revealed initially by X-radiography – confirming that huge blisters had formed and flaked off in the past. On the right side there were fewer losses, but many more blisters that needed to be secured. Panel paintings by Cima seem unusually prone to failure of adhesion between the support

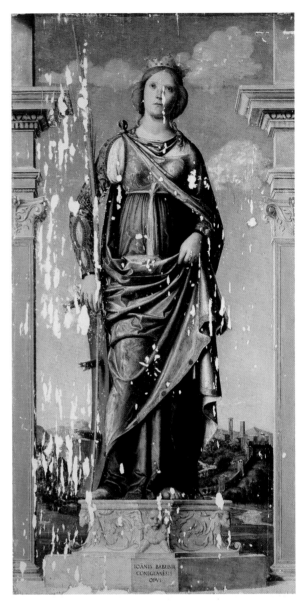

Plate 2 *Saint Catherine*, after cleaning, before restoration.

and the preparation, presumably because of defects in the composition or in the application of the layers of gesso and size.[12] Although the *Virgin and Child with Saints* had a different history in the later part of the nineteenth century, it too had been planed and cradled. It has not suffered from the same flaking as the main panel, but the original wood was under some tension and horizontal splits in the panel had been clumsily repaired.

As is the usual practice, both paintings were cleaned before structural treatment. The condition of the *Saint Catherine* varied considerably in different areas and colours (Plate 2). In general, the red and green draperies were found to be well preserved, retaining much of their original richness and intensity of colour. Flake losses were mostly relatively

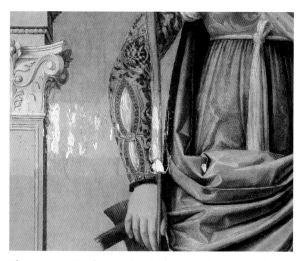

Plate 3 *Saint Catherine*, detail of the sky during cleaning.

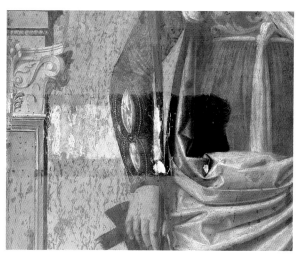

Plate 4 *Saint Catherine*, detail of the same area under ultra-violet illumination during cleaning.

small and widely scattered. Areas of flesh painting had suffered from abrasion, losing some of the fine detail and most of the translucent brown glazing in the shadows which is seen in better preserved paintings by Cima. A long chain of losses from blistering runs through the face of the saint, from the corner of her right eye, down the shadowed side of her nose and through to her chin; and most of the back of her right hand has been lost. Other large losses are in the pedestal and along the lower edge of the panel, but by far the worst affected areas are the sky and landscape on the left.

The varnish, which was fairly thin and only moderately discoloured, must have been applied in the restoration made by Holder in 1933 and could be removed without difficulty (Plate 3). The varnish also incorporated some retouchings, mainly over small losses or along ridges of raised paint. These had discoloured to a greenish colour and showed dark in infra-red and so they were probably executed using Prussian blue. The much older and harder repainting that had been scumbled over the entire sky was opaque and heavy in tone and of a slight purple hue. It was found to contain artificial ultramarine.[13] In ultra-violet light (Plate 4) it showed as dark, once the fluorescent varnish had been removed, whereas the original paint is light and reflective. The effect of this overpainting was to destroy the illusion of air and space behind the saint, an essential element of Cima's great altarpieces showing figures in a landscape setting, and still evident in the *Saint Catherine* despite its very damaged condition.

The same retouching paint, only much more thickly applied, covered the large losses in the sky. These had first been made level with a lead-white and oil mixture that also filled many of the losses in

Plate 5 *Saint Catherine*, detail of the landscape on the left during cleaning.

the overpainted landscape (Plate 5). Since the landscape had been repainted by 1857 it can be deduced that the panel must have flaked badly at some time before that date, but after the introduction of artificial ultramarine (first manufactured in 1828) and probably after the separation of the altarpiece, since there were no fillings of this type on the lunette panel. Instead, losses from this panel were filled with gesso or with coloured putties applied over areas of wood that had been scored with crosshatched lines to improve the adhesion. Some losses on the *Saint*

Catherine had also been treated in this way, and so these repairs would appear to date from an earlier campaign when the panels were still together, perhaps in the later part of the eighteenth century. The cleaning of the *Virgin and Child with Saints* was relatively straightforward (Plate 6). Since it had not been cleaned in 1933, the varnish was considerably more discoloured and contained a great deal of resinous retouching to disguise the damage and abrasion to the paint, in some areas so worn that little more than the underdrawing survives. The high finish to the restoration made the modelling of the figures, especially the two saints, appear hard and wooden, leading to suggestions of workshop participation.[14] However, removal of the retouching has revealed painting of great delicacy and sensitivity. Cima was surely responsible for the execution of the entire altarpiece.

Once the areas of blistering paint (Fig. 3) were free of the thick overpaint, they could be secured by introducing sturgeon glue and applying gentle pressure with an electrically heated spatula. This treatment was even more successful following removal of the cradle, since the panel was then able to adopt a convex warp, and was no longer causing compression of the paint and ground layers. Although the panel proved to be surprisingly robust once the splits and cracks had been joined, the extreme thinness of the remaining wood (no more than 3 mm) meant that the construction of an auxiliary support of balsa wood was necessary.[15] The lunette panel had also been planed down to a thickness of 3–4mm and so it too was reinforced in this way.

The restoration of the *Saint Catherine* (Plate 2) involved three main issues: the large losses caused by blistering and flaking; the severe abrasion to the paint of the sky, and, to a lesser extent, to areas of flesh painting and architectural detail; and, thirdly, the damage to the spatial construction caused by the cutting of the upper part of the panel. In general, the large losses did not present any particular difficulties as to how missing areas should be reconstructed. Little paint remains of the landscape on the left, but the surviving fragments indicate that the Baratti engraving is a reasonably faithful reproduction. By referring to this, and to landscapes in other paintings by Cima, it was possible to fill in the losses and to reintegrate the landscape to the extent that it now recedes behind the figure and architecture. It has deliberately been left a little blurred and indistinct in contrast to the well-preserved landscape on the other side.

The abraded condition of the paint of the sky was more problematic. The entire altarpiece, including

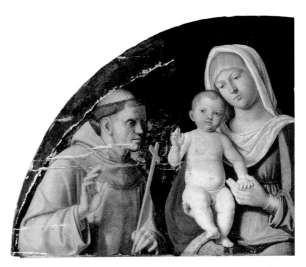

Plate 6 *The Virgin and Child with Saints Francis and Anthony of Padua*, detail during cleaning.

Fig. 3 *Saint Catherine*, detail of blisters photographed in raking light.

the side panels now in Strasbourg,[16] was evidently badly over-cleaned at some point, probably when it was still together in the original frame (discussed below). On the *Saint Catherine*, the modelling of the clouds is almost completely lost, leaving only cloud-shaped areas of the azurite blue that was employed as an overall underpainting for the sky.

Much of the final layer of ultramarine in the blue areas is missing;[17] it has survived undamaged only where it was protected by the mouldings of the frame. In retouching the sky thin glazes of ultramarine were

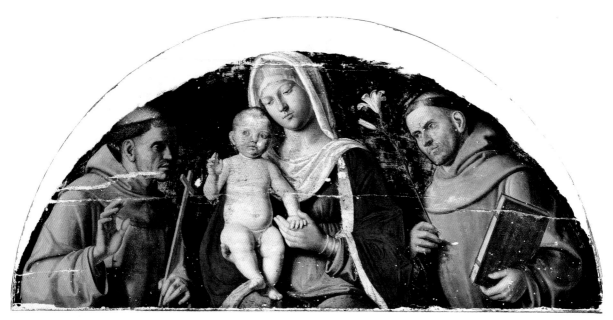

Plate 7 *The Virgin and Child with Saints Francis and Anthony of Padua*, after cleaning, before restoration.

applied more with the aim of reducing the unevenness rather than attempting to restore the colour to its presumed original density. It was considered important to retain the sense of space behind the figure gained by the removal of the heavy overpainting. In the case of the clouds, little more could be done other than to apply sufficient retouching to link the surviving patches of modelling and to indicate that they had once been clouds.

The large loss and the abrasions on the saint's face have been restored fully and the disturbing visibility of a pentimento in her eyes has been reduced. Most of the glazes on her draperies were in remarkably good condition, and retouching was necessary only to some abrasion of the thinnest glazes over the highlights of the green dress. In these lighter areas the green glazes have discoloured slightly, but in the shadows they have retained their original deep green colour. Areas of green drapery on paintings by Cima are often well preserved, and here, as elsewhere, they have been built up carefully with glazes of verdigris in oil over substantial underpaintings based on verdigris, lead-tin yellow and lead white.

The layer structure of the saint's red mantle (and the dress of the Virgin in the lunette) is also typically complex. The whole area was first blocked in with a bright opaque red, consisting principally of vermilion (with some red lake). Although covered by the upper paint layers, it is unlikely to represent a change of colour from a warm to a cool red. More probably it was intended to contribute to the final effect. Over this underpainting the highlights were modelled with

red lake and white and the shadows built up to a sumptuous intensity with multiple layers of red lake, the dyestuff identified as derived from kermes.[18] Kermes was the most expensive of the dyestuffs, and the ultramarine used for the picture is also likely to have been costly.

Unfortunately when ultramarine is used, as here, in an oil medium (identified as linseed oil)[19] and mixed with little or no lead white, it can degrade badly, resulting in a blanched and chalky appearance.[20] On the *Saint Catherine* the effect is most evident on the roundels decorating the border of the red cloak. In the shadowed folds the roundels were glazed with pure ultramarine, but the colour has become so blanched that they are now lighter in tone than the roundels painted over the highlights. To correct this reversal of the artist's intentions the roundels in the shadows have been slightly toned, but little could be done to the blanched ultramarine of the Virgin's mantle in the lunette (Plate 7). Except for a narrow strip along the lower edge, protected by the frame, the tonal variations in the modelling of the drapery folds are no longer apparent. In places the greenish blue colour of the azurite used to underpaint the ultramarine is now exposed. Since it gives some structure to the drapery folds it has not been suppressed by retouching. Scratch marks in the exposed gesso of the very damaged lining of the Virgin's mantle indicate that the paint was scraped off deliberately before repainting. The examination of a sample from one of the surviving fragments of orange paint identified the presence of realgar, a pig-

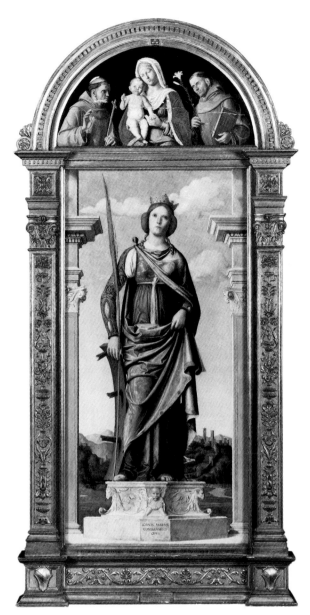

Fig. 4 *Saint Catherine of Alexandria* and *The Virgin and Child with Saints Francis and Anthony of Padua*, in the frame made in 1933 (photographed during restoration of the paintings).

Plate 8 *Saint Catherine*, detail of the upper right corner photographed in raking light, after cleaning, before restoration.

ment vulnerable to deterioration and damage, mixed probably with some earth pigment and perhaps a translucent brown.[21] On this evidence, the area of lining was re-glazed with an orange-brown colour, but no real attempt was made to suggest folds.

The final stage of the restoration was to consider the detrimental consequences of the cutting of the ceiling of the canopy or loggia above Saint Catherine. If the panels are positioned as they were in the frame made for them in 1933, the lunette is uncomfortably close to the top of the saint's head (Fig. 4). Furthermore, when looking at the upper part of the picture,

because of the absence of the receding orthogonals of the ceiling, the viewer tends to read the large projecting cornices of the painted architecture as being in front of the figure. Only when the eye travels down to the lower part of the image and locates the bases of the pilasters does it become apparent that they are supposed to be behind her. This makes the relationship between figure and architecture disconcertingly unstable.

Drawn lines and incisions into the gesso ground (Plate 8) indicate that originally the altarpiece had an architectural frame with pilasters, capitals and

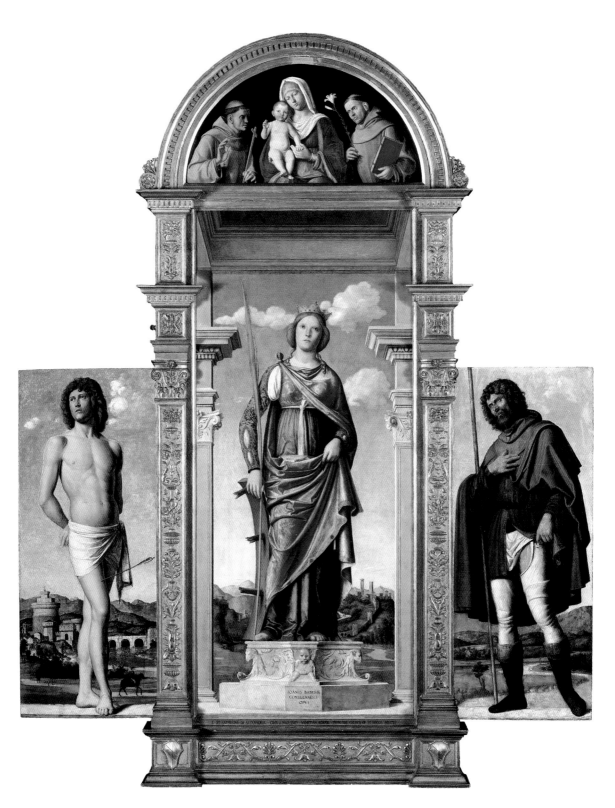

Plate 9 *Saint Catherine of Alexandria* and *The Virgin and Child with Saints Francis and Anthony of Padua* in the adapted frame. On the left (as a photomontage), *Saint Sebastian*, on the right, *Saint Roch*. Left panel 116.3 × 47.6 cm, right panel 116 × 47.2 cm, both Strasbourg, Musée des Beaux-Arts.

cornices of the same design and proportions as those of Cima's painted architecture. In fact the pilasters and entablature of the frame supply the front of the canopy that covers the saint. The ledge on which the Strasbourg saints stand is a continuation of the floor of Saint Catherine's loggia, but they are placed in the open air. These panels have not been cut down, as has sometimes been suggested,[22] and their upper edges must have been level with the mouldings immediately above the capitals of the lost frame (as indicated by the incisions into the panel). These mouldings would then have continued across to form the base of an entablature over the side compartments. The entablature was surmounted perhaps by carved volutes, vases or other such elements as can be seen on wooden and stone frames of the period.

Similarly, the lunette is likely to have been separated from the main panel by an entablature of the same width as the painted one – known from the eighteenth-century copy and the print. As is often the case with contemporary Venetian frames – and also buildings – the mouldings of the arch were not as wide as the pilasters and so the panel of the lunette is slightly wider than that of the *Saint Catherine*. A crescent-shaped area around the curved upper edge of the lunette was found to have been made up, the black paint overlying a greenish-blue coloured filling (Plate 6) applied to bare wood that had been scored in the same way as some of the flake losses on this and the main panel. It is possible that this area may once have contained a fictive stone arch, painted with the intention of pushing the figure group back into their space. A suggestion of such an arch appears on the copy at Mestre and a similar device was employed by Cima for the lunette of an altarpiece now in the Museo Civico at Feltre. However, no trace of paint from any arch has survived on the Wallace Collection picture and it was decided that the area should again be painted black.

Since both the frame and the lost ceiling had such an important function in defining the painted space, the possibility was considered of attempting a reconstruction of the missing area. Baratti's engraving had proved in other details to be reliable, and by placing a tracing taken from the Wallace panel over that in Mestre, it could be shown that the copy, although crude and clumsily painted, had been made from a careful tracing of the original painting.[23] More accurate measurements of the height of the entablature and ceiling could therefore be obtained than would have been possible by calculation from the print alone. Moreover, it was discovered that the frame made in 1933 could be adapted without great diffi-

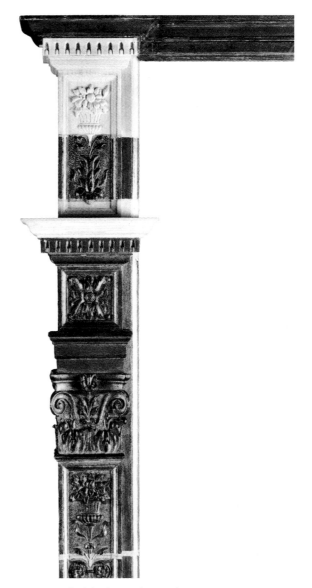

Fig. 5 Detail of the frame during alteration.

culty to accommodate the reconstruction and also to position the capitals and projecting cornices of the sides at exactly the same levels as those of the original frame (as indicated by the incisions into the gesso).

The proposal to replace the lost ceiling was made first to the Board of Trustees of the Wallace Collection and then to its Picture Conservation Panel, an international advisory panel comprising art historians, museum curators and conservators. Towards the end of the treatment, and before any alterations were made to the frame, the restored panels were returned temporarily to Hertford House, so that they could be tried in the position where they are to be displayed. The proposed alterations to the frame had been worked out by cutting and pasting actual size photographic prints and these were assembled around

the panels, allowing the Conservation Panel to judge and approve the likely outcome.

To adapt the frame a section needed to be cut out of each of the over-tall pilasters, but this could be relocated above the first projecting cornice (Fig. 5). The sides could then be completed with new pieces, copying the carved flower-filled urns from those at the tops of the pilasters and repeating the mouldings and dentils of the cornice.[24] The reconstruction of the ceiling is painted on a separate piece of gessoed wood, not attached physically to the original panel. The slight gap, and the fact that the new gesso has been left smooth, without any attempt to imitate craquelure, should make its modern origin evident.[25]

The restitution of the orthogonals means that there is no longer any confusion as to the saint's relationship with the architecture, and the alterations to the frame complete the illusion of a figure set in a defined space (Plate 9). As a result, the figure – in fact painted on a relatively small scale – gains in dignity and monumentality. The clarity of Cima's design enables it to command a vista in the same way that it must have done when it was still on the high altar of the church of San Rocco. It shares this distinction with the National Gallery's *Incredulity of Saint Thomas*.

Acknowledgements

In the early stages of the project the panels were under the curatorship of Richard Beresford. For an interim period following his departure they were in the care of Stephen Duffy, and then eventually Joanne Hedley. I am very grateful to them and to Rosalind Savill, Director of the Wallace Collection, both for their enthusiastic support and for their patience in the course of a long and complicated treatment.

Notes and References

1 Details concerning the acquisition of the painting by the Marquis of Hertford and its subsequent history at the Wallace Collection are taken from notes made by Richard Beresford from files held at the Wallace Collection.

2 Although there had been previous lists of the Collection they were unnumbered. The first proper catalogue was that made by the first Keeper, Sir Claude Phillips, and published in 1900.

3 See M. Wyld and J. Dunkerton, 'The Transfer of Cima's "The Incredulity of Saint Thomas"', *National Gallery Gallery Technical Bulletin*, 9, 1985, pp. 38–59, and J. Dunkerton and A. Roy, 'The Technique and Restoration of Cima's "The Incredulity of Saint Thomas"', *National Gallery Gallery Technical Bulletin*, 10, 1985, pp. 4–27.

4 For a summary of the early history of the altarpiece see P. Humfrey, *Cima da Conegliano*, Cambridge 1983, pp. 115–16.

5 See A. Perissa Torrini, 'Il Polittico del Duomo di Mestre', *Quaderni della Soprintendenza per i Beni Artistici e Storici di Venezia*, 19, 1994, pp. 131–3.

6 G. Waagen, *The Treasures of Art in Great Britain*, Vol. III, London 1854, p. 201.

7 The photograph, taken by Caldesi and Montecchi, was published as No. 88 in *Gems of the Art Treasures Exhibition, Manchester, 1857*, London and Manchester 1858.

8 A.G. Temple, *The Wallace Collection (Paintings) at Hertford House*, 1902.

9 It was presented by Mr and Mrs George Blumenthal of New York. Although the terms of Lady Wallace's Bequest stipulated that the Collection should be 'kept together, unmixed with other objects of art', the Trustees of the Collection accepted the lunette on the grounds that it was part of the same work as the *Saint Catherine*. The whereabouts of the lunette for most of the nineteenth century is not known. It reappeared in the Taylor sale of 1912, when it was bought by Langton Douglas.

10 The frame was supplied by the frame-maker Pierre Coulette, with funding provided by Lord Duveen.

11 This account of the more recent conservation history of the painting is based on notes made by Richard Beresford from files held at the Wallace Collection.

12 See Wyld and Dunkerton, cited in note 3, p. 51.

13 Scrapings from the layers of overpaint were examined for pigment identification by Ashok Roy. The different retouchings could also be distinguished in false colour infra-red photographs. The varnish and the retouchings assumed to be those applied by Holder in 1933 were readily soluble in acetone. The older, harder retouchings could be softened by the application of a solvent gel and then scraped off with the scalpel. The lead white fillings were often raised and lumpy, and tended to spread over original paint. Where necessary they were softened by repeated application of methylene chloride in a solvent gel and gradually scraped down.

14 See, for example Humfrey, cited in note 4, p. 116. The fact that Berenson, in 1916, believed that it was not fully autograph suggests that the heavy retouching was already present (see B. Berenson, *The Study and Criticism of Italian Art*, III, London 1916, pp. 200–1)

15 The blisters were secured by David Thomas, who also carried out the panel treatment with Anthony Reeve. The cradle was removed with chisels and saws in the normal way, and open and weak splits and cracks joined. The panel immediately took up a convex warp. Following moisture treatment to reduce the convex warp to an acceptable degree of curvature, the first stage was to attach an isolating layer of polyester fabric impregnated with 'Beva-371' heat-seal adhesive to the reverse of the panel. The 'Beva-371' was applied to the polyester only, the aim being to avoid any impregnation of the original wood. The isolating layer is present both to assist in the future reversibility of the treatment and to ensure that the panel is not impregnated with the

wax-resin used in the next stage of the process. The back of the panel was then built up with two layers of balsa-wood planks, embedded in wax-resin bulked up with sawdust. The planks of the first layer of balsa wood are laid running in the same direction as the grain of the original panel and those of the second layer run across the grain. To reduce further the strength of the balsa (already a soft and weak wood), cuts were made across the planks at regular intervals, the grooves extending to about half their thickness. To give protection to the back and edges of the auxiliary panel, a wax-impregnated canvas was then applied. For an account of the method, long in use at the National Gallery, but with various modifications introduced over the years, see A. Reeve, 'Structural Conservation of Panel Paintings at the National Gallery, London', *The Structural Conservation of Panel Paintings*, *Proceedings of a Symposium at the J. Paul Getty Museum 24–28 April 1995*, Los Angeles 1998, pp. 410–17. Following treatment, the panel has maintained its slight convex warp. Its condition would appear to be stable and should remain so, providing that it continues to be kept in a suitable environment.

16 The poor condition of the panels in Strasbourg has been thought to be a result of their having been in a fire at the museum in 1947. However, examination of the panels – made available by M. Jean-Louis Faure, Conservateur en Chef of the Musée des Beaux-Arts – confirms that they are in similar condition to the London panels. The lighter colours are equally abraded, also in places rubbed down to the underdrawing and gesso, and they would appear to have suffered from the same drastic cleaning, very probably with an abrasive substance.

17 This technique for painting skies features in many paintings by Cima. The thinness and translucency of the final layers of ultramarine give them a remarkable luminosity but also make them vulnerable to cleaning damage. Consequently the skies in many of his works now appear worn and patchy.

18 The dyestuff was identified by Jo Kirby using HPLC. Paint samples for pigment identification and for study as cross-sections were examined by Ashok Roy.

19 Samples for medium identification were analysed using GC–MS by Raymond White. A sample from a white or almost white area was found to contain linseed oil with no evidence for pre-polymerisation and brushmarks are clearly evident in the more bodied lighter colours, for example the architecture. The red lake and verdigris green glazes, however, contain partially heat-bodied linseed oil and have consequently dried with a smoother, more glassy finish. Although some pine resin was detected in the red lake sample, none was found in the green and so the glaze is not a so-called 'copper resinate'.

20 The precise causes of the blanching of natural ultramarine when used in an oil medium have not yet been established but it is known to be very vulnerable to acidic environments or possibly cleaning agents such as vinegar (acetic acid).

21 Realgar, highlighted with orpiment and glazed with a translucent brown pigment based on a softwood tar, occurs on the orange robe of Saint Peter in the National Gallery's *Incredulity of Saint Thomas* (see Dunkerton and Roy, cited in note 3, p. 17).

22 See Humfrey, cited in note 4, p. 115.

23 We are very grateful to Dr Annalisa Perissa Torini of the Soprintendenza per i beni artistici e storici di Venezia for arranging for Joanne Hedley and myself to have access to the copy of the polyptych.

24 The alterations to the frame were carried out by Clare Keller of the National Gallery Framing Department.

25 The reconstruction of missing sections of paintings on separate and clearly detached pieces of wood is a solution that has been used on several paintings in the National Gallery, most notably Pesellino's fragmented altarpiece of *The Trinity with Saints* reassembled in 1930, but missing the lower right section, or more recently *The Coronation of the Virgin* by Lorenzo Monaco discussed on pp. 43–57 of this *Bulletin*. The panel for the ceiling, which had to be shaped to follow the slight warp of the original panel, was made and prepared with gesso by Isabella Kocum of the Framing Department. The painting of the reconstruction and the restoration of Cima's panels were executed principally with pigments ground in 'Paraloid B-72'. Some final glazes, and especially the patination of the reconstruction, were applied using 'Gamblin' aldehyde resin colours. For the deepest red lake glazes on the cloak, the pigments were ground in 'Laropal K-80'. The preliminary and final varnishes were of 'Laropal K-80'.

The Discovery and Identification of an Original Varnish on a Panel by Carlo Crivelli

JILL DUNKERTON AND RAYMOND WHITE

THE *Dead Christ supported by Two Angels* (NG 602; Plate 1) was purchased by the National Gallery in 1859, the first of what was to become the largest group of paintings by Carlo Crivelli to be seen in any museum in the world. It came from the Roman dealer Cavaliere P. Vallati, who offered the Gallery the choice of several panels[1] from a partially dismembered polyptych, painted probably in the early to mid-1470s for the church of San Francesco at Montefiore dell'Aso, not far from Fermo.[2] In June 1859 Raffaelle Pinti, an Italian restorer resident in London who often worked for the National Gallery, was paid £10 for 'restoring' the picture.[3] The relatively modest sum and the short time between the

panel's arrival and the payment to the restorer indicate that this cannot have been a full cleaning and restoration. Moreover, the painting has suffered two very large losses requiring extensive reconstruction, including gilding. This was almost certainly carried out when it was on the market in Rome. The reconstruction of the missing areas was skilful, but with time the paints used in the restoration darkened – the consequences are most disturbing in the face of the angel on the right – and the nineteenth-century varnish lost its original transparency and became unevenly discoloured.

Inevitably the large losses presented certain difficulties during the recent cleaning and restoration of the painting,[4] but the treatment has also resulted in a notable discovery. When the painting was examined before cleaning under ultra-violet illumination a substantial layer of varnish with the expected greenish-yellow fluorescence of an aged natural resin varnish could be seen (a patch of this varnish remains immediately below Christ's hand in Plates 2 and 3). On top of it, and therefore showing as black, were several scattered retouchings. These were presumably those made by Pinti in 1859, and analysis indicated that they were executed in dammar, with the addition of a small amount of poppy oil. The varnish was not the usual mastic or dammar found on works restored at the National Gallery in the nineteenth century, but instead contained fir balsam, mixed with a little linseed oil and possibly some pine resin. It seems likely, therefore, to have been applied while the painting was still in Italy. Both varnish and retouchings were readily soluble and could easily be removed.

Underneath was another coating, barely discoloured and with a matt and slightly shrivelled surface. In ultra-violet this exhibits a very different fluorescence, of a warmer more orange-yellow colour. It is applied to the painted areas only, but around the contours the coating has spread a little onto the gilded background. This is most apparent under ultra-violet light, especially along the edge of Christ's torso. The coating must have been applied after the panel had been fitted into the frame since it

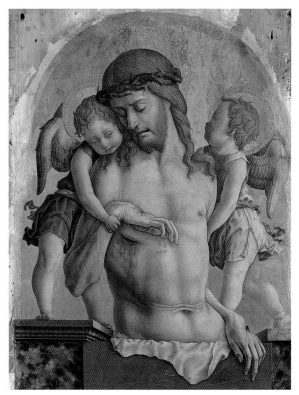

Plate 1 Carlo Crivelli, *The Dead Christ supported by Two Angels* (NG 602), *c*.1470–5. Panel, 75 × 59.5 cm, painted and gilded area 73 × 55 cm. Before cleaning.

70

Plates 2 and 3 *The Dead Christ supported by Two Angels*. Detail during cleaning, photographed in normal light, and under ultra-violet illumination.

does not cover a strip at the left edge of the parapet.[5] This gives an indication of the effect of the colour of the coating, although it is in fact notably thicker here than over other areas of the painting. In general it is of remarkably even thickness. Everywhere that the paint film is damaged so too is the coating: for example, the abrasions to the paint of Christ's forearm all show as dark in ultra-violet because the fluorescent coating is missing.[6] Conversely, where the coating fluoresces evenly, the paint film is immaculately preserved, above all in the beautifully painted head of the angel (Plate 4). The colours remain unfaded[7] and every last stroke of the finely hatched tempera paint is intact.[8] This, together with the fact that the coating has been applied to the painted areas only, exactly as specified by Cennino Cennini in his instructions on varnishing,[9] gave rise to the supposition that it might be the first varnish to have been applied to the painting, very probably in the fifteenth century, even if not necessarily by the artist himself.

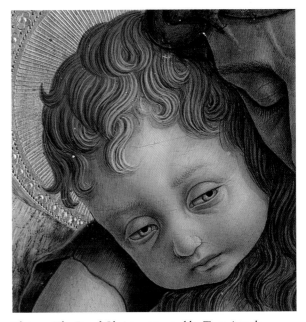

Plate 4 *The Dead Christ supported by Two Angels*. Detail after cleaning, before restoration.

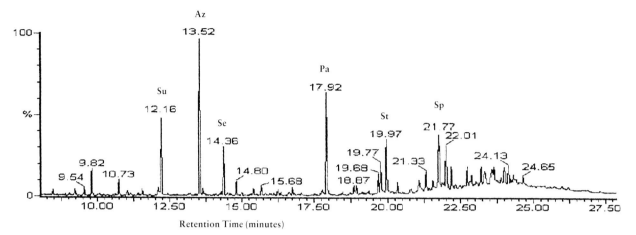

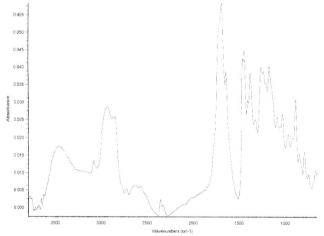

Fig. 1 Total ion chromatogram of original varnish, following thermolytic methylation (see text). Important components include: Su – dimethyl suberate; Az – dimethyl azelate; Se – dimethyl sebacate; Pa – methyl palmitate; St – methyl stearate; Sp – methyl sandaracopimarate. This pattern of components suggests the presence of a heat pre-polymerised walnut oil mixed with an (originally) sandaracopimaric acid-rich resin originating from trees that are members of the Cupressaceae. This family includes *Tetraclinis* as well as *Juniperus* spp. and both produce semi-hard resins, indistinguishable from one another in appearance and properties, which would be classified as sandarac resin.

Fig. 2 FTIR spectrum of glassy inclusions in original varnish layer, produced by use of a NicPlan infra-red microscope, employing a Reflachromat x32 infra-red cassegrain objective. Fourier Self-Deconvolution (FSD) has enhanced the spectrum in order to resolve partially overlapping infra-red absorption bands.

The Analysis

Given that most easel paintings of any antiquity have undergone many campaigns of cleaning, prior to the present century, it is rare to have the opportunity of examining an original or early varnish. In the past, abrasives such as powdered glass, sand or pumice, or solutions employing caustic alkali, would have had to be applied to many oleoresinous varnishes, during various campaigns of cleaning over previous centuries. So, having used the severest of cleaning regimes, it is hardly surprising that often little or no vestiges of the original varnish remain. Even when remnants do persist, it is difficult to obtain sufficient monomeric and characterisable organic material to be able to effect a satisfactory identification of the source of the resinous component.

On occasions trapped varnish remnants have been discovered and it has proven possible to undertake an analysis of the residues, with a successful outcome. Such a case was that of an early or original varnish, protected by fitments and revealed during conservation treatment, on a tempera panel attributed to Jacopo di Cione and his workshop, *Pentecost*

(NG 578). This was part of the high altarpiece of S. Pier Maggiore, Florence, begun in 1370. Gas chromatography, coupled to mass spectrometry (GC–MS), permitted the identification of the remains of a warm-toned, oleoresinous varnish as a mixture of heat-bodied linseed oil combined with a Cupressaceae resin, namely a sandarac-type resin as mentioned in fourteenth- and fifteenth-century varnish recipes.[10]

In the case of Carlo Crivelli's *The Dead Christ supported by Two Angels* (dated to about 1470–5), sampling was more restricted than in that of the panel from the S. Pier Maggiore altarpiece. The relatively recent varnish layer, sampled from the region of Christ's waist, exhibited some measure of yellowing. Almost certainly this represented an application of varnish, following cleaning, immediately prior to the work's entry into the Collection. Analysis by means of GC–MS, using the method reported earlier,[11] indicated that an oleoresinous varnish containing

Fig. 3 Total ion chromatogram of carbomethoxydrimane region of glassy inclusions pyrolytically methylated (see text), using a SGE Pyrolysis Unit (furnace type). The diagnostic carbomethoxydrimane fragments generated from the polymer of which these inclusions were predominantly composed are marked by the letters A, B and C. The corresponding electron impact spectra (70eV) are illustrated in Fig. 4 (A, B and C). These correspond to the drimane structures depicted in Fig. 5. The enantiomeric analogues (see Fig. 6), normally appearing approximately 0.6 minutes later – under the conditions employed here – were not detected. We may conclude that this material represents non-incorporated polycommunic acid-rich polymer from a sandarac resin, resulting from incomplete 'running' of the resin.

some linseed oil had been used. As mentioned above, the resinous components of this varnish appeared to be a fir balsam, possibly mixed with pine resin and an oleanonic acid-rich triterpenoid resin. Presumably this may have been some form of dammar-like resin. Curiously, though, other dammar components or degradation products – such as ocotillone-types or bisnordammarane keto-lactones – were not evident. There was no indication of the use of mastic resin.

Thermolytic methylation of a sample of the earlier varnish layer, situated directly above grey paint of a sash from the right-hand angel, of a greyish-yellow hue, was carried out using GC–MS. This study revealed the presence of a heat-bodied walnut oil with a resinous component, which exhibited a modest amount of a pimaradiene component, sandaracopimaric acid. This represents the residues of what must have been a sandaracopimaric acid-rich resin, when in a fresh state. In essence, it is reasonable to conclude that this varnish is composed of a Cupressaceae resin, combined with walnut oil, which had been heat-bodied. Careful examination of the chromatogram (Fig. 1) failed to provide any evidence for the presence of dehydroabietic or 7-oxodehydroabietic acids or any of their corresponding hydroxyl compounds. With this in mind, we may rule out the presence of the mixed pimaradiene-rich/abietadiene resins of the subfamily Araucariaceae. Such a resin would be typified by kauri copal from *Agathis australis* Salisbury, only available at the end of the eighteenth century, following the discovery of New Zealand; during the course of the nineteenth century, it was to become much favoured in the production of tough, durable varnish coatings. Moreover, the complete absence of residual traces of dicarboxylic labdanes, such as agathic and the *iso*agathic acids, argues against the inclusion of other copals from Araucariaceous sources, such as the Manila copals (*Agathis alba* (Rumphius) Warburg, otherwise known as *Agathis dammara* Richard).[12] Particularly worthy of note was the absence of diterpenoid labdanes of the enantiomeric series, which are normally the components of the hard copals from the African continent and the New World. Examples of resins from the former include East African or Zanzibar copals, known to have been traded in Europe by the Arabs from before the eleventh century, or those introduced to Europe within the last two hundred years, such as Congo copal and those of Accra and Sierra Leone. Such enantio-labdanes, too, are indicators for the use of both soft and hard South American resins, such as copaiba balsam (soft), from various *Copaifera* spp., and 'copal' from *Hymenaea courbaril* (hard).

Some glassy inclusions within the body of varnish are worthy of discussion. At first it was thought that some local and isolated clumps of these must represent the incorporation of sand or ground glass as an extender or bodying agent or, possibly, as a siccative agent. However, infra-red analysis of such particles unequivocally demonstrated their organic nature and the partially Fourier self-deconvoluted (FSD) spectrum (Fig. 2) compared favourably with that of a polycommunic acid polymer, such as that found in resins exuding from trees that are members of the

Fig. 4a

Fig. 4b

Fig. 4c

Figs. 4a, b and c Electron impact spectra of methylated drimane pyrolysis fragments at 70 eV, for components A, B and C marked in Fig. 3. The molecular ions are 236 Da (A), 250 Da (B) and 248 Da (C).

Fig. 5 Structural formulae of carbomethoxydrimanes resulting from 9/11 or 11/12 pyrolytic bond scission of the isoprenoid side chain of polycommunic acid polymers, of the type that may be encountered in sandarac resin.

Cupressaceae subfamily. Apart from some loss in intensity of the *c*.890 cm⁻¹ exocyclic- methylene band and an increase in overall carbonyl content, much as would be expected in an old sample, a polycommunic acid polymer basis seems most likely. This lends additional support to the principal evidence from GC–MS analysis of the residual monomeric indicators. These inclusions appear to result from ground sandarac resin that has not been sufficiently heated to cause scission of the polymer and decarboxylation

(so somewhat reducing polarity of the oligomers) to have permitted homogeneous incorporation of the resin particles with the walnut oil. This overall process is termed 'running' and usually involves careful, controlled heating of the resin alone, followed by the addition, with stirring, of hot drying oil. The latter may have already been heat pre-treated or may become heat-bodied during the overall process. Lack of careful control of the heating of the resin can result in resin fines, which end up in suspension and do

Fig. 6 Structural formulae of carbomethoxydrimanes resulting from 9/11 or 11/12 pyrolytic bond scission of the isoprenoid side chain of polyozic acid polymers, of the type that may be encountered in the hard copals from the Leguminosae trees. Examples include the African and South American copals.

not dissolve in the overall varnish mixture. Equally, excessive heating will result in partial charring or carbonisation of the resin, thereby resulting in a very dark varnish.

Confirmation of this conclusion was afforded by pyrolysis of a crudely separated clump of the glassy particles, in conjunction with *in situ* thermolytic methylation of any carboxylic acid-functionalised fragments so formed. To this end, the clumps of particles were assembled with the aid of a microscope and suspended in 2μL of a 5% methanolic solution of 3-(trifluoromethyl)phenyl trimethyl ammonium hydroxide. This suspension was taken up in a cleaned quartz pyrolysis capillary and pyrolysed at 400° Celsius in a SGE Pyrojector (a pyrolysis unit based on a furnace design), which was continuously flushed with helium gas maintained at a pressure of 8.8 psig above the column head pressure. The chromatogram obtained for this material is displayed in Fig. 3.

Peaks A, B and C were found to possess the spectra that appear in Fig. 4. From their retention times and spectra, we may identify them as carbomethoxylated drimane analogues as depicted in the corresponding sub-figure of Fig. 5. Most importantly, they may be characterised specifically as having a β-methyl substituent at position 10, relative to the plane of the ring. Clearly, they can only originate from the pyrolytic cleavage of either the 9,11 (favoured by the presence of residual allylic isoprenoid side-chains)[13] or the 11,12 bonds of labdane structures falling into the communic acid series, in other words, the sandarac type.[14] The latter series would exhibit β-methyl substituents at position 10

(that is, the ring A/B junction) and the corresponding β-isoprene side chain substituent at position 9.

By contrast, had the polymer been of the ozic or iso-ozic acid type – that is, of the *enantio*-series with both the 10-methyl and the 9-isoprene substituents having α-stereochemistry (with respect to the A/B ring plane) – drimane-related fragments, of the type appearing in Fig. 6, would have been anticipated. They would have been characteristic of the African and New World copals, for example. These enantiomers appear at positions with retention times increased by approximately 0.6 minutes in relation to the corresponding communic-derived analogues. That the polymer had some monomeric diterpenoid units incorporated is made clear by the appearance of small amounts of sandaracopimaric acid, liberated in the course of the thermal fragmentation process.

The fact that the sandarac and walnut oil varnish was probably not subjected to prolonged heat may account for its remarkably undiscoloured state. This would explain why it was never removed. Also it may be significant that the panel was on the upper tier of the altarpiece and therefore more inaccessible to early picture cleaners.[15] With increasing refinement of methods of analysis it has become possible to identify thin surface coatings on paintings with much greater precision than before. Nevertheless, the coating found on *The Dead Christ supported by Two Angels* is likely to remain an exceptionally rare example of a very early and, possibly, even 'original' varnish. Its importance is magnified by the fact that it has protected passages of some of the most consummate painting that Crivelli ever produced.[16]

Notes and References

1 When Otto Mündler saw the panel in Rome in May 1858 it was among Vallati's 'lately purchased' pictures by Carlo Crivelli. He noted that 'the execution is delicate; the colouring light in tone and harmonious: state of preservation excellent' (in this he was mistaken). He also commented on two panels from the main tier, the central *Virgin and Child* and the *Saint Francis* (both eventually acquired by the Musée des Beaux-Arts in Brussels) and a predella of Christ with seven apostles, then apparently still a single plank, but soon after cut up and dispersed as single panels. Two of these panels (see below) are now part of the National Trust collection at Upton House. See C. Togneri Dowd, ed., 'The Travel Diary of Otto Mündler', *The Walpole Society*, 55, 1985, p. 233.

2 Six panels from the polyptych remain at Montefiore, transferred to the church of Santa Lucia. For a reconstruction of the altarpiece see P. Zampetti, *Carlo Crivelli*, Florence 1986, pp. 116 and 265–70.

3 This was not recorded in the National Gallery Manuscript Catalogue and therefore not transcribed into the Conservation Record. The payment is among bills in Account Books in the National Gallery Archive. Payments relating to the conservation of paintings and frames have been transcribed by Sarah Perry and we are grateful to her for drawing our attention to them.

4 It is intended to publish an account of the restoration in a future issue of this *Bulletin*.

5 The panels still at Montefiore have retained elements of the original frame.

6 The crown of thorns, completed with oil-containing glazes of copper green, now very discoloured, appears dark under ultra-violet illumination. This is partly because of the effect of the green pigment, but it may be that the varnish did not cover this colour – it would already have been glossy because of the final glaze.

7 Two panels from the dismembered predella of the altarpiece that are now at Upton House, Banbury, have also been cleaned at the National Gallery. It was hoped that the original varnish might be present, but only traces survive, mainly around the contours of the figures and where it has extended onto the gilded backgrounds. There is evidence to suggest that the varnish was removed long before the nineteenth century (when the panels were also with Vallati) and, as a result, colours containing red lake have faded badly. Small areas that were protected by the original frame show that originally the colours were the same as those in the National Gallery panel.

8 GC–MS showed the medium of Christ's white loincloth and the red cloth draped over the parapet to be egg tempera alone. A sample from the dark green (now discoloured to brown) of the marbling contained a little walnut oil in addition to the egg. Since the sample was taken from the edge, which was protected by the frame from the coating, the walnut oil cannot represent contamination of the sample. A little walnut oil was also found with the egg in the dark green paint of the crown of thorns.

9 See Cennino d'Andrea Cennini, *The Craftsman's Handbook*, trans. by D.V. Thompson, Jr, Dover reprint, New York and London 1954, p. 99; and also J. Dunkerton, J. Kirby and R. White, 'Varnish and Early Italian Tempera Paintings', *Cleaning, Retouching and Coatings, Preprints of the Contributions to the Brussels Congress of the International Institute for Conservation*, ed. J. S. Mills and P. Smith, London 1990, 3–7 September 1990, pp. 63–9.

10 Dunkerton, Kirby and White, cited in note 9, pp. 63–9 for historical background, analytical details, discussion and a selection of recipes from the fifteenth century. See also D. Bomford, J. Dunkerton, D. Gordon and A. Roy, with a contribution from J. Kirby, *Art in the Making: Italian Painting Before 1400*, London 1989, pp. 182–5.

11 R. White and J. Pilc, 'Analyses of Paint Media', *National Gallery Technical Bulletin*, 17, 1996, pp. 91–103.

12 Manila copal produced by *Agathis alba* (Rumphius) Warburg, commonly known as the Amboyna Pitch tree, can vary in both colour and transparency and has been classified into three types. These were known by their local names as 'damars': *Damar Merah* (semi-fossilised, light to dark brown lumps from the ground); *Damar Batu* (or *Damar Puti*), pale, clean lumps; *Damar Poeteh*, fine resin collected by incision of the tree's bark.

13 P. W. Atkinson and W. D. Crow, 'Natural and Thermal Isomers of Methyl *trans-* Communate', *Tetrahedron*, 26, 1970, pp. 1935–41.

14 K. B. Anderson, R. E. Winans and R. E. Botto, 'The Nature and Fate of Natural Resins in the Geosphere – II. Identification, Classification and Nomenclature of Resinites', *Organic Geochemistry*, 18(6), 1992, pp. 829–41.

15 The panels that are still at Montefiore were cleaned many years ago by Alfio del Serra. The varnish removal that he carried out was only partial, but he remembers the paint surfaces as being exceptionally well preserved and thinks that they could well have retained some of the original surface coating (personal communication).

16 The fact that Crivelli placed his signature on this panel as well as more conventionally on the main panel of the *Virgin and Child* suggests that he recognised its exceptional quality. The signature, which is under the varnish, has often been doubted in the past (see, for example, Martin Davies, *National Gallery Catalogues, The Earlier Italian Schools*, London 1961, reprinted 1986, pp. 153–4).

Pollution and the National Gallery

DAVID SAUNDERS

London Pollution and the National Gallery in the Nineteenth Century

When the National Gallery was founded in 1824, London was already a polluted city, mainly because of the many coal-burning industries and utilities located within the city. Coal was not a new fuel, having supplanted wood as the major source for heating as early as the thirteenth century.[1] However, as London's population increased, so more 'sea coals' were transported from the north east of England to London to satisfy the need for domestic heating and to support industries, including dyeing, brewing and tanning. The diarist John Evelyn, in the mid-seventeenth century, also blamed 'Lime-burners, Salt and Sope-boylers' in his *Fumifugium*.[2] This book, subtitled *The Inconvenience of the Aer and Smoake of London Dissipated*, was presented to Charles II in 1661; it described the ill effects of smoke ('that Hellish and dismall Cloud of SEA-COALE'[3]) on buildings, furnishings and paintings, suggested the use of fuels that generated less smoke and proposed that obnoxious industries be relocated to a site some miles east of London, where the prevailing winds would carry smoke away from the city.[4] This site may well correspond to the promontory at Greenwich, at present occupied by the Millennium dome. Throughout the eighteenth century, increased industrialisation, notably the introduction of steam engines in the latter part of the century, contributed to London's reputation as a smoky city, although, compared to the industrial cities of the North, its pollution was relatively mild.

The period in the 1820s during which the National Gallery was established coincided with the earliest moves to introduce modern smoke-abatement legislation. The MP for Durham, M.A. Taylor, introduced a bill that required furnaces to consume their own smoke, but like later legislation, it was weak and poorly enforced, having little effect on the level of pollution.[5]

By 1839, when the Trustees' attention was drawn to 'the heat & foulness of the air in the rooms',[6] the National Gallery had moved from its original site in Pall Mall to Trafalgar Square. The same correspondent, a Mr Joseph Hume, complained again in 1842 of the 'want of sufficient ventilation in the Galleries'[7] and drew the attention of the Trustees to the *Report of the Select Committee of the House of Commons on National Monuments and Works of Art* of June 1841, evidence to which had described the Gallery as 'wretchedly ventilated'.[8] It is clear that the Trustees of this period wished, on the one hand, to ensure adequate ventilation, while expressing concern over the amount of dust and smoke admitted to the rooms through open skylights. In 1847 the Keeper, Charles Eastlake, 'stated to the Trustees that he has found it necessary to cause the floors of the Gallery to be watered occasionally to lay the dust that conduces so much to disfigure the frames of the pictures – and that he has employed the Stoker for this purpose – and recommends to the Trustees a small remuneration to him for his additional labour'.[9]

Meanwhile, during the early 1840s a Committee to enquire into the *Means and Expediency of preventing the Nuisance of Smoke arising from Fires and Furnaces* gathered information from scientists, including Michael Faraday. However, two early smoke-abatement bills were defeated in the House of Commons and although the 1846 Public Health Bill incorporated a clause on the prevention of smoke, further smoke-abatement bills in the 1840s fell or were withdrawn.

Faraday was also a member of a number of Select Committees looking at the problem of smoke and pollution in the context of the National Gallery. In his evidence to the *Select Committee on the National Gallery* in 1850, he describes the different types of pollutant 'that can exist in the atmosphere of a great city like London', mentioning 'both the inorganic fumes from chimneys and the organic miasma from the crowds that are in the town'.[10] Faraday also differentiated between sulphuretted gases that emanated from the sewers and 'animal exhalations and the perspiration' and 'the sulphurous acid which is directly in the atmosphere

Fig. 1 Aerial view of London from the *London News*, 1861; note the surrounding chimneys and the steam boats on the Thames.

[that] proceeds to a very large extent, from the coal burnt in London'.[11] Both Faraday and Thomas Uwins, the Gallery's Keeper, describe the blackening of lead white by sulphuretted hydrogen (hydrogen sulphide).[12] Faraday also described the effect sulphurous acid (produced by combination of the sulphur dioxide and water generated during the combustion of coal) had on a 'copper apparatus' at the Athenaeum club-house, producing a 'large body of sulphate of copper'.[13]

One of the questions examined by the 1850 Select Committee was whether the Gallery might experience less pollution were it to be sited away from the centre of the metropolis where it was in the 'vicinity of several large chimneys, particularly that of the Baths and Washhouses ... and that part of the Thames to which there is constant resort of steamboats'[14] (see Fig. 1). Faraday thought that wherever the Gallery was sited near the centre of London, smoke would carry towards it on the wind. However, because of the 'prevalence of westerly winds' he thought it would be best if the Gallery were sited at 'a point to the westward of which there was no coal burning'.[15] Although the Committee were 'not prepared to state that the preservation of the pictures

and convenient access for the purpose of study and the improvement of taste would not be better secured in a Gallery further removed from the smoke and dust of London' they did not 'positively recommend its removal elsewhere' as they were 'in ignorance of the site that might be selected', which might offer no benefit over the current site and involve considerable expense.[16]

As a means of temporary preservation, the Committee recommended that 'pictures of a moderate size should be covered with glass, and that the backs of all pictures should be carefully protected; provided always that such measures of protection should be adopted with the utmost caution and under the immediate direction and control of practical men' and that 'increased attention should be paid to . . . the ventilation of the Gallery'.[17] In response, the Trustees, meeting in February 1851, 'requested Sir C.L. Eastlake and Mr Russell to examine the pictures in this Gallery, at their earliest convenience, in order to ascertain which of them especially require protection by means of glass'(see Fig. 2).[18]

Over the next decade paintings were glazed and the backs protected from dust; for example, 'During the year [1856], 86 pictures, including 34 by Turner,

Fig. 2 Paintings leaning against the walls of the 'new rooms' in 1876; from the reflections it is clear that the paintings have been glazed.

have been protected so as to exclude dust from the backs. The material at present used for this purpose is glazed brown holland, the glazed surface being outside . . . it is proposed that on all occasions when pictures not previously so treated are moved, . . . the backs of the pictures should be protected in the same or some other effectual mode.'[19] By April 1860 the Director was able to report that 'with the exception of one picture, on wood – the Orcagna No. 569, the frame of which does not admit of a canvas being attached to it – all the pictures and drawings in the National Collection, whether in Trafalgar-square or at South Kensington, are protected at the back'.[20]

The choice of backing material had been the subject of considerable research: 'After many experiments with a view to select a light, impervious, and sufficiently incombustible substance to protect the backs of pictures (experiments in which great assistance has been rendered at various times by Professor Faraday, Mr. Barlow, and Mr. Warren de la Rue) the least objectionable substance for the purpose has been found to be canvass [sic] prepared in the ordinary way for painting, the primed or painted surface being outside ... The system will be adopted with all future acquisitions.'[21] This material was preferred

to glazed brown holland, 'patent parchment, at first used for the backs of some small pictures', but which was found to 'contract and break'[22] and tin foil, which was an early suggestion by Faraday.[23]

In 1857, the *National Gallery Site Commission* reconsidered other possible sites for a new National Gallery building, including the British Museum site, two sites at Kensington and Regent's Park, but 'found our choice, in fact, limited to two sites, the site of the present National Gallery, sufficiently enlarged, and the Kensington Gore Estate'. They concluded that although the site at Trafalgar Square was inferior to that at Kensington in terms of 'atmospheric impurities', the former site was 'incontestably more accessible – more in the way of all classes, and, from long usage, more familiar to them, than any position in the outskirts of the metropolis'. They again recommended a 'more general protection of the pictures by glass, which is strongly recommended by some of our more competent witnesses' and hoped that 'recent legislation, which has done much to purify the metropolitan atmosphere, and may do more, would probably much improve its present condition'.[24]

But progress with smoke abatement in the latter part of the nineteenth century was not as fast as had been expected and, although less smoke may have been produced as a result of more efficient furnaces and chimneys, there was no effective monitoring of the level of smoke to define this decrease. Perhaps because of the increased frequency and thickness of fogs during this period, the smoke and pollution seemed to be getting worse.

The Gallery continued to face a dilemma: if the skylights were closed to exclude dust and smoke, the air in the poorly ventilated rooms rapidly became foul and over heated; 'all endeavours to exclude the smoke which sometimes abounds in the vicinity, are counteracted by the necessity of keeping the sky-lights open when the rooms are crowded.'[25] The situation became worse when it became evident that the new galleries designed by Barry in the 1870s were particularly prone to poor ventilation. Although there were concerns about the effect of gases, particularly 'sulphuretted hydrogen' (H_2S) in the foul air, more potentially damaging was the desiccating effect of overheated air on panel paintings. Mr Bentley, a restorer used by the Gallery, reported '. . . that the panel pictures of the National Gallery had suffered very considerably since their removal to the new rooms; that he attributed this deterioration to the over heated atmosphere and to foul air arising from bad ventilation; that the damage to the pictures had diminished

in consequence of the measures taken to improve the condition of the atmosphere, but had not ceased.'[26] One such improvement, instigated by the then Director, Sir Frederic Burton, to counteract blistering, was 'that towards the close of last winter he had ordered zinc troughs filled with water to be laid down under some of the gratings in the floor over the hot air outlets with the view of moistening the hot air'.[27]

Although all the paintings were backed by the end of the 1860, routine dusting of the painted surface, or its covering glass, and of the frames and backs was still required. As early as 1852 William Russell informed the Trustees that 'The constant deposit from atmospheric and other sources ... leads to a dull appearance in the pictures which amounts to a denial of enjoyment of them to the public' and went on to suggest they 'authorize the allowance of a proper remuneration to Mr Seguier for attending from time to time to keep the pictures, by the timely & proper use of the silk handkerchief, in a sufficient state of cleanness so that they may be fairly seen by the Public'.[28] Other methods used to dust or clean the paintings included dry or moist cotton,[29] 'soft full feather brushes'[30] or a combination of materials. 'The pictures in Trafalgar Square, and at South Kensington have been carefully wiped and polished with cotton and a silk handkerchief ... and in some few cases sponged also, previous to polishing.'[31]

Cleaning the surfaces of the painting was not to be repeated unnecessarily and should be 'undertaken only by the person employed by the Director', while 'The Keeper will see that the glasses by which some of the pictures are protected are cleansed as often as may be necessary'.[32] It was recommended in 1862 that 'the senior assistant porter, at Trafalgar Square, should have ordinary charge of the frames of pictures to keep them well dusted'.[33]

The annual Gallery closure, or vacation, allowed dust to be swept from the cornices and walls, but it was not until after Sir William Gregory had 'called attention to the risk of injury to which the pictures in the Gallery were exposed from being unprotected by any covering ... during the annual cleaning' in 1879[34] that steps were taken to protect the paintings during this operation, the Trustees resolving that 'it is expedient that the pictures in the National Gallery should be covered with brown holland or some such material during the annual cleaning'.[35] This practice seems to have been adopted, but not before a bureaucratic wrangle between the Gallery and Her Majesty's Office of Works, after the latter declined to supply the required materials.[36]

THE NATIONAL GALLERY AND ITS NEIGHBOURS: VIEW SHOWING THE DANGEROUS POSITION OF THE BUILDINGS IN THE EVENT OF AN OUTBREAK OF FIRE.

Fig. 3 Illustration of the Gallery roof from the *Daily Graphic*, 6 June 1895, p. 968.

By the turn of the century the Gallery had settled on a regime based on protecting the fronts and backs of paintings whenever possible, regular dusting[37] and improved ventilation.[38] Despite the unremitting emission of smoke in the vicinity of the Gallery (see Fig. 3) no attempts had been made to filter the air by, for example, 'passing [it] through a layer of loosely packed carded cotton' as recommended by Church in his book *The Chemistry of Paint and Paintings*, first published in 1890.[39]

The Effect of Pollution on Paintings
Smoke and dust (particles)

The soiling of buildings and their contents by smoke and dust has been known for many centuries. Evelyn described how 'this horrid Smoake ... obscures our Churches ... fouls our Clothes, and ... spreads a Yellow upon our choycest Pictures and Hangings'.[40] The soiling of paintings can be much reduced by glazing or backing the frames, and varnished paintings can often be cleaned to remove the dirt accreted to, or absorbed by, the protective layer. It is far more difficult, however, to clean unvarnished paintings, or works on paper.[41] In the nineteenth century lack of any means of preventing dust and smoke from entering the Gallery meant that objects that would be irreversibly damaged were generally not displayed. In 1841, there was some discussion as to whether the Raphael cartoons should be transferred to the metropolis for display at the Gallery, an idea rejected by the Keeper, William Seguier, who stated that the cartoons would be 'destroyed in a very few years ... by the smoke of London' because 'they are watercolour, and of course when the smoke has fallen upon them there is no means of removing it'.[42] Ruskin later proposed that Turner drawings be stored in cases for their protection against dust and light and only exposed to the light infrequently,[43] a process that was taken one step further when the Victoria and Albert Museum placed a painting by Turner in a sealed case from which the air had been evacuated.[44]

Apart from soiling, particles can also instigate chemical reactions. Although smoke is primarily elemental carbon, unburnt residues of organic compounds can be present. Descriptions of smogs in nineteenth- and twentieth-century London describe them as containing oily or greasy particles and of various colours from chocolate brown to yellow; at the turn of the century, Church refers to 'the solid and liquid particles suspended in yellow fog'.[45]

Some particles contain metals, for example iron or lead, although the latter is primarily a twentieth-century problem caused by lead additives to motor fuels, and its level has been much reduced by the introduction of unleaded petrol. Iron, however, is often present in particulate matter (see later section) and has been implicated in the catalytic oxidation of sulphur dioxide (SO_2) to the potentially much more damaging sulphur trioxide (SO_3). When SO_2 or SO_3 dissolve in moisture in the air or water on the surface of the object they produce sulphurous or sulphuric acid respectively, which can be extremely deleterious. Dust may also contain traces of other metals that, theoretically, have the ability to catalyse reactions on the surface of objects, particularly in the presence of water or water vapour, but there is little evidence that these processes play a significant role in deterioration of paintings. Alkaline particles, frequently associated with concrete or cement dust, have been identified as a potential hazard to dyes, silk and certain pigments.[46]

Gaseous pollutants
Reduced sulphur gases

Early reports of the effect of gaseous pollutants stress the effect of miasmata or organic emanations from people or animals, including those associated with poor public hygiene. Experiments with painting materials in the nineteenth century tended to concentrate on the effect of such vapours, so it is no surprise that Field's experiments during the first quarter of the century involved exposing a sample '*to the foul air* by suspending it beneath the seat of a privy'.[47] Although many of the pigments he examined were affected by light, only iodine scarlet (mercury iodide) and lead-containing pigments were changed by the 'foul air'; the latter were blackened by 'exposure to the mephitis of a jakes'.[48] The principal contaminant in these *emanations* was presumably hydrogen sulphide, although other reduced sulphur gases, such as carbonyl sulphide, may also have been present. These species react with certain metals or metal compounds to create black or dark-coloured sulphides; the darkening of paintings associated with the formation of lead sulphide was noted in a number of nineteenth-century sources.[49] Church cautioned that such pollution in galleries might arise because the air used to ventilate the rooms was taken from gratings 'on the level of the ground, in out-of-the-way and dirty corners, and certain depositories of uncertain rubbish. From such sources air laden with organic and inorganic impurities alone can come'.[50]

Sulphur dioxide

Until the introduction of clean air legislation in the second half of the twentieth century, the most common gaseous pollutant in London was undoubtedly sulphur dioxide. This arises from the burning of coal with a significant sulphur content; coal produced in Britain has an average sulphur content of about 1.6% but, historically, had a higher proportion of sulphur, as less care was taken to select good-quality fuel for mining. The sulphur is present both as organosulphur compounds and as inorganic sulphides, notably pyrites (FeS_2). Sulphur dioxide (SO_2) is readily soluble in water to give sulphurous acid (H_2SO_3) and, on oxidation, sulphuric acid (H_2SO_4); it is these acids that are largely responsible for the deleterious effects of SO_2.

Another concern in the late nineteenth century and early twentieth century was whether gas lighting ought to be introduced at the National Gallery. Quite apart from the fire risk, was the fear that the gas, or its combustion products, might be damaging. Church summarised the potential dangers: 'Gas, before and after burning, is bad for pictures. The evil effects of an occasional escape of unburnt gas are less to be dreaded than those caused by the products of gaseous combustion. These products are sulphuric acid, sulphurous acid, carbonic acid and the moisture, which is formed at the same time. Thence results a hot, moist atmosphere laden with these corrosive compounds.'[51]

Buildings are attacked by sulphur dioxide, particularly those that are constructed from limestone (calcium carbonate), which is converted to calcium sulphate by prolonged exposure to acidic conditions. The crust of calcium sulphate formed on damaged buildings is often black, as its formation is accompanied by smoke deposition (see Fig. 4). A similar problem affects wall paintings, many of which are executed on a chalk-based substrate. Conversion of the chalk (calcium carbonate) to calcium sulphate causes a change in volume, which can cause surface disruptions ranging from the appearance of small 'pustules' on the surface to severe delamination.

Metals can also be damaged by sulphur dioxide; by 1912, an iron girder in Charing Cross station (a few hundred metres distant from the National Gallery) was found to contain around 9% iron sulphate when

Fig. 4 The smoke-blackened façade of the National Gallery, *c.*1900.

it collapsed after long exposure to smoke from coal-fired railway engines.[52] As we have already seen, Faraday recognised the role of the sulphur acids generated by burning coal in the conversion of copper to copper sulphate.[53]

Faraday had also called attention to the deterioration of leather armchairs at the Athenaeum Club,[54] a process attributed to sulphur-containing gases by Church, who determined that the calf-leather binding of a damaged book contained the equivalent of 6% of free sulphuric acid.[55] Other organic materials such as wood, cotton, wool and silk are attacked by the acids formed from SO_2. Although acid gases attack paper, it is often difficult to distinguish between the effect of these gases and deterioration caused by acidic materials in the composition of certain types of paper, particularly those based on wood pulp rather than cotton rag. Acid-catalysed hydrolysis of cellulose- or protein-based textiles is responsible for weakening fabrics, including painting canvases, which yellow and embrittle.

Most pigments and dyes are relatively insensitive to sulphur dioxide, although some acid-sensitive pigments may be affected by the gas once it has been oxidised and hydrolysed to yield sulphuric acid. For example, a preliminary test on artificial ultramarine indicated that even at quite high SO_2 concentrations and at high RH there was little apparent damage, while as soon as drops of water condensed on the surface, decoloration was immediate.[56] Church, having noted that acidic gases dissolved in moisture were 'very injurious to paper, wood, canvas and pigments,' went on to recommend that galleries be coated with a distemper paint containing white lead to 'absorb the sulphuretted hydrogen as well as the sulphuric and sulphurous acid present in town air'.[57]

Nitrogen dioxide

Although oxides of nitrogen are present in the atmosphere from natural sources, the levels have increased in urban areas, particularly during the twentieth century, due to high-temperature combustion processes that oxidise atmospheric nitrogen to, for example, nitric oxide (NO) or nitrogen dioxide (NO_2). Of the oxides of nitrogen, nitrogen dioxide is of most concern to the conservator; it can dissolve in water to form nitrous acid, which, on aerial oxidation, yields nitric acid, a strong acid and oxidant.[58] As nitric acid is of a comparable strength to sulphuric acid, it might be expected to corrode metals, attack calcareous stone and damage textiles in the same manner, were it not for its volatility, which reduces its effect. There is little specific evidence to relate the presence of NO_2 to damage, as it is usually present alongside other potentially damaging gaseous pollutants, such as SO_2. Nitrogen dioxide has, however, been shown to affect iron gall inks, some synthetic dyestuffs, the arsenic sulphide pigments orpiment and realgar, and a few traditional organic colorants, both on silk and paper; these changes resulted from an exposure equivalent to five or six years in an urban museum with no chemical filtration.[59] Brimblecombe has reviewed the effect of NO_2 and other gaseous pollutants on various museum artefacts.[60]

Changes in Air Pollution in the Twentieth Century

The air in London, as in most major cities, is now considerably less smoky that at the turn of the century, despite a considerable growth in population. A number of factors have contributed to this decline, including a dilution effect as populations have spread over a greater area, changes in fuel use patterns away from high-sulphur, sooty fuels, increased use of electricity which is generated away from city centres and clean air legislation.[61] In London, smogs, a term for dense smoky/sooty fogs, continued to affect the city during periods when certain meteorological conditions prevailed until the 1950s. A particularly severe smog settled upon London in 1952, which has been estimated to have caused four thousand additional deaths,[62] and which was one of the factors leading to the passing of the 1956 Clean Air Act. Although the Act focused on reducing smoke pollution, by creating smokeless zones and promoting the use of smokeless fuels, SO_2 levels were reduced in tandem, as smokeless coals and oils generally have a lower sulphur content. The continuing move from coal to gas and electricity, combined with the relocation of electricity generating stations and heavy industry away from city centres, has further reduced the SO_2 and smoke levels in urban areas.

Tall chimneys, stipulated in the 1968 Clean Air Act, were intended to reduce SO_2 concentrations at ground level by providing better dispersal. More recently, systems have been introduced that remove SO_2, either during combustion or from flue gases, often by reaction with calcium carbonate, as limestone chips or as a slurry; the calcium carbonate

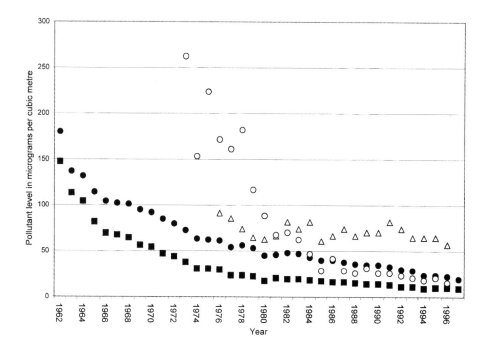

Fig. 5 Yearly average UK and London pollutant levels over the last four decades in micrograms per cubic metre: UK average smoke level ■; UK average SO_2 level ●; London average SO_2 level ○; London average NO_2 level △.

reacts with SO_2 to give calcium sulphate and carbon dioxide. The effect of such measures can be seen in Fig. 5. Over the period 1962–97, average smoke levels for the UK have fallen from around 150 to less than 10µg.m^{-3}, while SO_2 levels have dropped from nearly 200 to 20–30µg.m^{-3}. In London, the levels of SO_2 have declined more markedly still, from 200–250µg.m^{-3} in the mid-1970s (at a time when the national average was around 60µg.m^{-3}) to around 20µg.m^{-3} in the late 1990s, somewhat lower than the national average.[63]

Unfortunately, the decline in pollution from coal burning has coincided with the rapid expansion in the use of motor vehicles which, by 1997, had become responsible for around 50% of the total emissions of smoke and oxides of nitrogen in the UK (see Fig. 6). As the primary pollutant generated by combustion is NO, the level of NO_2 will not necessarily rise or fall in tandem; the rate of oxidation of NO to NO_2 may be limited by the availability of oxidants such as atmospheric ozone.

As in the nineteenth century, the Gallery's position in central London makes the building susceptible to high levels of pollution, currently from motor vehicles in general and buses in particular. The latter are typically powered by diesel engines which, although more fuel efficient, produce higher levels of particles and nitrogen oxides than the petrol engines found in most cars; indeed, particles from diesel engines are one of the major pollutant problems for the Gallery at present. As a result, the levels of NO_2 in the air surrounding museums are now often of more concern than those of SO_2. Although the number of motor vehicles has continued to increase, there has been some reduction in the levels of certain pollutants over the last few years; for example in Figs. 5 and 6 it can be seen that NO_2 levels began to drop slightly in the period 1990–7. Pollution control has been driven by a number of air-quality directives produced by the European Community and UK governments, and since 1993 all new cars sold within the European Union have been fitted with catalytic converters. These reduce pollutant emissions by passing the exhaust gases through a honeycomb structure coated with platinum group metals; the large surface area of the catalyst ensures efficient (up to 90%) conversion of carbon monoxide and hydrocarbons to carbon dioxide and water and the reduction nitrogen oxides to nitrogen. While reducing the levels of harmful pollutants, catalytic converters do not help to reduce levels of carbon dioxide, the increase in the levels of which has been identified as a major cause of 'global warming'.

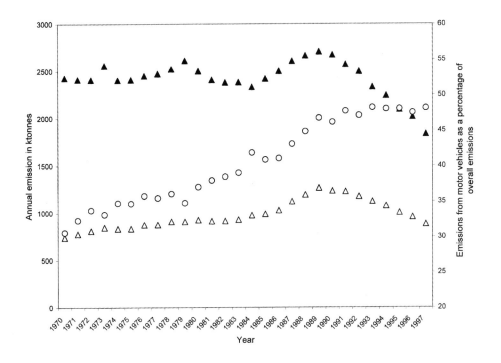

Fig. 6 Emissions of nitrogen oxides in the UK over the last three decades in kilotonnes: left axis, total emissions ▲, emissions from motor vehicles △; right axis, emissions from motor vehicles as a percentage of total emissions ○.

London remains a polluted city, not least because of motor traffic, but is not often subject to the modern phenomenon of 'photochemical smog' that affects the atmosphere in cities such as Los Angeles, where high levels of ozone, nitrogen oxides and other potentially damaging species (associated with high vehicle use and local meteorological conditions) present particular problems for museum collections.

Pollutant Control and Monitoring in London Museums

The first study of pollution in the National Gallery was conducted by Rawlins in 1936, in an era when none of the rooms at Trafalgar Square had air-conditioning or filtration. He began by examining paintings that had been framed and backed to protect them against dust, reporting that the 'experience is not very cheering ... the amount of dust, both on the inside of the glass and on the picture itself, was extraordinarily large'.[64] Rawlins used syphon recorders, which periodically drew two litres of air through a filter paper. The device used to measure levels outside the Gallery was partially automatic, so that a semi-continuous record was available against which to compare the measurements made inside the building. The amount of 'smoke' was determined by comparing the spots on the filter paper with a graduated shade chart. This comparative method was not capable of producing very accurate results, but external measurements revealed an average level of about $1000\mu g.m^{-3}$, with peaks of $3200\mu g.m^{-3}$.[65] The indoor to outdoor ratio was around 70%, with a 'lag' of an hour between peaks in the exterior level affecting the dust concentrations in the rooms. Finally, a jet method was used to collect particles for microscopic examination. The carbonaceous particles in the smoke were described as 'thin, buckled plates, greasy-looking and quite soft',[66] and it was suggested that this might cause them to adhere more easily to the painting surface.

By the time Thomson conducted further studies of pollution in the 1960s, some of the rooms had been equipped with air-conditioning systems that incorporated particle filters, which over a two-month period in 1959 had been found to remove over 90% by weight of dust; recirculating the air raised the efficiency.[67] Thomson observed that because 'clean air' legislation was taking effect, leading to a reduction in particles, SO_2 had become the primary pollutant.[68] Levels of SO_2 in towns varied seasonally and were typically 300 to $400\mu g.m^{-3}$ (as expected, higher than the national average shown in Fig. 5), while the level of NO_2 in London was in the range 10 to $30\mu g.m^{-3}$.[69]

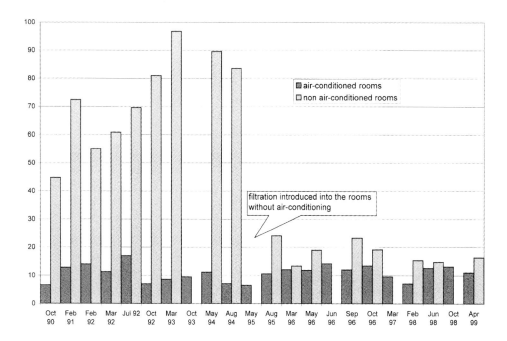

Fig. 7 NO$_2$ levels in air-conditioned and non air-conditioned rooms during 1990–9, expressed as a percentage of the exterior level.

In the air-conditioned rooms at the National Gallery, 95 to 97% of the SO$_2$ was removed when the air was passed through the water spray used in humidification.[70] At the same time similar levels of SO$_2$ (200 to 600µg.m^{-3}) were recorded by Padfield at the Victoria and Albert Museum. He noted that even without chemical filtration the inside levels were only 50% of those outside, perhaps due to absorption of gas by, or reaction with, walls and fabrics.[71]

An extensive study of SO$_2$ levels at the Tate Gallery was conducted by Hackney between 1978 and 1983.[72] Outside SO$_2$ levels, measured on seventeen days during this period, ranged from 31 to 208µg.m^{-3}. Within the building, the level was reduced, particularly in air-conditioned rooms fitted with chemical filters, where, except on days with very high external SO$_2$ levels, the pollutant level was below the detection limit of the gas analyser.[73] Measurements of NO$_2$, made in 1977, ranged from 44µg.m^{-3}, at the main entrance to the Tate Gallery, to <5µg.m^{-3} in a display case. As a result of this survey, the use of activated carbon filters to remove gaseous pollutants, and their regular replacement, were recommended. Lower levels were also found behind canvases when paintings were fitted with backboards, or surrounding objects stored in enclosures.[74]

In the last decade there have been a number of investigations of pollutants in museums in London, including a recent study of gaseous pollutants and suspended particles in two London museums, the National Museum of Childhood and the Museum of London. At the former, the average outdoor levels were 51µg.m^{-3} (NO$_2$) and 60µg.m^{-3} (SO$_2$), while at the Museum of London average levels of 58µg.m^{-3} (NO$_2$) and 20µg.m^{-3} (SO$_2$) were recorded.[75] Inside the naturally ventilated Museum of Childhood, the NO$_2$ concentration was 84% of the external level while the SO$_2$ level was only 16% of that outside. In the air-conditioned Museum of London, the levels of both NO$_2$ and SO$_2$ were much reduced, to 19 and 14% respectively,[76] suggesting that for SO$_2$ reduction in these museums, full air-conditioning did not confer significant extra benefit.

Current Programmes of Monitoring at the National Gallery

Unlike many other museums, the National Gallery is fortunate to have a collection that is, from a material standpoint, quite homogeneous. A single climate suffices for the long-term preservation of the Collection, obviating the need for individually conditioned, sealed display cases with their attendant

problems associated with the accumulation of pollutants, for example carbonyl species or reduced sulphur gases. The principal pollutants of concern are, therefore, those generated by visitors, and those entering from outside the building and described in earlier sections detailing London's pollution. Following the recommendations given by Thomson, the National Gallery attempts to limit the concentration of both NO_2 and SO_2 to less than $10\mu g.m^{-3}$,[77] and to reduce particle concentrations by using efficient filters on the intake and recirculation air systems. As rooms at the Gallery have gradually been equipped with air-conditioning over the last five decades, particle and chemical filters based on activated carbon have been fitted. For the last five years, the air supplied to those galleries without air-conditioning has also been passed through particle and chemical filters prior to entering the room.

Gaseous pollutants

In order to assess the success of pollutant control at the Gallery, routine gaseous pollution measurements have been made in the Gallery since 1990, using diffusion tube techniques.[78] Tubes sensitive either to NO_2 or SO_2 have been exposed for two-week periods in both air-conditioned and non-air- conditioned rooms. During each survey one tube is exposed on a roof at the north of the Gallery and another left unopened in a refrigerator to act as a control. The NO_2 diffusion tubes measure the cumulative dose absorbed by tris-(2-hydroxyethyl)amine (triethanolamine, TEA) coated on a stainless steel mesh at the closed end of the tube. After exposure, the tube is sealed and sent for analysis; the quantity of NO_2 absorbed by the TEA as nitrite is determined spectrophotometrically after conversion to a diazonium compound.[79] The SO_2 sampler works on a similar principle; the quantity of SO_2 converted to sulphate is measured by ion chromatography. We have had no great success with diffusion tubes designed to measure ozone levels, perhaps because the levels of this gas inside the Gallery are at, or below, the detection limit of the tubes.

SO_2 levels outside the Gallery in the period since 1992 have been in the range 7.5 to $27\mu g.m^{-3}$, in broad agreement with the levels shown in Fig. 5. In the air-conditioned rooms, SO_2 levels were between 1.2 and $9.4\mu g.m^{-3}$, equating to indoor to outdoor ratios of between 5 and 41%; the highest reading (41%) corresponded to a level of $3.1\mu g.m^{-3}$ in a gallery over a period when the exterior level averaged only $7.5\mu g.m^{-3}$. In the rooms without air-con-

ditioning levels of up to 50 to 75% of the outdoor concentration were measured.

Over the period 1990 to 1999 NO_2 levels have been measured on at least twenty occasions. Exterior levels (on the roof of the Gallery) have been in the range 34 to $76\mu g.m^{-3}$. Again, these are of the same order as the average data for London shown in Fig. 5. In the air-conditioned rooms the average levels were found to be 2.9 to $9.8\mu g.m^{-3}$, which equates to between 6 and 17% of the outside level, see Fig. 7. Although the average was always below the Gallery's target of $10\mu g.m^{-3}$, the level in some rooms was occasionally greater than this value. On investigation, the principal cause was found to be that the chemical filters for these rooms were coming to the end of their useful life and were in need of replacement. In other instances, the high level could be attributed to the proximity to unconditioned spaces, particularly the entrance vestibules at the Trafalgar Square entrance.

Fig. 7 also shows the indoor to outdoor ratio of NO_2 in the rooms without air-conditioning. Two distinct periods can be seen. Before 1995, the average level in these rooms was always more than 40% of the outside concentration, while after this time the level was always less than 25%. This clearly shows the value of the introduction of chemical filters in the air supply to rooms without air-conditioning, although full air-conditioning gives more efficient NO_2 removal, presumably because the gas is also removed as it dissolves in the water spray in the humidifier unit.

Dust

To assess the levels of dust in the Gallery, several surveys of suspended particles have been undertaken. These studies have two purposes: first to indicate the success of dust removal methods by mapping

Fig. 8 Grimm dust monitor in use in Room 15.

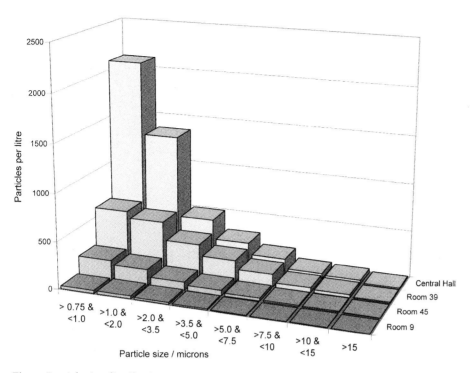

Fig. 9 Particle size distribution in Rooms 9, 45, 39, and Central Hall.

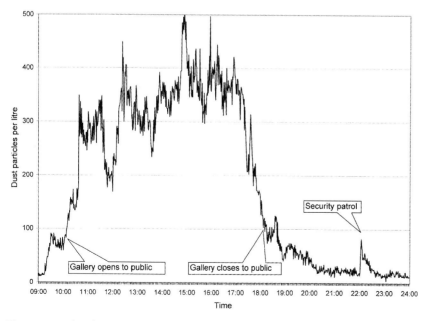

Fig. 10 Dust levels in Room 45 (particles > 0.75 μm), showing the relation between level and visitor occupation.

Table 1 **Results from dust surveys during 1998–9**

Room	Surroundings	Survey 1	Survey 2
Not air-conditioned		31–81%	36–72%
Air-conditioned	Not air-conditioned	18–64%	16–74%
Air-conditioned	Air-conditioned	1–12%	3–12%

the distribution of dust through the air-conditioned and ventilated rooms in the Gallery, and second, at a time of much building work, to look at the impact of construction on adjacent areas. Both types of survey are designed to highlight strengths and weaknesses of present arrangements and to suggest improvements to practice.

The dust surveys have been conducted using a Grimm 1.105 dust monitor (see Fig. 8) similar to that used recently by Cassar et al.[80] The instrument operates by drawing air into a sampling chamber at a constant, known rate. In the chamber, a light beam emitted by a laser diode is scattered by the dust particles. The light scattered at an angle of 90° is collected and particles quantified by analysing the signal from a photo-diode detector. The dust monitor can be set to measure either particles per litre or micrograms per cubic metre and is able to differentiate between particles of different sizes (>0.75μm, >1.0μm, >2.0μm, >3.5μm, >5.0μm, >7.5μm, >10μm and >15μm). The inlet filter on the monitor excludes very large particles, so textile fibres (confirmed as one of the major sources of particles in the Gallery by examination of dust samples under the microscope) are excluded from the measurements. The drawback of this method is that the larger particles (>20μm), thought to be responsible for loss of gloss and for soiling, are not measured by this meter,[81] which is optimised to monitor the smaller particles associated with health hazards.

To obtain an average level, the monitor was left in each room for one hour. At the beginning and end of each measurement period, the level of dust outside the Gallery was measured for comparison. Fig. 9 shows the number of particles in each size range for a number of different rooms at the National Gallery. Rooms 9 and 45 are fully air-conditioned, but Room 45 is adjacent to the main vestibule, which has no air filtration and is connected to Trafalgar Square by single doors. The Central Hall leads off the vestibule

and has no air filtration, while Room 39 is supplied with filtered, but not conditioned, air.

The results of two recent surveys (during 1998–9) are summarised in Table 1. The rooms have been divided into those that are air-conditioned and those that are not. The air-conditioned rooms have been further subdivided into rooms that are adjacent to areas that are not air-conditioned and those that are surrounded by other air-conditioned spaces. All the figures are for particles >0.75μm in diameter, expressed as a percentage of the exterior dust level at the time.

It can be seen that the non air-conditioned rooms and those rooms that were adjacent to unconditioned areas, particularly those near the public entrances, had higher levels. For example, the level of 74% recorded for an air-conditioned room in the second survey was for a special exhibition in Room 1,

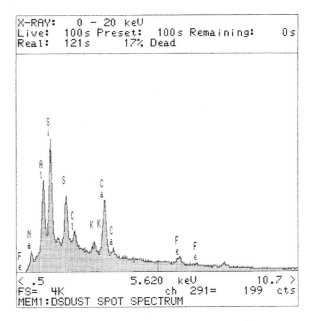

Fig. 11 EDX spectrum of a dust sample taken during a routine survey.

which is close to the main entrance from Trafalgar Square. The exhibition was extremely popular; the room was crowded and the door to the unconditioned vestibule opened and closed continually.

During these surveys it became clear that, as might be expected, the level in a room varied with occupancy; a much higher level of dust was present in a particular room in the middle of the day than when the Gallery opened. The dust monitor was placed in several rooms for a whole day; the results confirmed that the level rose during public hours and decreased once the Gallery closed (see Fig.10). The variation of dust levels with visitor numbers may be one of the reasons that the dust levels measured in air-conditioned rooms cover such a wide range (1 to 12%).[82]

The low level of dust at night indicates that the air-filtration systems are operating efficiently, restricting the amount of dust penetrating from outside the building. There are two possible fates for the dust present in the rooms during the day. First it may settle on the walls, floors and paintings during the night when there are no visitors to 'stir' the air in the room; in these surveys no measurements of precipitated dust have been made. The second possibility is that some or all the dust is removed from the air by recirculation through filters during the night. In the former case, much of the dust in the rooms will be present continually, but only airborne during the day, while the latter option implies that 'new' dust builds up in the rooms during each day, only to be removed at night. That the frames of paintings still require periodic dusting, despite good air filtration, suggests that some dust precipitates during the night. It seems likely, however, that a considerable percentage of the dust present in the building is generated by visitors, or brought in with them, rather than entering from outside in the air used to ventilate the rooms.

Analysis by energy dispersive X-ray fluorescence (EDX) of a sample of the dust collected during the survey showed significant peaks for silicon, aluminium, calcium, potassium, sulphur, phosphorus, iron and copper (see Fig. 11). These elements suggest that minerals, including silicates, aluminates, sulphates and phosphates, are present. The EDX technique used was not able to detect carbon, the principal element present in smoke. In addition, conspicuous peaks for sodium and chlorine were observed, suggesting that a significant component of the dust might be exfoliated skin cells. A subsequent analysis

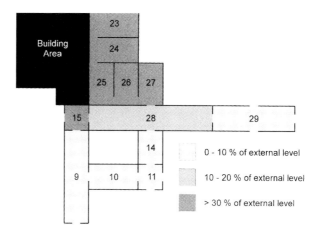

Fig. 12 Dust levels, as a percentage of the exterior level, in the rooms surrounding an area in which building work was occurring.

of the organic components by gas chromatography/mass spectrometry (GC–MS) revealed the presence of squalene, a marker compound for skin cells.[83]

A survey conducted in a series of air-conditioned rooms during construction work revealed that, as might be expected, the dust levels in the rooms next to the building site were higher than those further away (see Fig. 12). The levels close to the area in which very dusty construction work was being undertaken were not, however, greatly different to the levels in air-conditioned rooms near entrance vestibules, suggesting that the measures taken to isolate the building area from the galleries were working reasonably well.

Conclusions

In the 175 years since the Gallery's foundation, the character of pollution in Central London has changed; particles and NO_2 emitted by vehicles have replaced smoke and SO_2 from coal burning as the major pollutants in urban areas. It is not, however, clear whether the greater concentration of NO_2 poses a more serious threat to museum collections, as the relative damage caused by SO_2 and NO_2 has not been quantified.

The Gallery no longer faces such an acute dilemma in ventilating the building without admitting noxious vapours and smoke, as the air supply to all exhibition rooms is filtered. But this supply air is drawn from outside the building in the midst of

London traffic and, as shown by the surveys described above, infiltrates some rooms from the public entrances. Visitors also bring pollution with them, on their clothing and feet, although not to the same extent as in the nineteenth century when the pavements around the Gallery were reduced to mud in wet weather. When asked by the 1850 Select Committee if 'the time of year make any difference in the accumulation of dirt', the Keeper, Thomas Uwins, responded that 'Wet weather will necessarily make a great difference, because it is brought in in the shape of mud on the feet, and that very soon crumbles into an impalpable powder, and becomes diffused through the rooms'.[84] A recent study has confirmed that wet weather greatly increases the quantity of material brought into a gallery on visitors' shoes.[85]

The surveys of pollutants have shown that the particle and chemical filtration provided by air-conditioning gives very high standards of pollution control in rooms surrounded by others of similar standard. The influence of the surrounding rooms is most obvious in the dust measurements, particularly if the adjacent area is unconditioned and connected directly to one of the public entrances. Moves which (rightly) give greater access to the Gallery for disabled visitors have led to the removal of revolving doors, which provide increased protection from pollution.[86] The doormats and air-curtains that have replaced revolving doors do not provide adequate protection and there is a tendency to wedge the doors open in warm weather. Once in the building, there is perhaps a greater expectation that visitors will behave with decorum than might have prevailed in the last century. Thomas Uwins described an impromptu picnic he had witnessed at the Gallery: 'On another occasion, I saw some people, who seemed to be country people, who had a basket of provisions, and who drew their chairs round and sat down, and seemed to make themselves very comfortable, they had meat and drink; and when I suggested to them the impropriety of such a proceeding in such a place, they were very good-humoured, and a lady offered me a glass of gin, and wished me to partake of what they had provided.'[87]

Following a recent study, during which the results from diffusion tube analysis were compared with measurements made with a gas analyser in the inlet ducts and air supplies to conditioned rooms,[88] the NO_2 and SO_2 surveys are being used to monitor the performance of chemical filters to indicate when these need replacement. Early indications are that

this type of monitoring may reduce the frequency with which filters need to be replaced.

Finally, increased public awareness of environmental issues and the problems associated with pollution may encourage further legislation to reduce pollutant levels in cities. For the National Gallery, the proposed pedestrianisation of Trafalgar Square may prove to be a significant factor in reducing pollution in the immediate vicinity of the building.

Acknowledgements

In the National Gallery Archive, David Carter and Matthew Stephenson have supplied me with invaluable assistance in locating Board minutes, reports and visual material. In the Scientific Department, Jo Kirby has provided assistance in locating nineteenth-century sources, while Marika Spring and Raymond White performed inorganic and organic analyses on samples of dust. The interest of the Gallery's Chief Engineer, Frank Brown, made this research possible and his colleagues Ischa Mulder and Justine Haskell from the Building Department helped conduct the pollutant surveys. I am particularly indebted to Professor Peter Brimblecombe of the University of East Anglia for his critical reading of a draft version of this manuscript and for his many publications on the history and science of pollution, all of which I have shamelessly plagiarised. Finally, I should like to thank Nick Penny for suggesting that I research the history of pollution control at the National Gallery.

Notes and References

1 P. Brimblecombe, 'History of Air Pollution', in *Composition, Chemistry and Climate of the Atmosphere*, ed. Hanwant B. Singh, New York 1995, p. 3.
2 J. Evelyn, *Fumifugium, or the Inconvenience of the Aer and Smoake of London Dissipated*, (London 1661), London 1961, p. 18. Reprinted by the National Society for Clean Air, the page references derive from this edition.
3 Evelyn, cited in note 2, p. 17.
4 Evelyn, cited in note 2, p. 30.
5 P. Brimblecombe, *The Big Smoke*, London 1987, p. 101.
6 Minutes of the National Gallery Board of Trustees, April 1839, Vol. I, p. 145.
7 Minutes of the National Gallery Board of Trustees, April 1842, Vol. I, p. 191.
8 Report from the Select Committee on National Monuments and Works of Art, 16 June 1841, paragraph 2658.
9 Minutes of the National Gallery Board of Trustees, July 1847, Vol. I, p. 356.

10 Report from the Select Committee on the National Gallery, 25 July 1850, paragraph 684.

11 Report from the Select Committee on the National Gallery, 25 July 1850, paragraph 667.

12 Report from the Select Committee on the National Gallery, 25 July 1850, paragraphs 667 and 220.

13 Report from the Select Committee on the National Gallery, 25 July 1850, paragraph 669.

14 Report from the Select Committee on the National Gallery, 25 July 1850, p. iv.

15 Report from the Select Committee on the National Gallery, 25 July 1850, paragraph 697.

16 Report from the Select Committee on the National Gallery, 25 July 1850, p. v.

17 Report from the Select Committee on the National Gallery, 25 July 1850, p. v.

18 Minutes of the National Gallery Board of Trustees, February 1851, Vol. II, p. 115.

19 Report of the Director of the National Gallery to the Lords Commissioners of Her Majesty's Treasury, 6 April 1857, section entitled 'Backs of the Pictures'.

20 Report of the Director of the National Gallery to the Lords Commissioners of Her Majesty's Treasury, 2 April 1860, section entitled 'Backs of the Pictures'.

21 Report of the Director of the National Gallery to the Lords Commissioners of Her Majesty's Treasury, 5 April 1858, section entitled 'Backs of the Pictures'.

22 Report of the Director of the National Gallery to the Lords Commissioners of Her Majesty's Treasury, 2 April 1860, section entitled 'Backs of the Pictures'.

23 Report from the Select Committee on the National Gallery, 25 July 1850, paragraph 659.

24 Report of the National Gallery Site Commission, London 1857, p. vi.

25 Report of the Director of the National Gallery to the Lords Commissioners of Her Majesty's Treasury, 6 April 1857, section entitled 'Conservation of the Pictures'.

26 Minutes of the National Gallery Board of Trustees, 2 May 1881, Vol. V, p. 173.

27 Minutes of the National Gallery Board of Trustees, 22 December 1880, Vol. V, p. 160.

28 Minutes of the National Gallery Board of Trustees, February 1852, Vol. II, pp. 143–4.

29 Report of the Director of the National Gallery to the Lords Commissioners of Her Majesty's Treasury, 5 March 1856, section entitled 'Conservation of the Pictures'.

30 Report of the Director of the National Gallery to the Lords Commissioners of Her Majesty's Treasury, 5 March 1856, Appendix No. 4, section entitled 'Conservation of the Works of Art'.

31 Minutes of the National Gallery Board of Trustees, December 1865, Vol. IV, p. 375.

32 Report of the Director of the National Gallery to the Lords Commissioners of Her Majesty's Treasury, 5 March 1856, Appendix No. 4, section entitled 'Conservation of the Works of Art'.

33 Minutes of the National Gallery Board of Trustees, May 1862, Vol. IV, p. 286.

34 Minutes of the National Gallery Board of Trustees, 26 November 1879, Vol. V, p. 137.

35 Minutes of the National Gallery Board of Trustees, 2 February 1880, Vol. V, pp. 140–1.

36 Minutes of the National Gallery Board of Trustees, 7 August 1882, Vol. V, p. 221.

37 Minutes of the National Gallery Board of Trustees, 22 July 1902, Vol. VII, p. 168.

38 Minutes of the National Gallery Board of Trustees, 7 July 1896, Vol. VI, p. 360.

39 A.H. Church, *The Chemistry of Paints and Painting*, London 1890, p. 275.

40 Evelyn, cited in note 2, p. 18.

41 R. Perry, 'Problems of dirt accumulation and its removal from unvarnished paintings: A practical review', *Dirt and Pictures Separated*, UKIC, 1990, pp. 3–6.

42 Report from the Select Committee on National Monuments and Works of Art, 16 June 1841, paragraphs 2498–9.

43 Minutes of the National Gallery Board of Trustees, 9 February 1857, Vol. IV, p. 77.

44 S. Edmonds, 'A microclimate box for a panel painting fitted within a frame', *Preprints for the UKIC 30th Anniversary Conference*, 1988, pp. 50–3; W.S. Simpson, 'An Improved Method of Preserving Oil Paintings, Water Colour Drawings, Engravings, Photographs, Prints and Printed Matter from Atmospheric Deterioration and Decay', British Patent BP6556: 1892.

45 Church, cited in note 39, p. 275.

46 K. Toishi and T. Kenjo, 'Some aspects of the conservation of works of art in buildings of new concrete', *Studies in Conservation*, 20, 1975, pp. 118–22.

47 G. Field, *Examples and Anecdotes of Pigments. Practical Journal 1809*, Field Manuscripts, Field/6, photographic copy, Courtauld Institute Library, London. Field's results are discussed in R.D. Harley, 'Field's Manuscripts: Early nineteenth century colour samples and fading tests', *Studies in Conservation*, 24, 1979, pp. 75–84. Field's description of exposing samples to 'foul air' is given on p. 77.

48 Harley, cited in note 47, pp. 79–80.

49 L. Carlyle, and J.H. Townsend, 'An investigation of lead sulphide darkening of nineteenth century painting materials', *Dirt and Pictures Separated*, UKIC, 1990, pp. 40–3.

50 Church, cited in note 39, p. 275.

51 Church, cited in note 39, p. 274.

52 The high sulphate content of the girder at Charing Cross was reported by Rideal at the International Smoke Abatement Exhibition in London in 1912, see A. Marsh, *Smoke (The problem of coal and the atmosphere)*, London 1947, p. 100. Marsh also reports the results of a study by Longmuir, which demonstrated that the sulphate content of fencing wire in a polluted city (Sheffield) was 1.95%, compared to 0.73% in a

rural environment (Flamborough Head); p. 100.

53 Report from the Select Committee on the National Gallery, 25 July 1850, paragraph 669.

54 A. Parker, *Destructive Effects of Air Pollution on Materials*, National Smoke Abatement Society (UK), 1955.

55 Church, cited in note 39, p. 274.

56 Samples of natural and artificial ultramarine in oil and egg tempera media and as dry powders were coated on PTFE plates. After exposure to >1000μg.m⁻³ of SO_2 in a chamber at 40°C and 80% RH for two months, no changes were noted to any of the samples. When, however, a powder sample of artificial ultramarine on PTFE that had been maintained at 25°C was inserted into the chamber, condensation formed on the surface and the sample decoloured immediately.

57 Church, cited in note 39, pp. 275–6. There is no evidence that the walls were deliberately painted with lead white, but as this was the principal white pigment during the nineteenth century, it is difficult to make this distinction. Although lead white primed canvases were used to protect the back of paintings, which might have helped protect them from acid gases, this would have been a standard preparation for supplied canvases. In the 1850s, when paintings were fitted with backing canvases, it is clear that their main function was to reduce dust deposition on the backs of the pictures. Any benefits from lead white absorption of atmospheric pollutants were probably fortuitous rather than intentional.

58 G. Thomson, *The Museum Environment*, 2nd edn., London 1986, pp. 151–2.

59 P.M. Whitmore, and G.R. Cass, 'The fading of artists' colorants by exposure to atmospheric nitrogen dioxide', *Studies in Conservation*, 34, 1989, pp. 85–97.

60 P. Brimblecombe, 'The Composition of Museum Atmospheres', *Atmospheric Environment*, 1990, 44B(1), pp. 1–8.

61 Brimblecombe, cited in note 1, p. 5.

62 Brimblecombe, cited in note 5, pp. 168–9.

63 In this paper, the concentrations of both particles and gaseous pollutants have all been converted to micrograms of pollutant per cubic metre of air (μg.m⁻³).

64 F.I.G. Rawlins, 'Atmospheric Pollution with special reference to the National Gallery', *Journal of the Institute of Heating and Ventilation Engineers*, 5, 1937, pp. 400–24; this description appears on p. 402.

65 Rawlins, cited in note 64, p. 411.

66 Rawlins, cited in note 64, p. 413.

67 G. Thomson, 'Air Pollution – A Review for Conservation Chemists', *Studies in Conservation*, 10, 1965, pp. 147–67; see p. 160.

68 Thomson, cited in note 67, p. 147.

69 Thomson, cited in note 67, pp. 149–50.

70 Thomson, cited in note 67, p. 162.

71 T. Padfield, 'The Control of Relative Humidity and Air Pollution in Show-cases and Picture Frames', *Studies in Conservation*, 11, 1966, pp. 8–30.

72 S. Hackney, 'The Distribution of Gaseous Air Pollution within Museums', *Studies in Conservation*, 29, 1984, pp. 105–16; see, in particular, pp. 109–12.

73 Hackney, cited in note 72, p. 112.

74 Hackney, cited in note 72, p. 115.

75 M. Cassar, N. Blades and T. Oreszczyn, 'Air pollution levels in air-conditioned and naturally ventilated museums: A pilot study', *ICOM Committee for Conservation, 12th Triennial Meeting*, Lyon 1999, pp. 31–7.

76 Cassar et al., cited in note 75, p. 36.

77 Thomson, cited in note 58, p. 158.

78 A preliminary report of the use of these tubes can be found in D. Saunders, 'The environment and lighting in the Sainsbury Wing of the National Gallery', *ICOM Committee for Conservation, 10th Triennial Meeting*, Washington DC, 1993, pp. 630–5.

79 The mesh is first treated with a measured amount of a solution of sulphanilamide in orthophosphoric acid. To this an aliquot of a solution of N-1 naphthyl ethylene diamine dihydrochloride (NEDA) is added. The nitrite reacts with the sulphanilamide to form a diazonium compound which couples with the NEDA to form an azo dye. The concentration of the azo dye is determined from the absorbance of the resulting solution at 540nm. A calibration curve allows the absorbance to be related to the concentration of nitrite and hence of absorbed NO_2. The atmospheric concentration of NO_2 is derived by applying Fick's law of diffusion, taking into account the length of the sampling period. See D.F.H. Atkins, J. Sandalls, D.V. Law, A.M. Hough and K. Stevenson, 'The measurement of nitrogen dioxide in the outdoor environment using passive diffusion tube samplers', United Kingdom Atomic Energy Authority, publication AERE R 12133, HMSO, London 1986.

80 Cassar et al., cited in note 75, p. 31.

81 The size distribution of the particles responsible for soiling furniture surfaces shows a peak in the 40–50 micron range. A method for measuring these larger particles is given in: T. Schneider, O.H. Petersen, J. Kildesø, N.P. Kloch and T. Løbner, 'Design and Calibration of a Simple Instrument for Measuring Dust on Surfaces in the Indoor Environment', *Indoor Air – Copenhagen International Journal of Indoor Air Quality and Climate*, 6(3), 1996, pp. 204–10.

82 A study of particles inside the Sainsbury Centre for the Visual Arts found significant quantities of clothing fibres, and dust brought in on visitors' feet. See Y.H. Yoon and P. Brimblecombe, 'Role of the floor in contributing to dust within the Sainsbury Centre for the Visual Arts', *Studies in Conservation*, 45, 2000, in press.

83 A sample was derivatised with TMTFTH, using the treatment procedure described previously, see R. White and J. Pilc, 'Analyses of Paint Media', *National Gallery Technical Bulletin*, 17, 1996, p. 95, and analysed by gas chromatography / mass spectrometry (GC–MS) by Raymond White. In addition to fatty acid

methyl esters, the gas chromatogram of this sample showed evidence of a component whose mass spectrum consisted of a base peak (the most stable fragment ion) with a molecular mass (Da/z) of 69. Other peaks in the spectrum were at 81 (93% of base peak ion intensity), 137 (42%), 341 (2%) and 410 Da (3%, molecular ion). A base peak with a mass of 69 Da is typical of a number of (generally) open chain isoprene-based components. Overall, the spectrum may be interpreted as that of squalene ($C_{30}H_{50}$), or (all E) 2, 6, 10, 15, 19, 23-hexamethyl-2, 6, 10, 14, 18, 22-tetracosahexaene, which has a molecular mass of 410. Squalene is a characteristic component of skin dust, of which it may constitute some 1–2% by weight. A blank analysis, carried out on the reagents alone, was run immediately prior to the dust sample, as inadvertent handling of syringe needles or deposition of fingerprint grease and dead skin particles on glassware can also give rise to the appearance of

squalene. No squalene was detected in the control chromatogram.

84 Report from the Select Committee on the National Gallery, 25 July 1850, paragraph 323.

85 It has been found that the mass of material brought into the Sainsbury Centre for the Visual Arts on visitors' shoes is up to 17 times greater in wet weather than in dry weather. However, when rain was falling at the time of measurement, the mass was reduced to less than that in dry conditions. See Yoon and Brimblecombe, cited in note 82, Table 2.

86 Hackney, cited in note 72, p. 115.

87 Report from the Select Committee on the National Gallery, 25 July 1850, paragraph 82.

88 *Instrumental Monitoring of Sulphur Dioxide and Oxides of Nitrogen concentrations at the National Gallery*, 9th March–27th April 1999, unpublished report, Emcel Filters Ltd., London 1999.

Pictures cleaned and restored in the Conservation Department of the National Gallery, October 1997–January 2000

Antonio de Solario *The Virgin and Child with Saint John* NG 2503

Attrib. Bonfigli *The Adoration of the Kings, and Christ on the Cross* NG 1843

Style of Bonifazio *The Labours of the Months: January–June* NG 3109

Style of Bonifazio *The Labours of the Months: July–December* NG 3110

Canaletto *Venice: Palazzo Grimani* NG 941

Castagno *The Crucifixion* NG 1138

Willem Claesz. Heda *Still Life: Pewter and Silver Vessels and a Crab* NG 1469

Attrib. Clarisse Master *The Virgin and Child* NG 6571

Corot *A Wagon in the Plains of Artois* NG 2628

Corot *Sketch of a Woman in Bridal Dress* NG 4733

Courbet *Beach Scene* NG 6396

Degas *Portrait of Elena Carafa* NG 4167

Workshop of Dürer? *The Virgin and Child ('The Madonna with the Iris')* NG 5592

Attrib. Francia *Mourning over the Dead Christ* NG 2671

Dirck Hals *A Party at Table* NG 1074

Harpignies *Autumn Evening* NG 6325

de Hooch *The Courtyard of a House in Delft* NG 835

Ingres *Pindar and Ictinus* NG 3293

Italian, Venetian *The Dead Christ* NG 3893

Jacob Maris *A Drawbridge in a Dutch Town* NG 2710

van Mieris the Elder *Self Portrait of the Artist with a Cittern* NG 1874

Lorenzo Monaco *The Coronation of the Virgin* NG 215, 1897, 216

Pacher *The Virgin and Child Enthroned with Angels and Saints* NG 5786

Potter *Cattle and Sheep in a Stormy Landscape* NG 2583

Imitator of Raphael *Portrait of a Young Man* NG 2510

Rubens *The Brazen Serpent* NG 59

Studio of Rubens *Drunken Silenus supported by Satyrs* NG 853

Ruisdael *The Shore at Egmond-aan-Zee* NG 1390

Scheffer *Mrs Robert Hollond* NG 1169

Scheffer *Saints Augustine and Monica* NG 1170

Giorgio Schiavone *The Virgin and Child* NG 904

Signorelli *The Adoration of the Shepherds* NG 1133

Signorelli *The Adoration of the Shepherds* NG 1776

Steen *The Interior of an Inn ('The Broken Eggs')* NG 5637

Zanobi Strozzi *The Annunciation* NG 1406

Attrib. Tournières *La Barre and other Musicians* NG 2081

van Velsen *A Musical Party* NG 2575

Veronese *The Rape of Europa* NG 97

Vroom *A Landscape with a River by a Wood* NG 3475

Wertinger *Summer* NG 6568

Ysenbrandt *The Magdalen in a Landscape* NG 2585